ABANDONED
ALBERTA

JOE CHOWANIEC

MacIntyre Purcell Publishing Inc.
194 Hospital Rd.
Lunenburg, Nova Scotia
B0J 2C0
(902) 640-3350

www.macintyrepurcell.com
info@macintyrepurcell.com

Printed and bound in Canada by Friesens

Cover design: Denis Cunningham
Book design: Denis Cunningham
Author photo (back cover): Darcy Evans

ISBN: 978-1-77276-147-4

Library and Archives Canada Cataloguing in Publication Title: Abandoned Alberta / Joe Chowaniec. Names: Chowaniec, Joe, photographer. Identifiers: Canadiana 20200227254 | ISBN 9781772761474 (hardcover) Subjects: LCSH: Alberta—Pictorial works. | LCSH: Abandoned buildings—Alberta—Pictorial works. | LCGFT: Photobooks. Classification: LCC FC3662 .C46 2020 | DDC 971.23/040222—dc23

MacIntyre Purcell Publishing Inc. would like to acknowledge the financial support of the Government of Canada and the Nova Scotia Department of Tourism, Culture and Heritage.

Funded by the Government of Canada | Canada NOVA SCOTIA

*To my wife, Rami, for being my rock through
times good and bad, and for just being you.
And for my parents, who would have been so proud of my successes.
Thank you for the valuable life lessons.*

The Rossdale power plant in Edmonton's river valley is an important piece of Alberta's industrial heritage. Originally a coal-fired plant, in 1970 it provided one quarter of Alberta's power. The plant stopped producing in 2008 and was decommissioned in 2011-12. It now sits abandoned, but there are ongoing discussions about repurposing the building.

Introduction

"You know there are moments such as these when time stands still ..."
— Dorothea Lange

As I travelled around the province of Alberta, either for work or vacation, I began to notice the abandoned homes and farms in the fields. It is not like they weren't there before, it's just that for whatever reason my wandering mind started to notice them.

At first, I would stop and look at the buildings, wondering where the people had gone and what had prompted them to leave. In December 2016, I brought my camera along on one of my drives and I saw through the viewfinder a glimpse of times past. As my shutter clicked and clicked, this journey began.

A few buildings have extensive stories. In many cases there are no stories, only the fading memories of families that have long since moved on. With homesteads, there often was no next generation or a generation that didn't want the farming lifestyle and instead moved to the cities.

Alberta has a relatively short but rich history. Alberta became a province in 1905, but for centuries the land was home to First Nations peoples who populated the prairies. The first immigrants from French Canada arrived in the 1870s, followed by Methodists from Ontario in the early 1880s, and settlers from the Utah area in 1887. Shortly thereafter, settlers began arriving from Europe, including the Scandinavian countries.

As I pondered the structure of this book and the path of my erratic journeys around Alberta, I remembered there were many days that my wife would ask me where I was headed. I would respond with "wherever the car decides to go."

Since December 2016, I have covered over 10,000 kilometres of highways, range roads and township roads, scouring the countryside for photographic opportunities. Some days I would easily cover 800 kilometres in a day and come back with no photos. Other trips would provide a goldmine of photographs. In the end, I decided the hunt for the perfect shot should follow no path and be as random as my travels.

No photos were staged; they were all candid and the property was always respected. Only photos were taken and nothing was removed or damaged. Remember, "abandoned" means that the property or building has sat empty and neglected. It does not mean that there is no owner. If you are out exploring, be respectful.

The odd exception, where noted, is a building that may still be used a few times a year, but has been included for its historical importance.

Enjoy your journey through *Abandoned Alberta*!

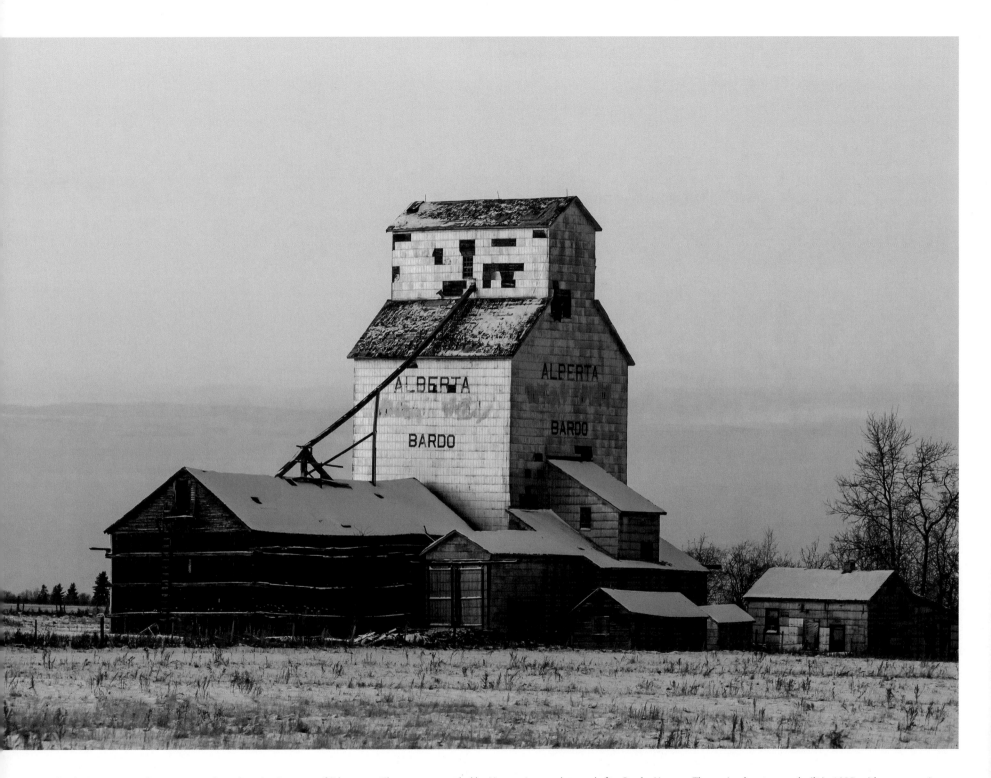

Bardo is not a town but a community or location just east of Edmonton. The area was settled by Norwegians and named after Bardo, Norway. The grain elevator was built in 1923, with an expansion added between 1941 and 1944. The grain elevator and its remaining buildings sit on the family property of Phil Johnson, an avid collector and restorer of old tractors and cars.

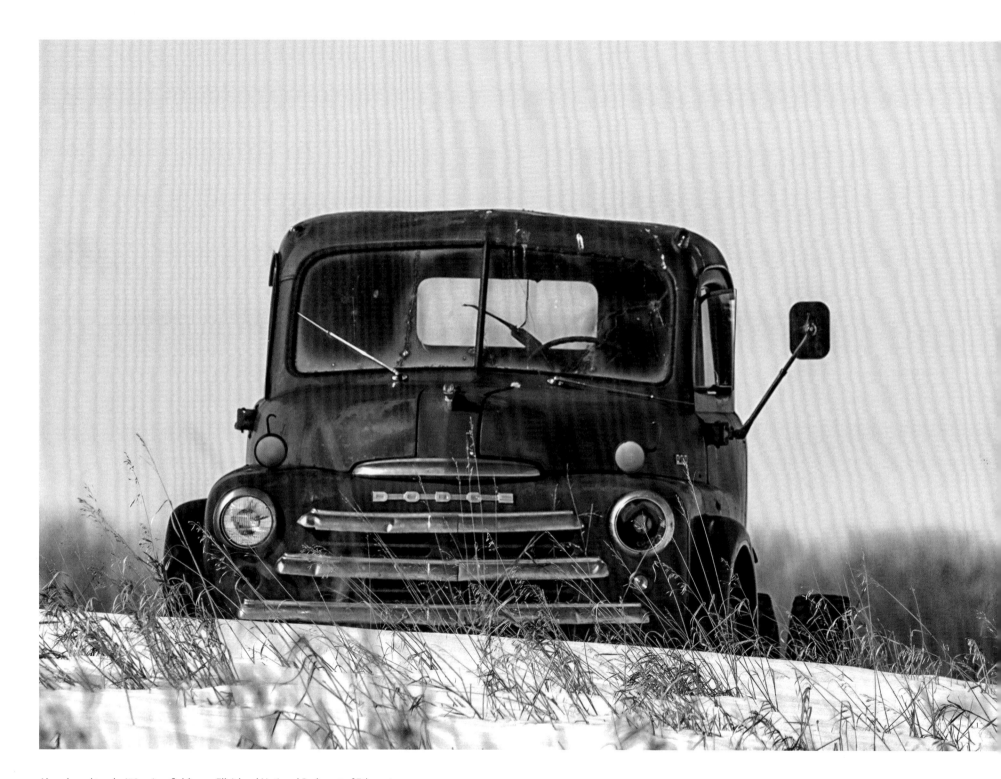

Abandoned truck sitting in a field near Elk Island National Park east of Edmonton.

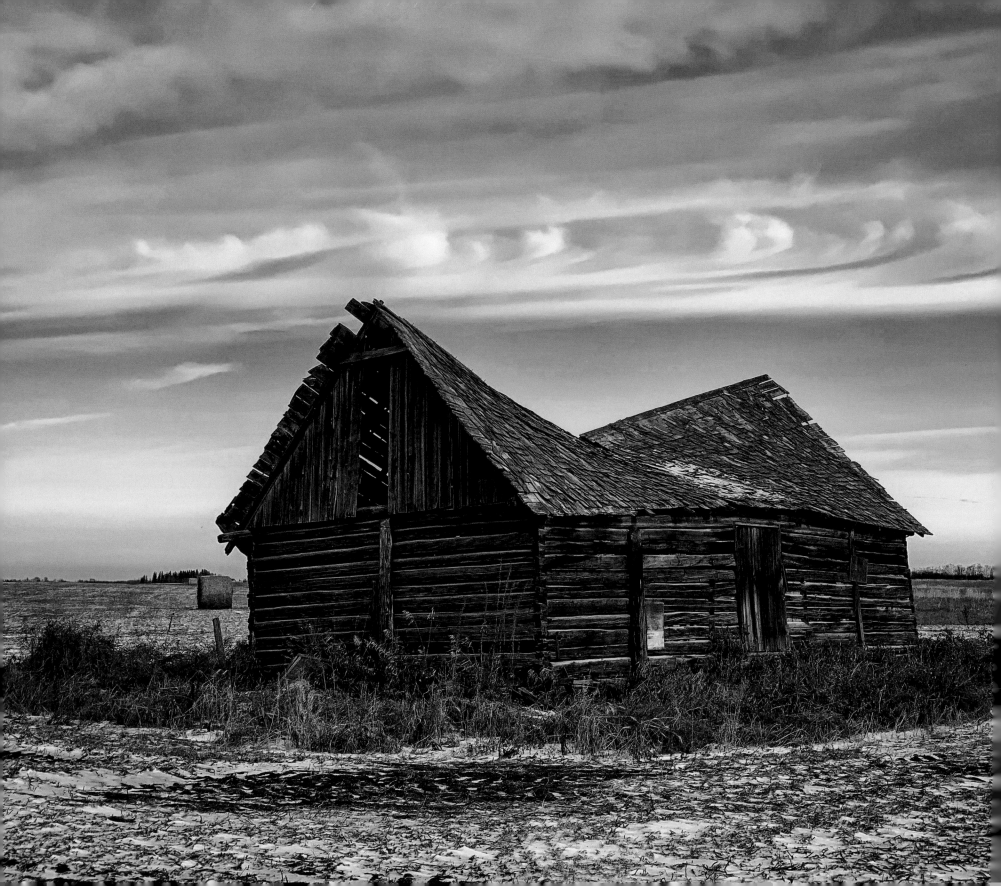

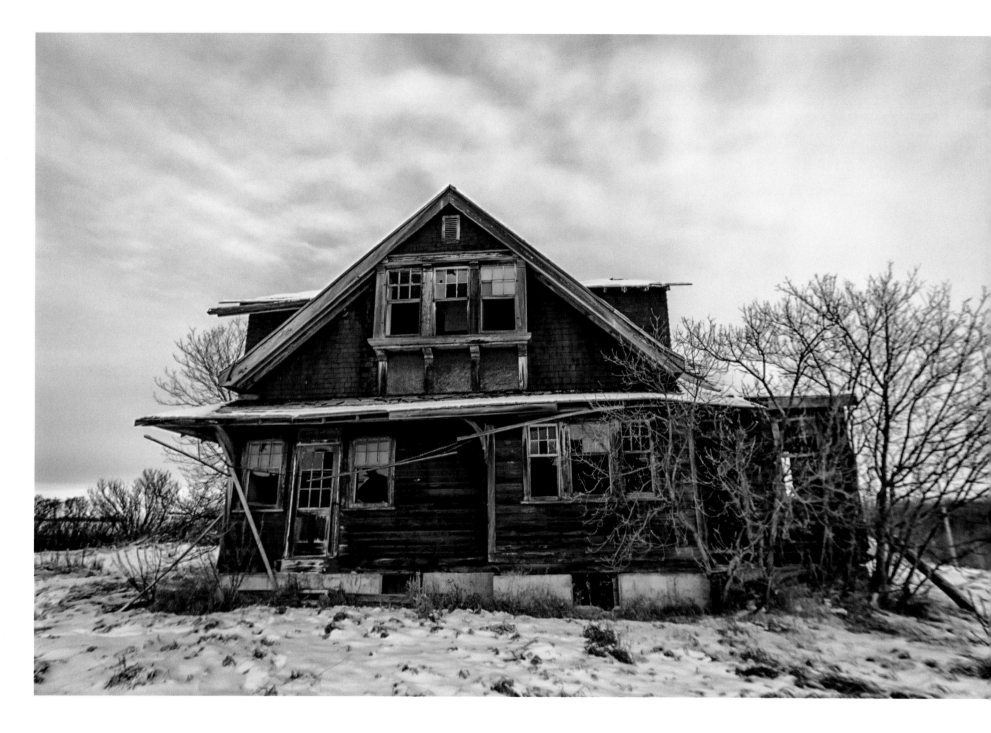

(Opposite) This old farm building near St. Michael may have only one more winter before the toll of time collapses her.

(Above) The railroad station at Myrnam, which oddly isn't in Myrnam and appears to have been moved a few kilometres away, possibly for use as a home. This station dates to at least 1927 or earlier.

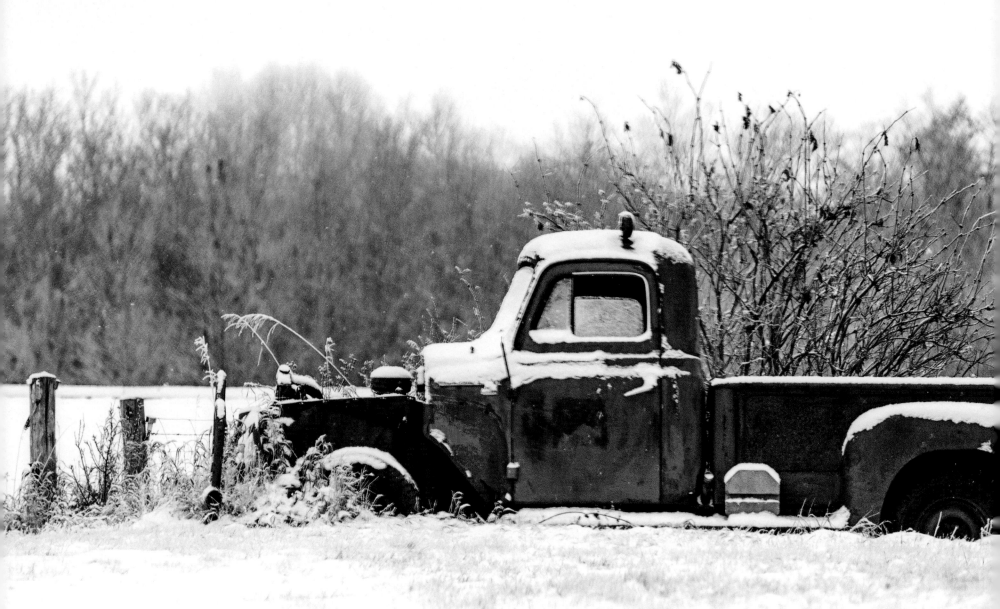

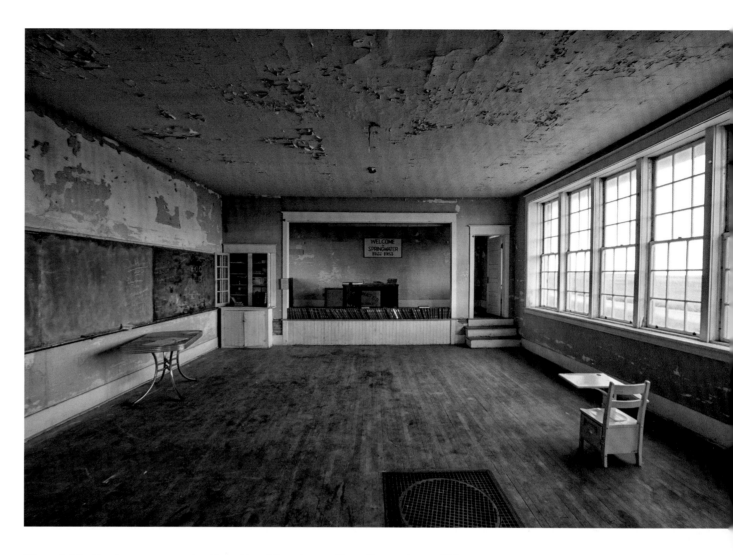

(**Opposite**) Red truck, once someone's pride and joy, sitting alone and forgotten southeast of Edmonton.

(**Above**) Inside Springwater School, the red books on the stage are bound copies of National Geographic and the bookcase contained copies of the magazine from 1927.

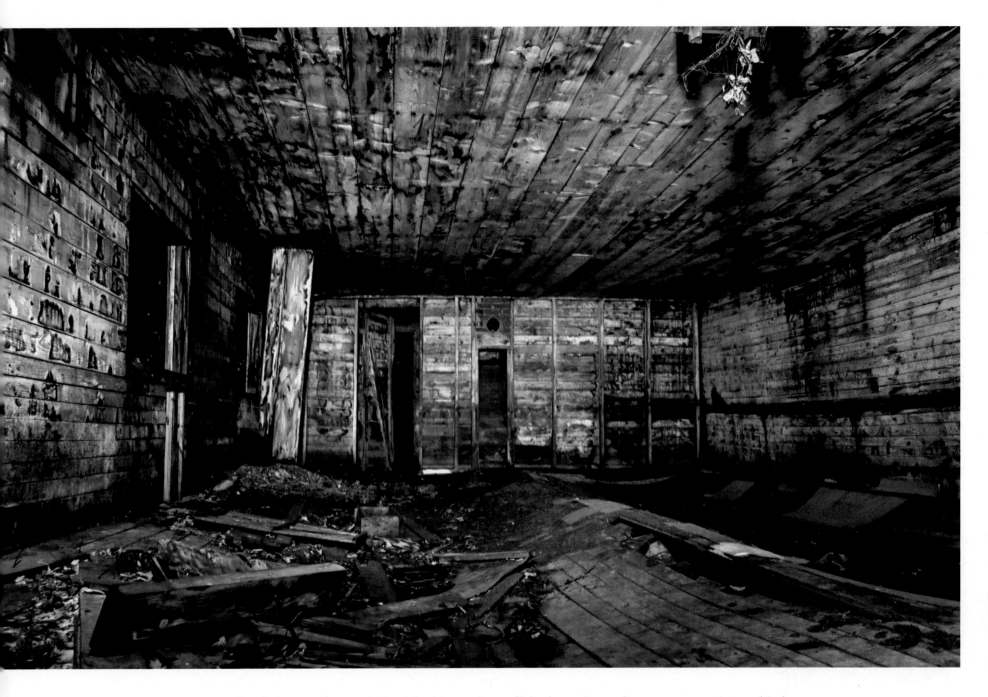

Inside a farm building on the western edge of Edmonton. Photographed at night with strategic use of light, she remains standing even as nature tries to reclaim her from above and below.

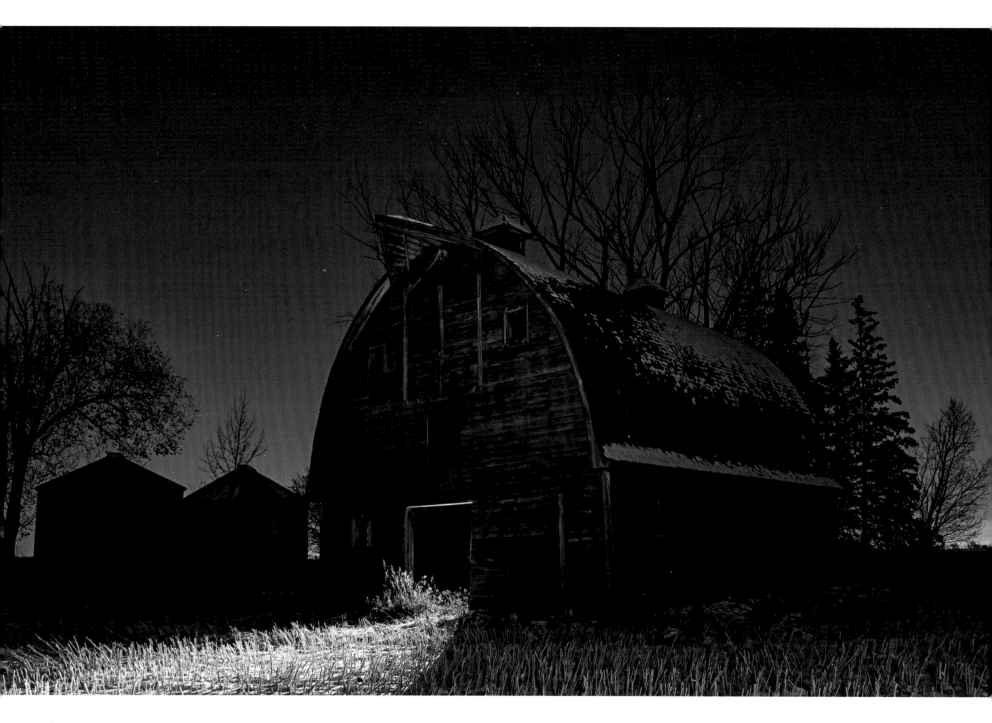

Barn on the western edge of Edmonton. The interior was illuminated with a few lights while a flashlight points outwards.

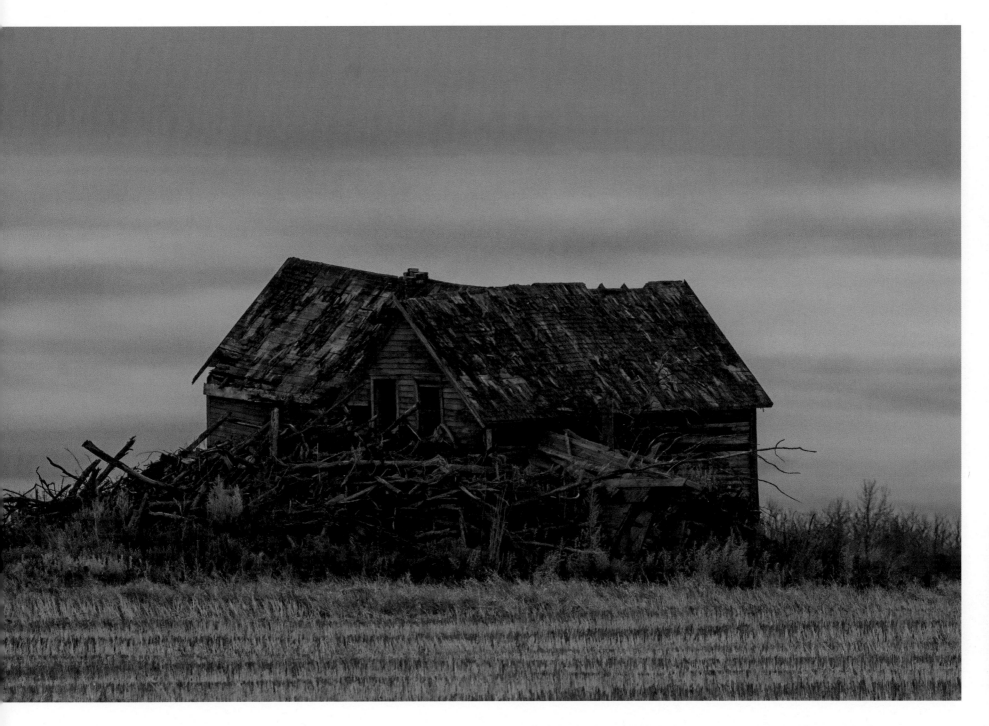

(Above) Debris from field clearing is piled against this house in central Alberta that was once someone's home.

(Opposite) Inside the main floor kitchen of a two-storey home in east central Alberta. The exact location is withheld as this property has been heavily vandalized by individuals stripping the barn wood off the exterior.

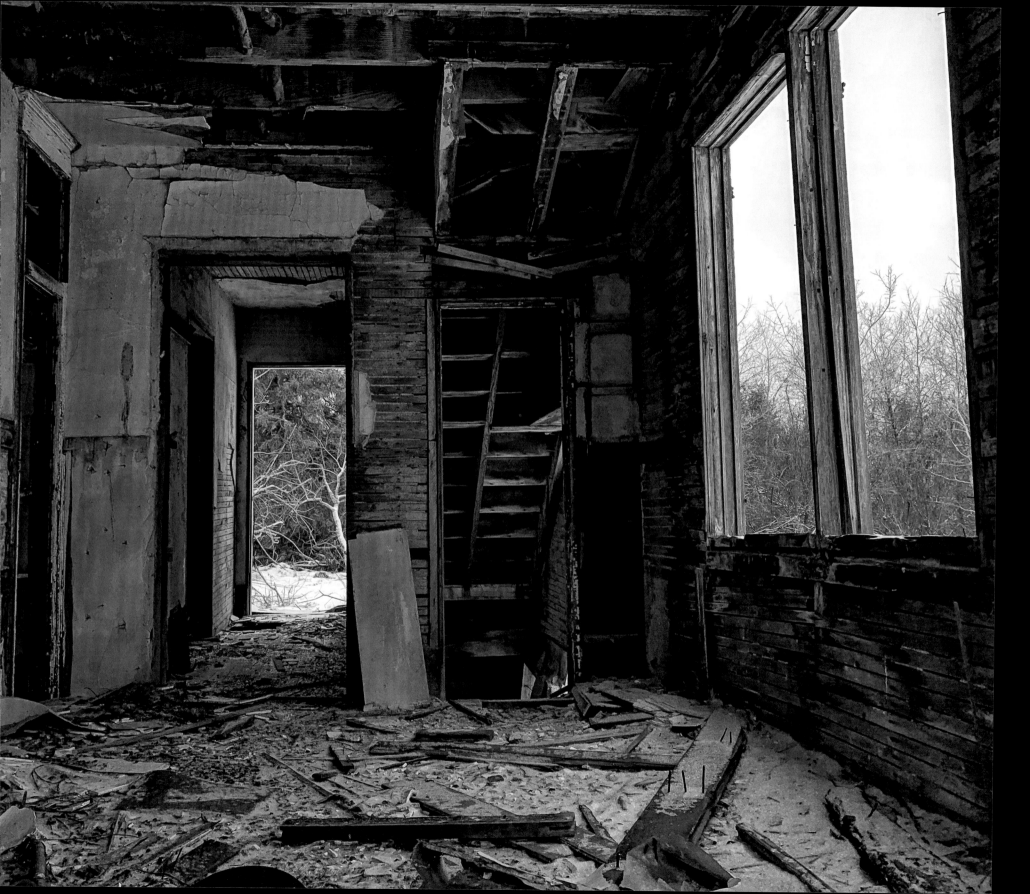

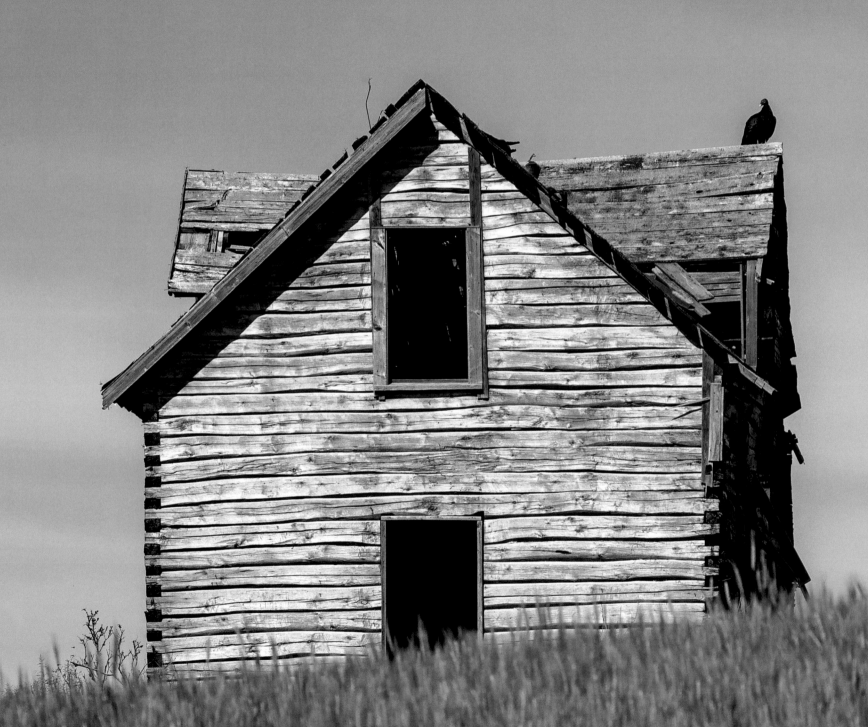

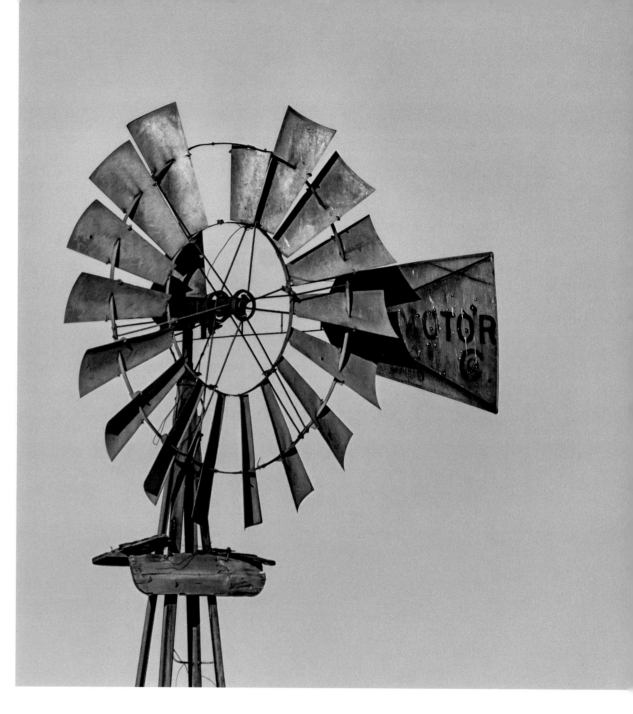

(Opposite) Old house with a dovetail notch construction technique near Bashaw, a community named after the original owner of the town site. The building is a popular lookout spot for turkey vultures on hot summer days. (Photo by Rob Brennen).

(Above) A common site across Alberta — old windpump that powered the water pump for the homestead.

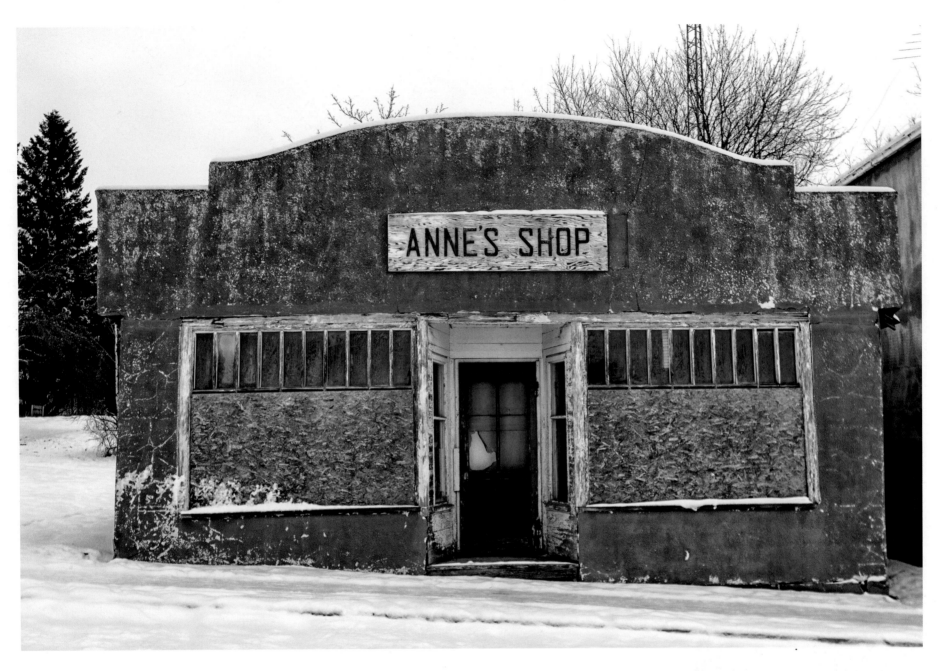

(**Above**) Anne's Shop in Myrnam. Interestingly, the original Myrnam Hospital was featured in a Canada Heritage Minute video — "The struggle of one small Alberta community to care for its residents during the Great Depression marks a tiny step in the evolution of Canada's universal health care system in 1937." Myrnam's post office opened in 1908; the town began to flourish in 1927 when the trains arrived.

(**Opposite**) The general store in Wostok was probably once a popular place for the locals to gather and gossip. Shortly after this photo was taken in October 2019, the building was pulled down.

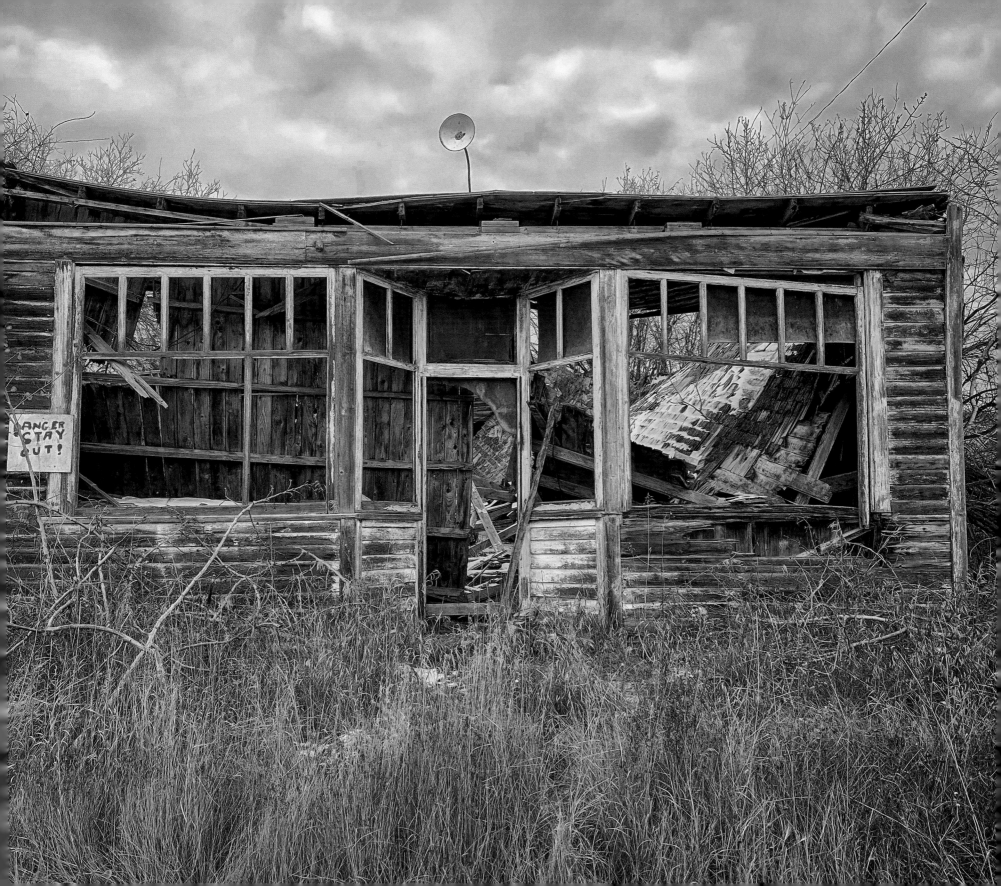

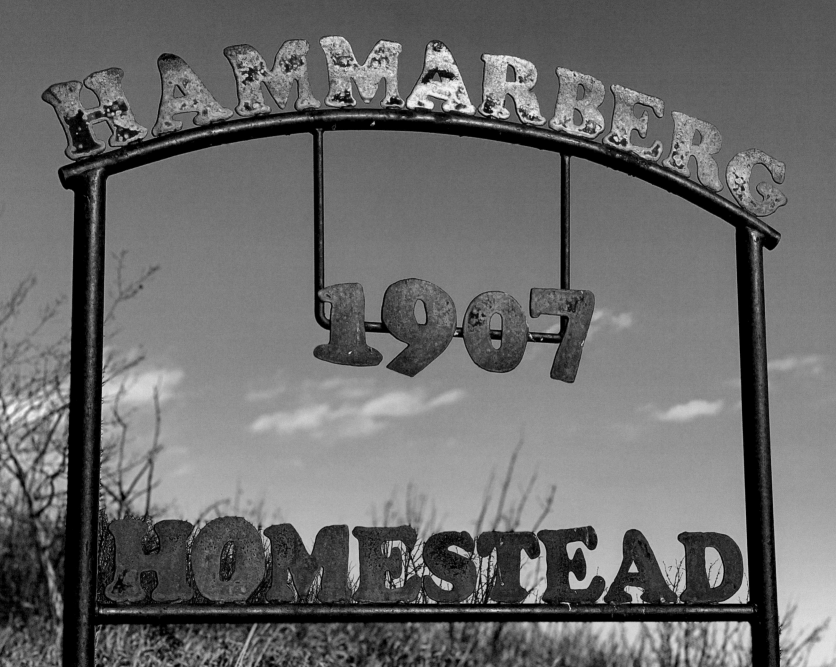

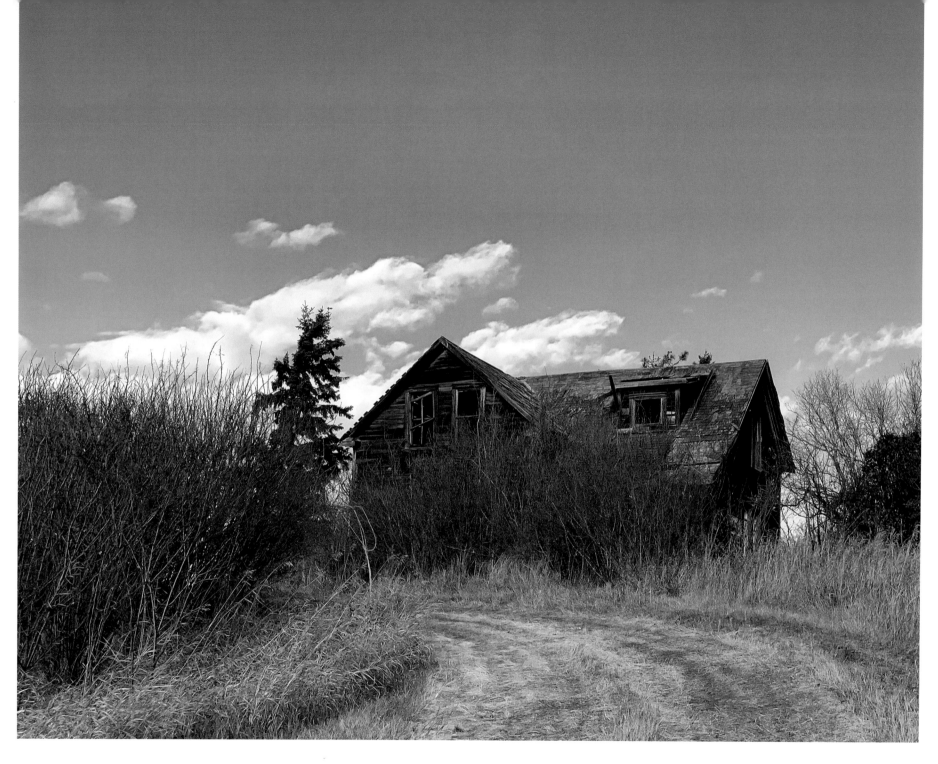

(Opposite) Hammarberg Homestead founded in 1907 near Donalda, a small community founded by Norwegian settlers. All that remains of the homestead is the sign and the large house.

(Above) At times barely visible from the highway, the trees have slowly started to swallow what could have been one of the largest homes in the Donalda area. The house at Hammarberg Homestead was lived in until 1970 by Carl August Hammarberg and Margorie Mary Cram. Carl, known as August, was born in the house in 1914.

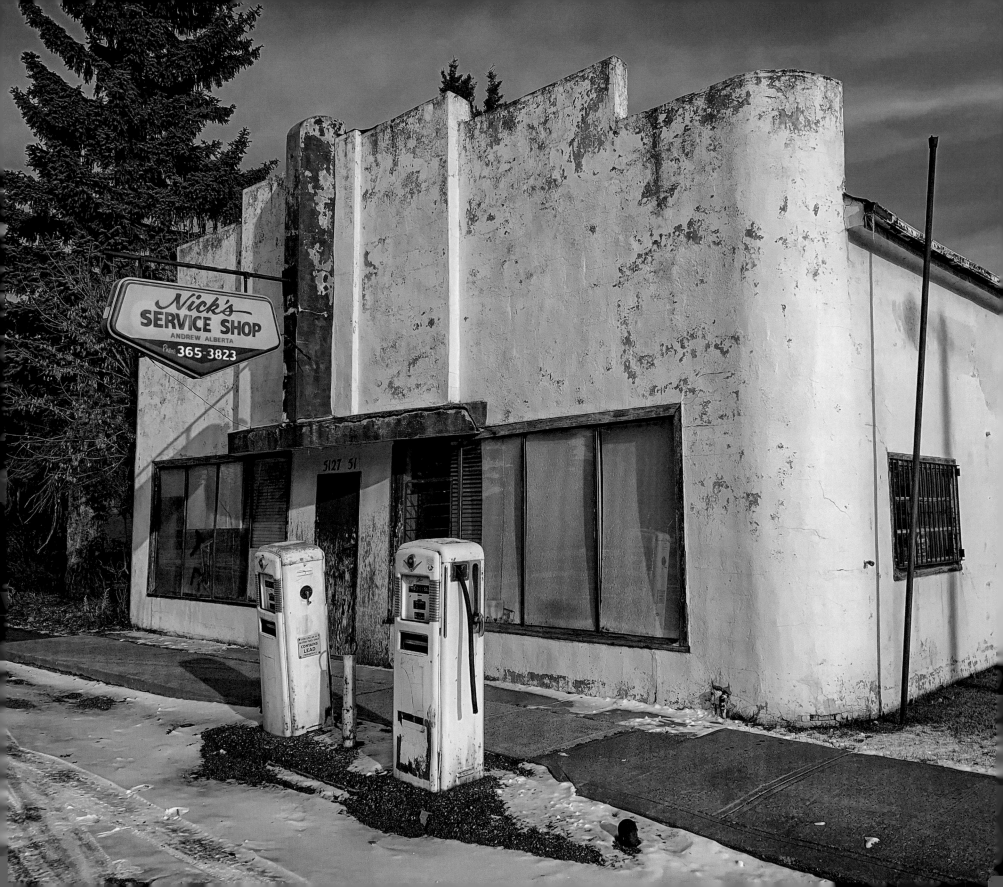

I'm left all alone
Springtime in Alberta
Chills me to the bone
I can see the storm clouds comin'
Lord they're dark across the sky

Ian Tyson, Spring Time in Alberta

(Opposite) Nick's Service Shop in Andrew with the pumps still proudly standing in September 2019.

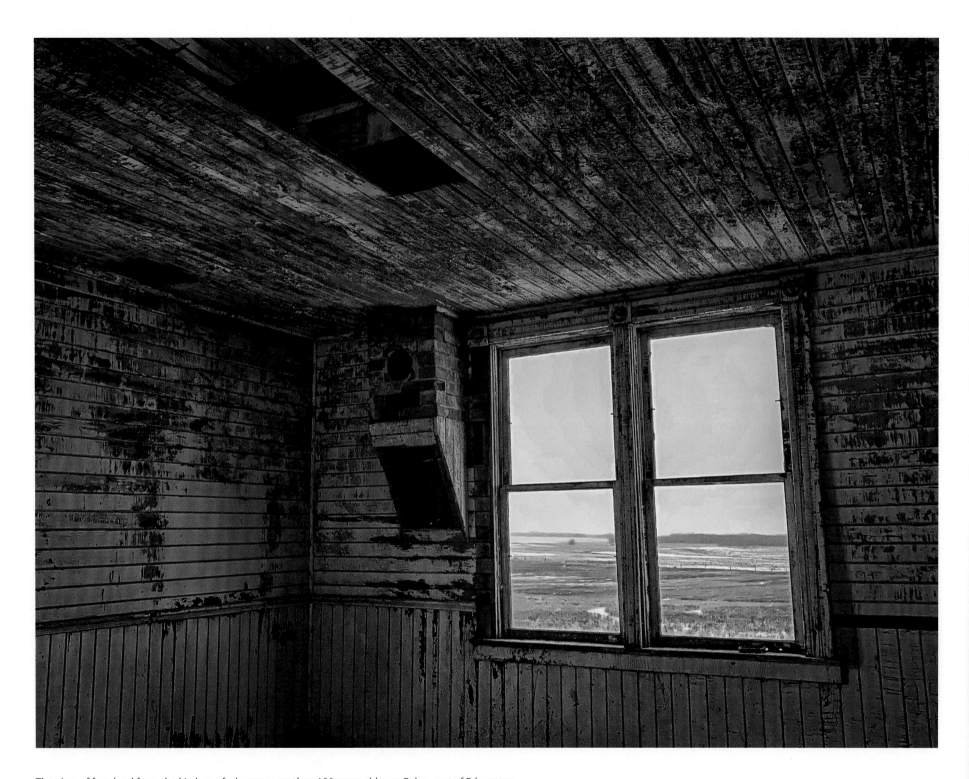

The view of farmland from the kitchen of a house more than 100 years old near Ryley, east of Edmonton.

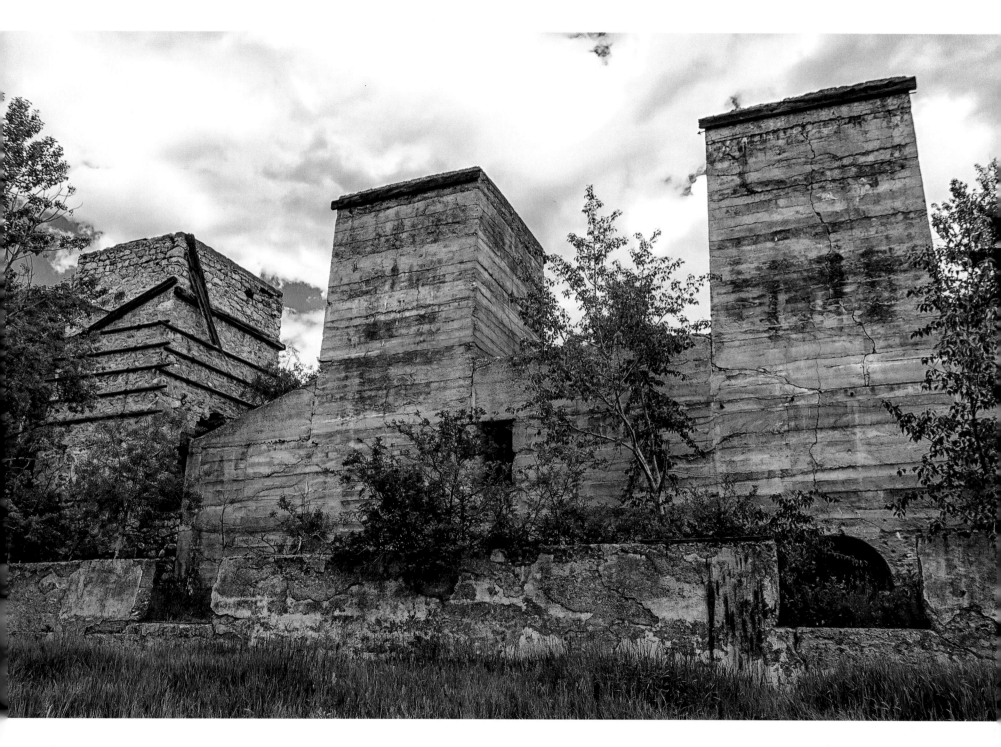

Welcome to Lime City, located on the eastern edge of the Frank Slide in the Crowsnest Pass of southern Alberta. Lime was used extensively in coalmines for rock dusting as a way to control dangerous coal dust. In 1909, local entrepreneur Joe Little recognized that the Frank Slide provided a seemingly endless supply of limestone with no quarrying required. What remains are the wood-fired "drawn kilns" that allowed continuous operations. Limestone boulders were broken into manageable pieces and dumped into the top of the kilns and then baked at high temperatures. The lime was then drawn out of the bottom of the kilns through the openings at ground level.

(Left) The sun sets on an old homestead near Beaverhill Lake in September 2018.

(Bottom) In 1909, the Maple Leaf Coal Company commenced operations at the Mohawk Bituminous Mine and constructed the settlement of Maple Leaf adjacent to Bellevue in the Crowsnest Pass. Little of the mine remains; foundations for other parts of the collier can be found across the train tracks from the main building severely damaged in a fire in the late 1950s.

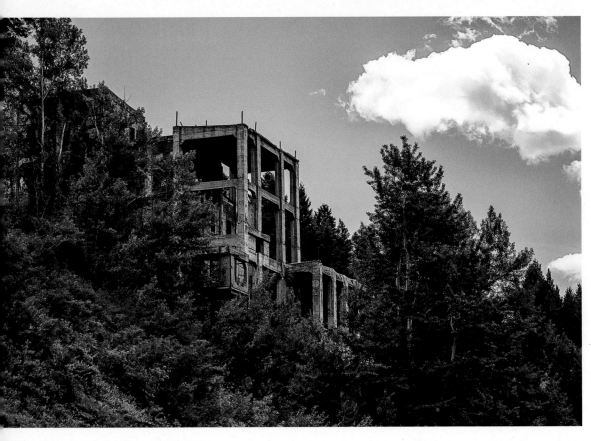

(Opposite) Mining cart found in the creek bed of the Mill Creek ravine in Edmonton. The Edmonton area was heavily mined for coal at the turn of the last century. Occasionally, after a heavy rain or large spring runoff, relics return to remind of us the past.

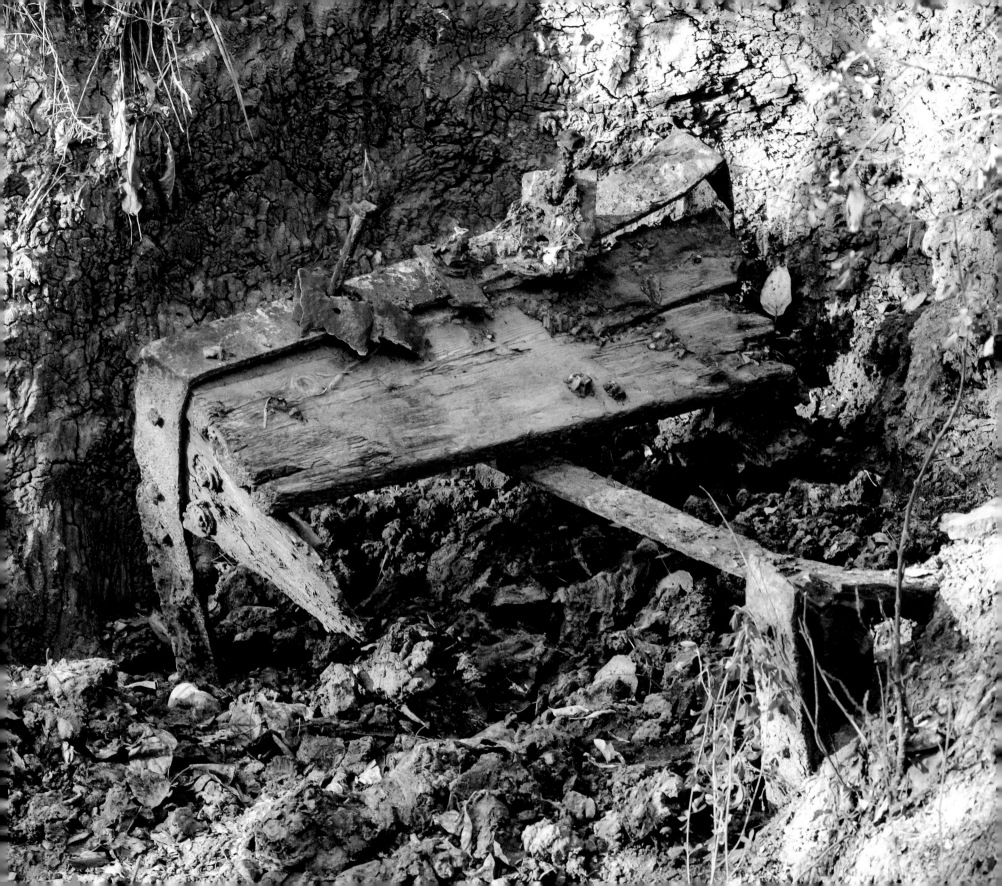

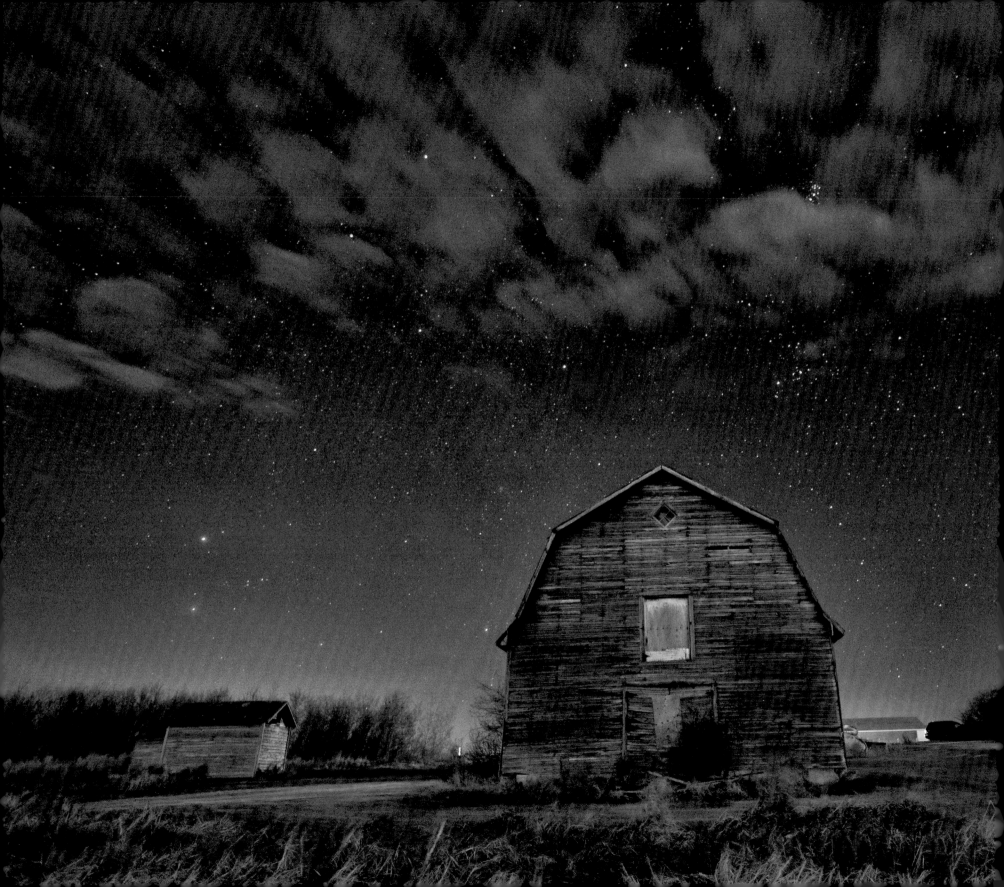

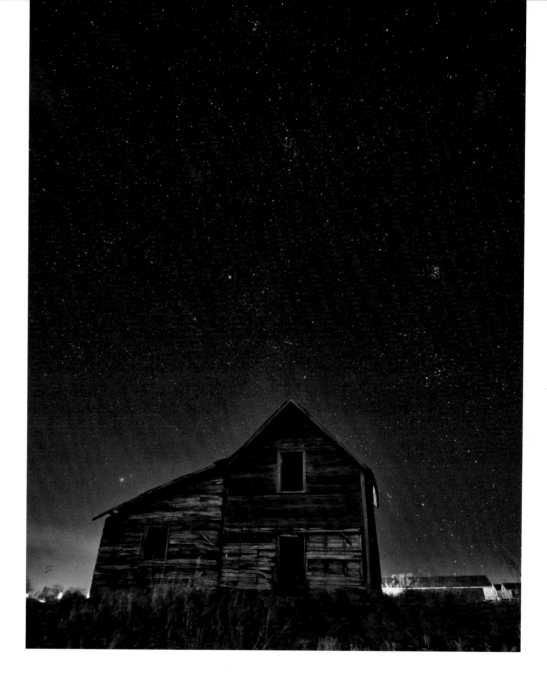

(**Opposite**) Old farm near Lamont on a starry night as cloud approaches. Details about this property's history are sparse.

(**Above**) Old homestead near Lamont late at night as the stars shine brightly and the aurora tries to dance across the sky.

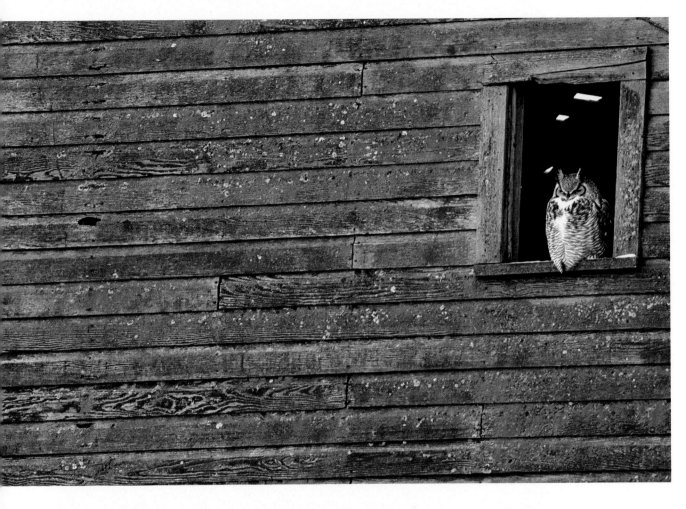

(Above) For over two years, I searched for an owl that had taken up residence in an abandoned barn. Finally, in November 2019, my patience was rewarded. This Great Horned Owl has the perfect home in east central Alberta.

(Opposite) A beautiful two-storey house near Ryley that has stood the test of time. This century-old dwelling built from mahogany was approximately 1,100 square feet over two floors. Home to nine children over the years, much of the family remains in the area.

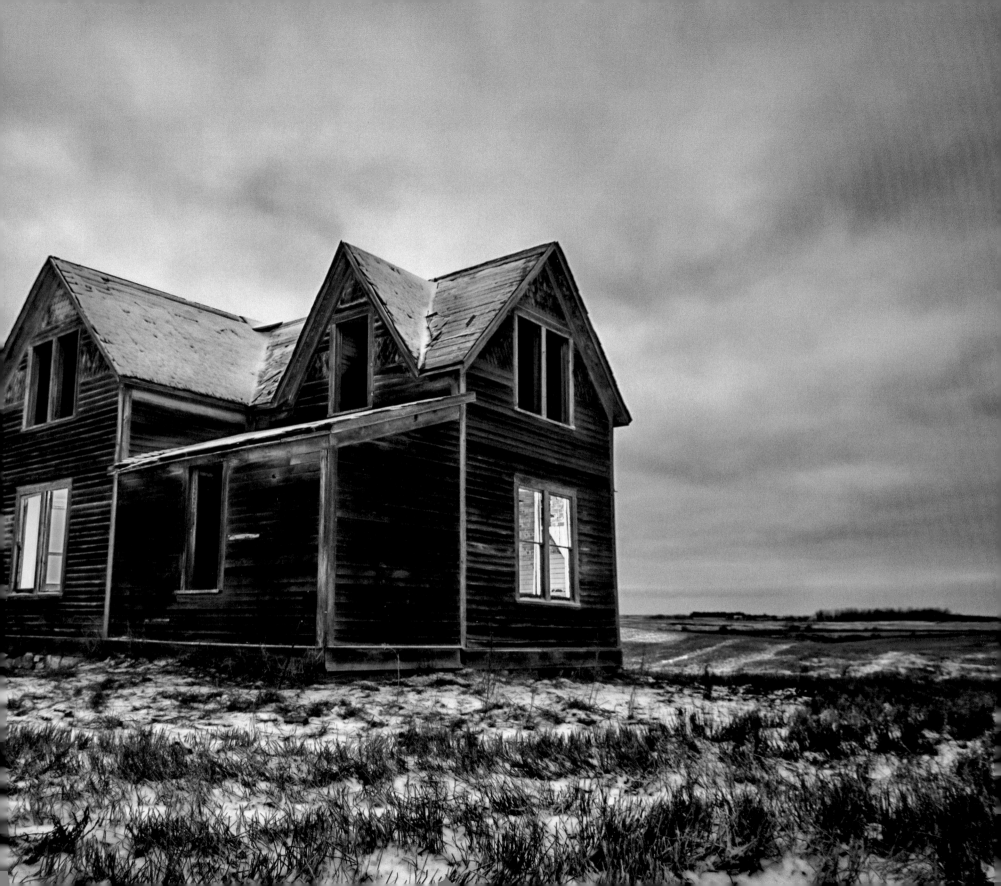

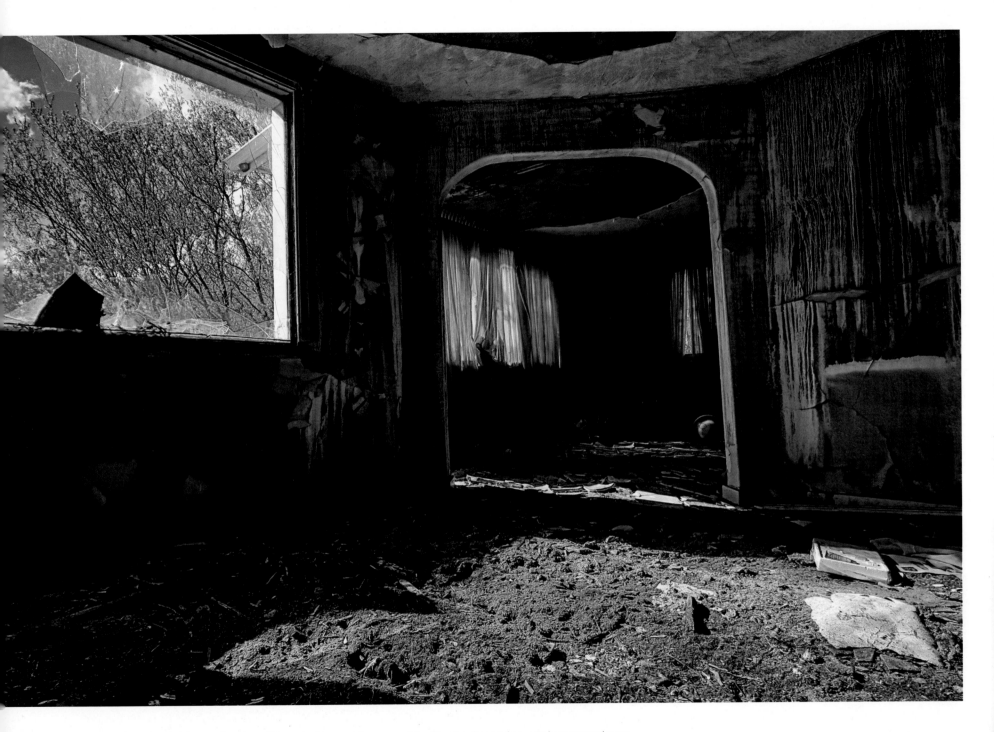

The interior of the Serediak home. Curtains still hang in the second room, and the floor has been taken over by moss and grass.

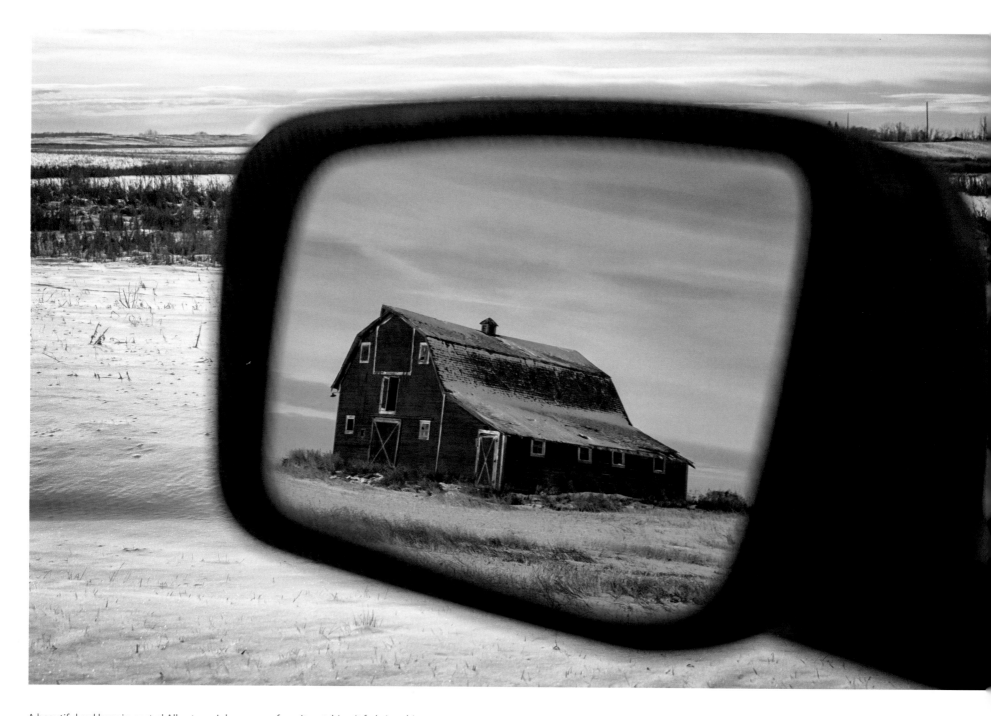

A beautiful red barn in central Alberta, as I drove away from it watching it fade into history.

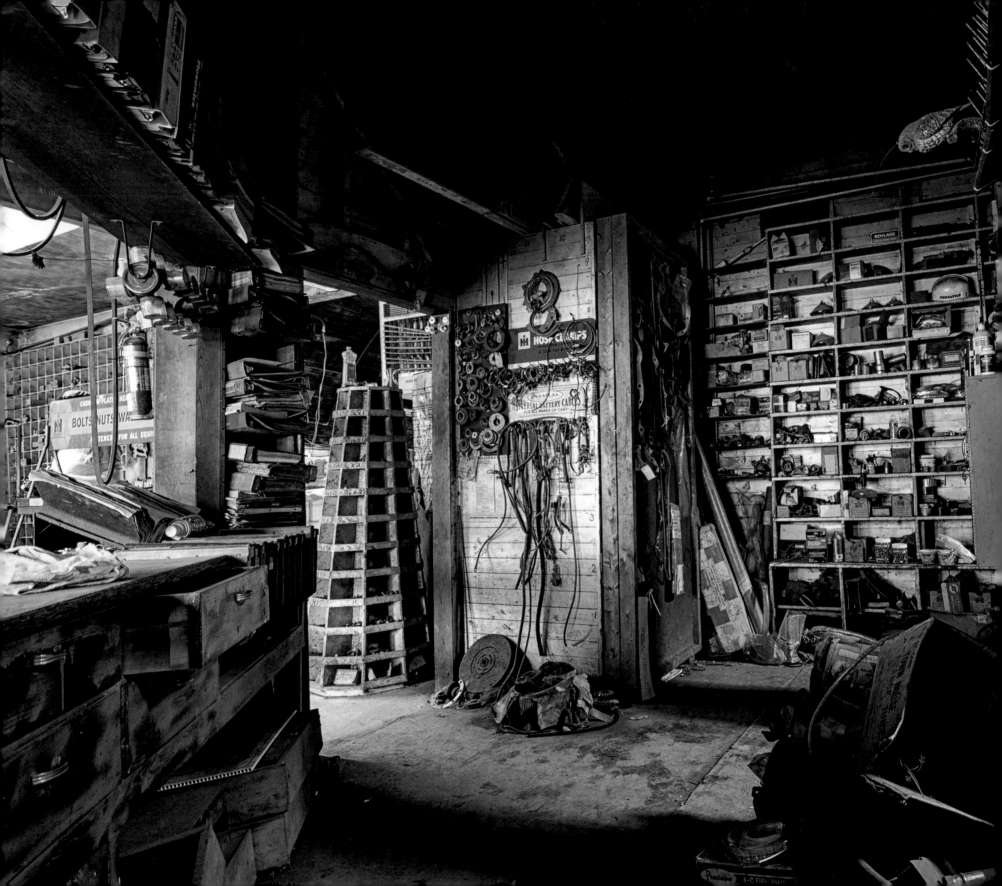

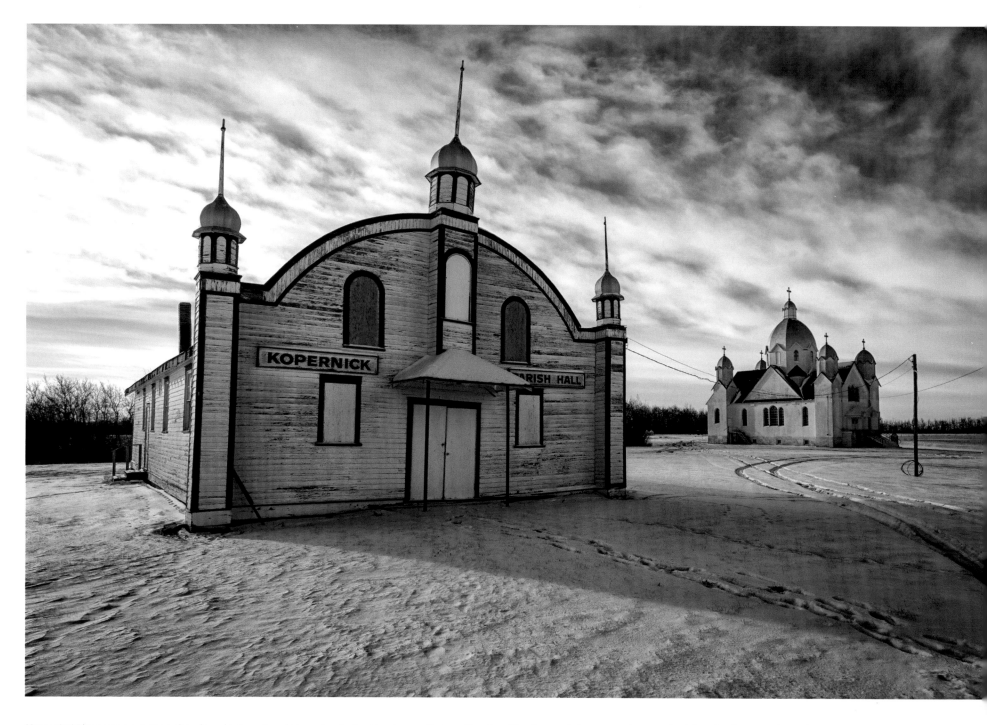

(Opposite) The parts room at an abandoned International Harvester dealership at an undisclosed location. The shop and showroom sit untouched since its closure in the early 1960s.

(Above) Kopernick Hall and Ukranian Catholic Church in Beaver County. The hall was built in 1933 and there has been a church on the site since 1904. The current church was completed in 1960 and saw its last regular service in 2009, though the grounds and church are still maintained.

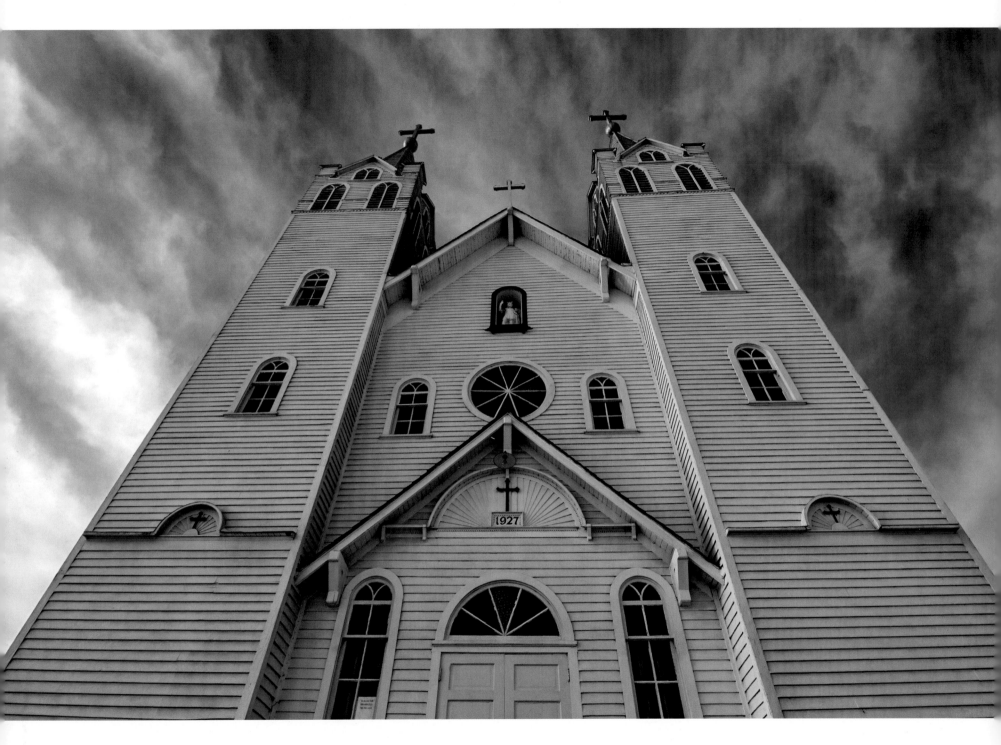

St. Peter's Roman Catholic Church in Flagstaff County. The first church on the site was in 1903 following the arrival of German immigrants from Minnesota via rail. The current church was built in 1927 and was declared a historical resource in 2013. It is now protected and hopefully preserved for many years to come. It is used occasionally for weddings and funerals.

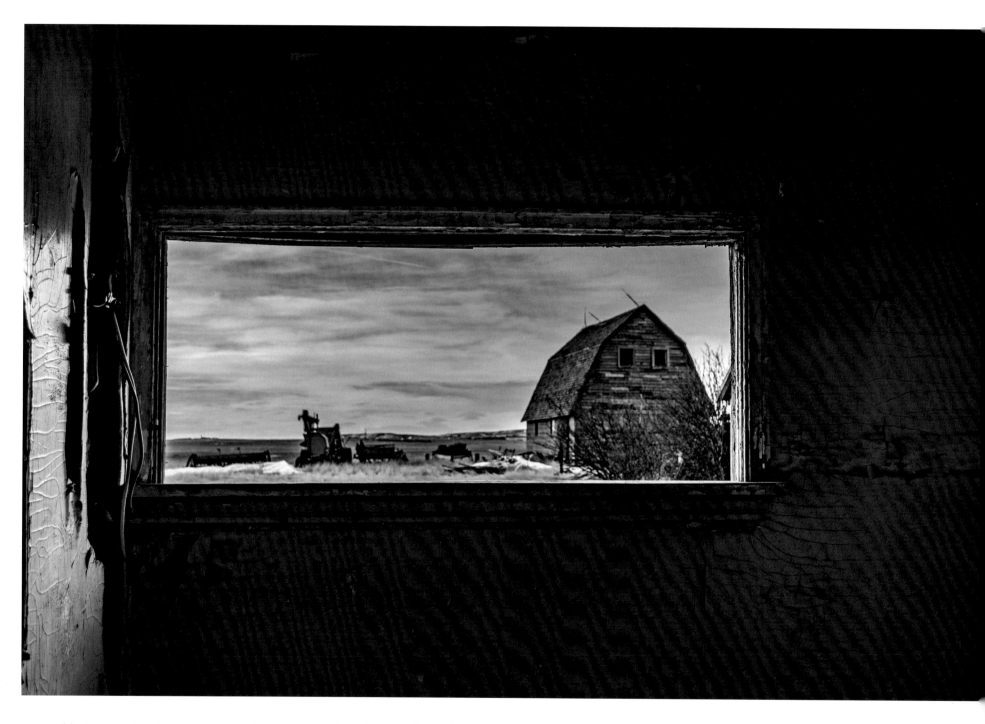

Visions of days gone by. View from an old kitchen of a long forgotten home in Warner County. One can only imagine what the farmer's wife must have dreamt about as she gazed through the window while cooking supper. (**Photo by Allison Blackburn Billings**)

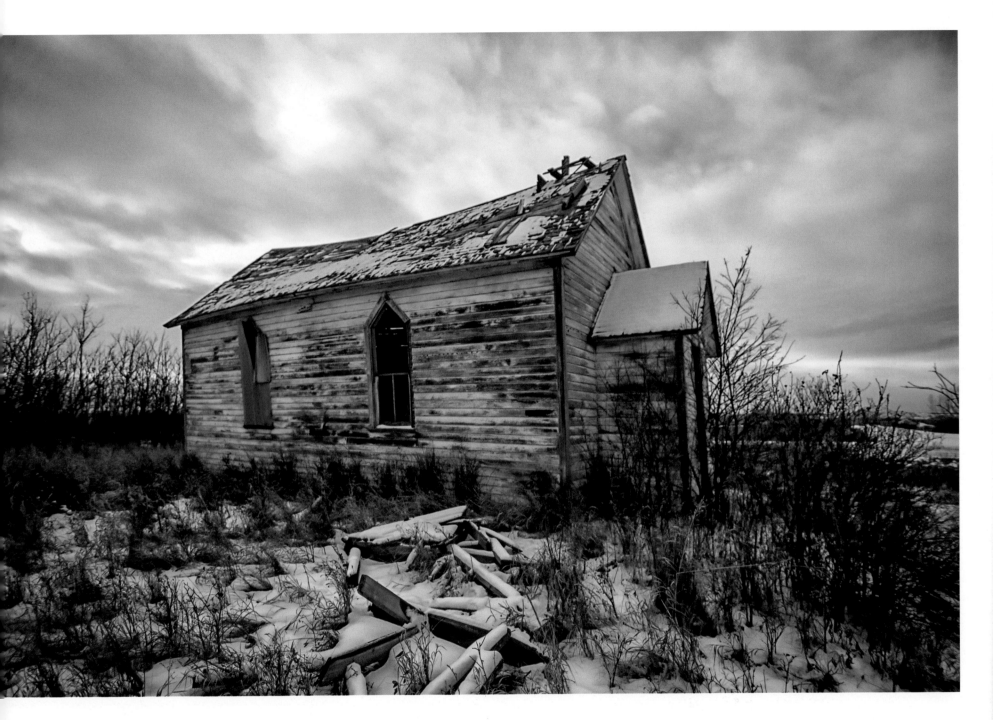

(**Above**) Approximately 105 years old, Notre Dame de Savoie Church in central Alberta is suffering from the ravages of time. She stands fighting against nature, weather and gravity, and her steeple has fallen but even in her current condition, she is beautiful. The church has been empty since the 1960s, as the community that she survived has long since disappeared. This was one of the smallest churches I have visited but I felt a sense of peace in her presence.

(**Opposite**) Inside Notre Dame de Savoie Church in December 2019.

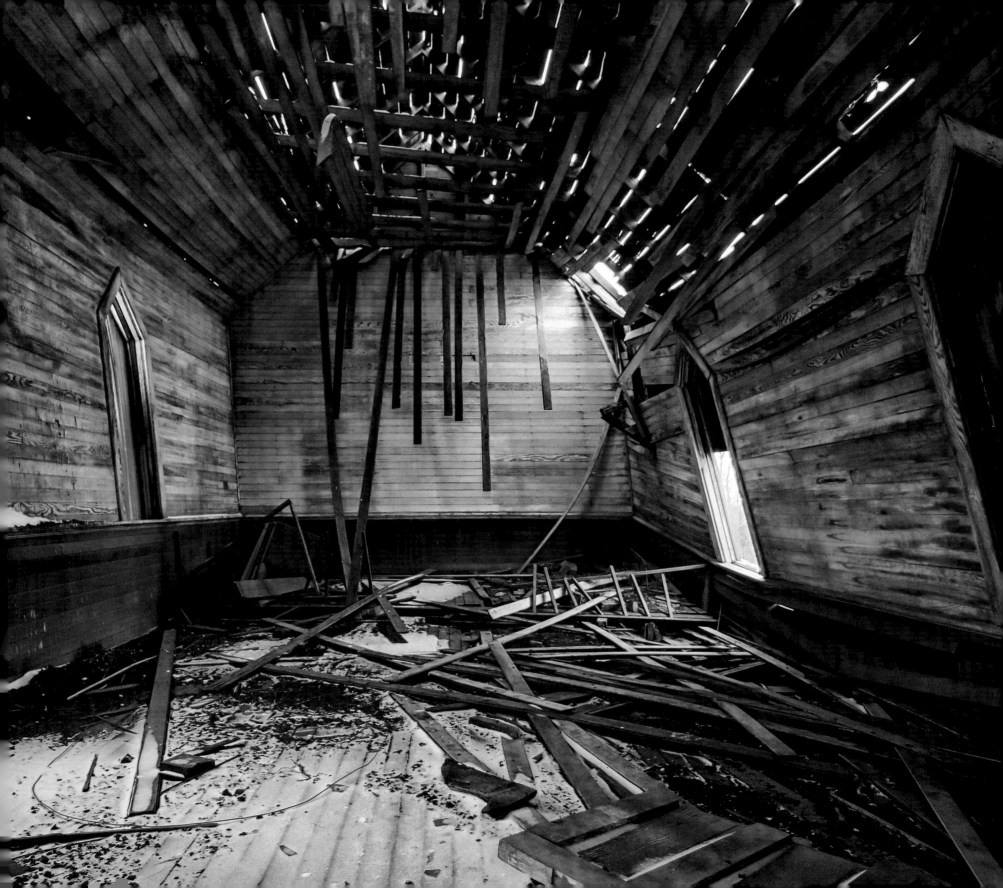

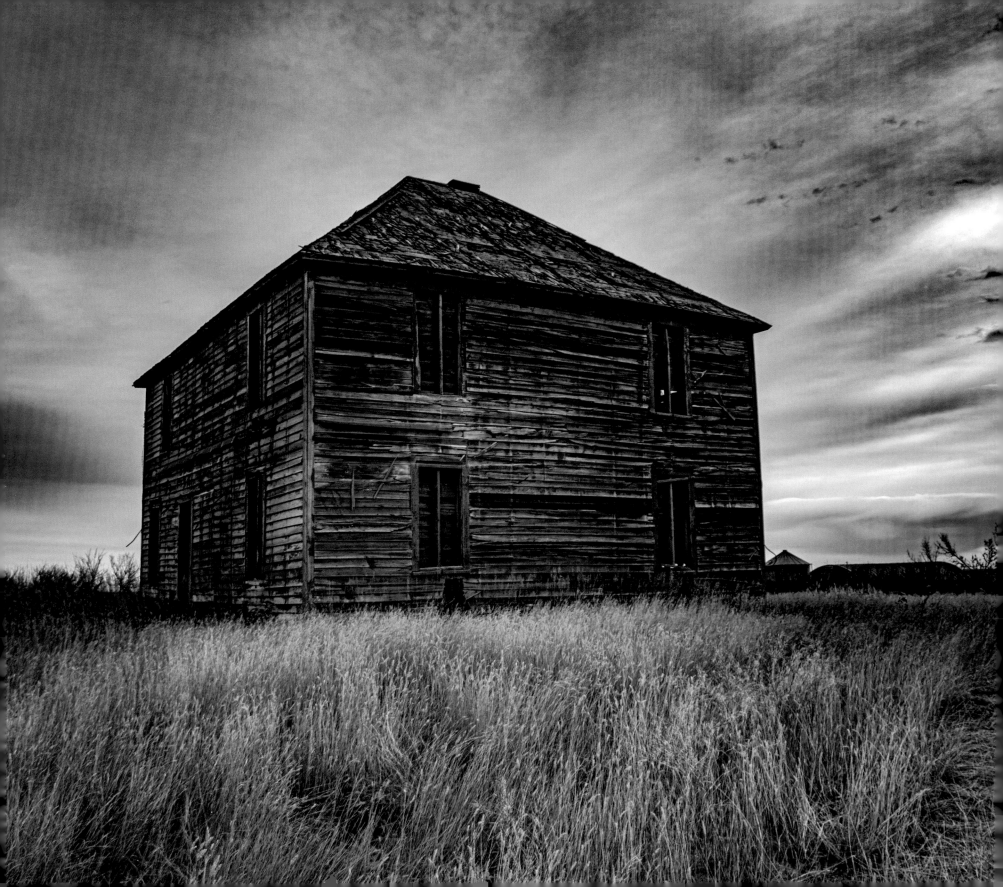

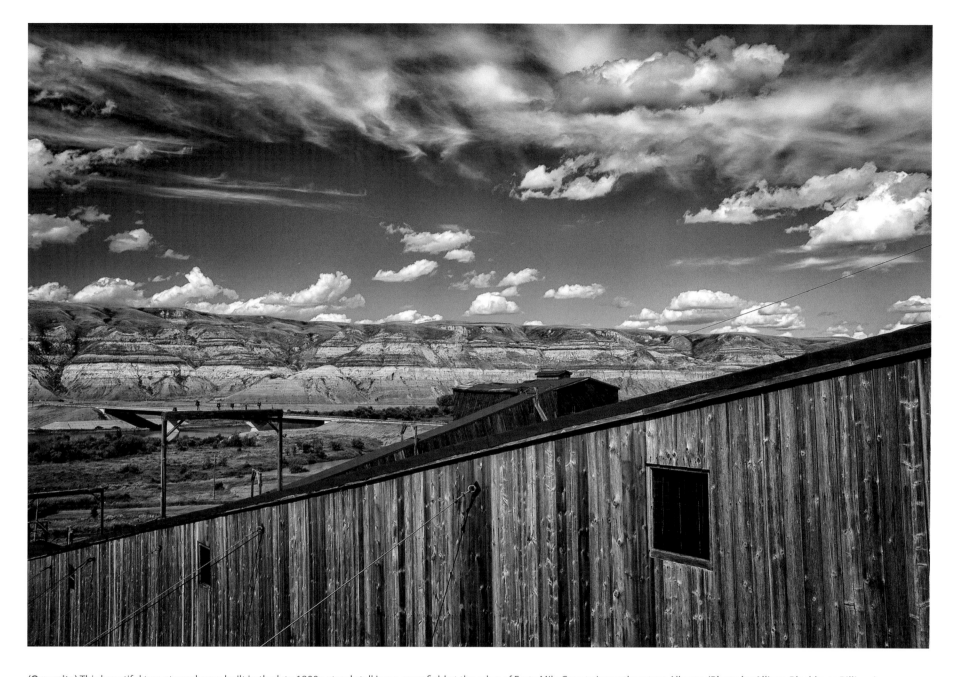

(**Opposite**) This beautiful two-storey home built in the late 1800s, stands tall in an open field at the edge of Forty Mile County in southeastern Alberta. (**Photo by Allison Blackburn Billings**)

(**Above**) The Atlas Mine in East Coulee near Drumheller operated when "Coal was King." The Atlas was the last of 139 mines in the area. The tipple, the conveyor, battery locomotive, washhouse, and lamp house still survive. The tipple – a coal loading and sorting machine – is the last remaining wooden tipple in Canada and soars above the ground at seven stories in height. The mine never suffered from methane explosions like many others, but was the victim of tunnel collapses during its history. View from the top of mine looking down into the valley and the Badlands.

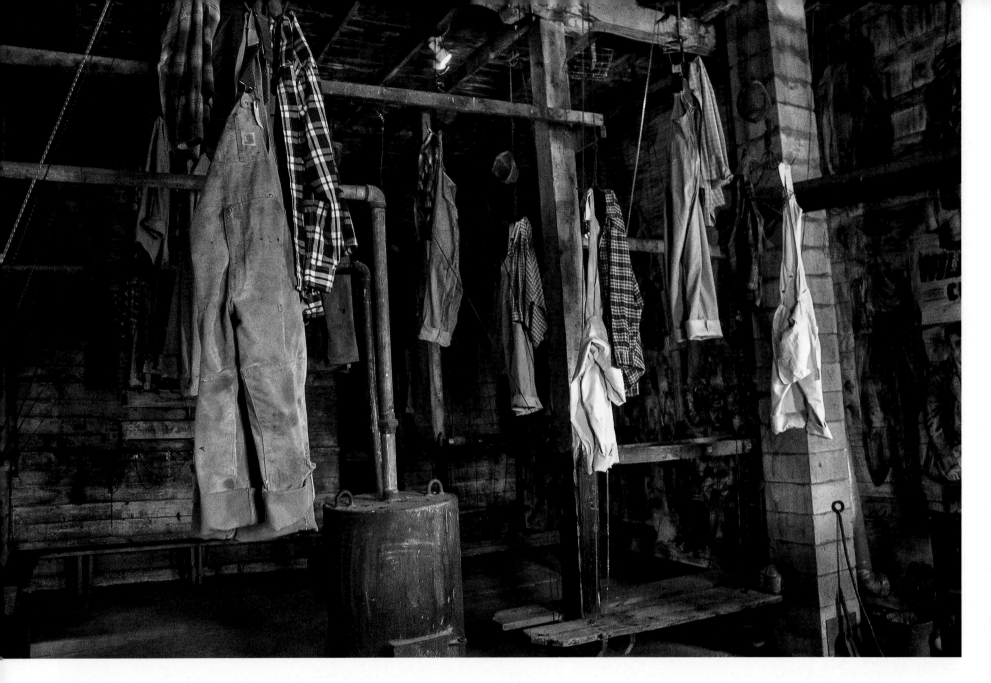

(Above) The shower room of Atlas Mine. Miners would arrive for their shift and hang their clothes in this changing area heated by a small stove. Significant restoration of this national industrial heritage site and a dynamic interpretive program offer visitors a glimpse into the heyday of the working mine.

(Opposite) Inside the Bellevue Coal Mine in Crowsnest Pass. Taking photos is difficult due to the limited light - 1,000 feet into the mine shaft the only source of light comes from helmets, and the temperature is a steady zero degrees Celsius. The mine was founded in 1903 and closed in 1961 with over 13 million tonnes of coal mined. Workers in the early days made as little as 50 cents per tonne of coal mined. It was one of the first mines in the area with a power washing station to clean the coal. During its history, 50 men lost their lives in the mine that stretched deep into the mountain. This was a way of life that is now much maligned, but it served its time and the needs of Canadians. Men and later women put their lives on the line for their families and country. Today it serves as museum and memorial to those souls.

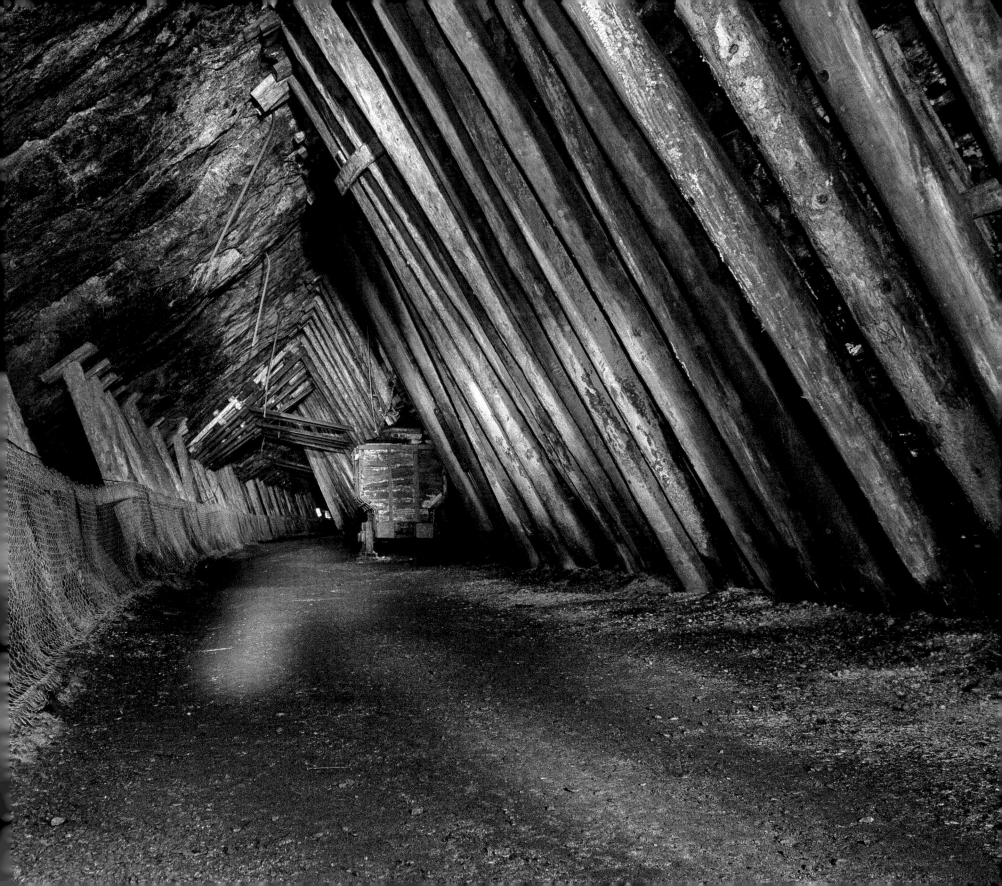

The crack of the bat, the sound of baseballs thumping into gloves, the infield chatter are like birdsong to the baseball starved.

W. P. Kinsella, from Shoeless Joe

(Opposite) About two kilometres west of Musidora is a field with three ball diamonds, including bleachers, dugouts and concession stands. It has been many years since the diamonds heard the crack of the bat and the cheers of victory. Home plate and the pitcher mound rubber were still in the ground.

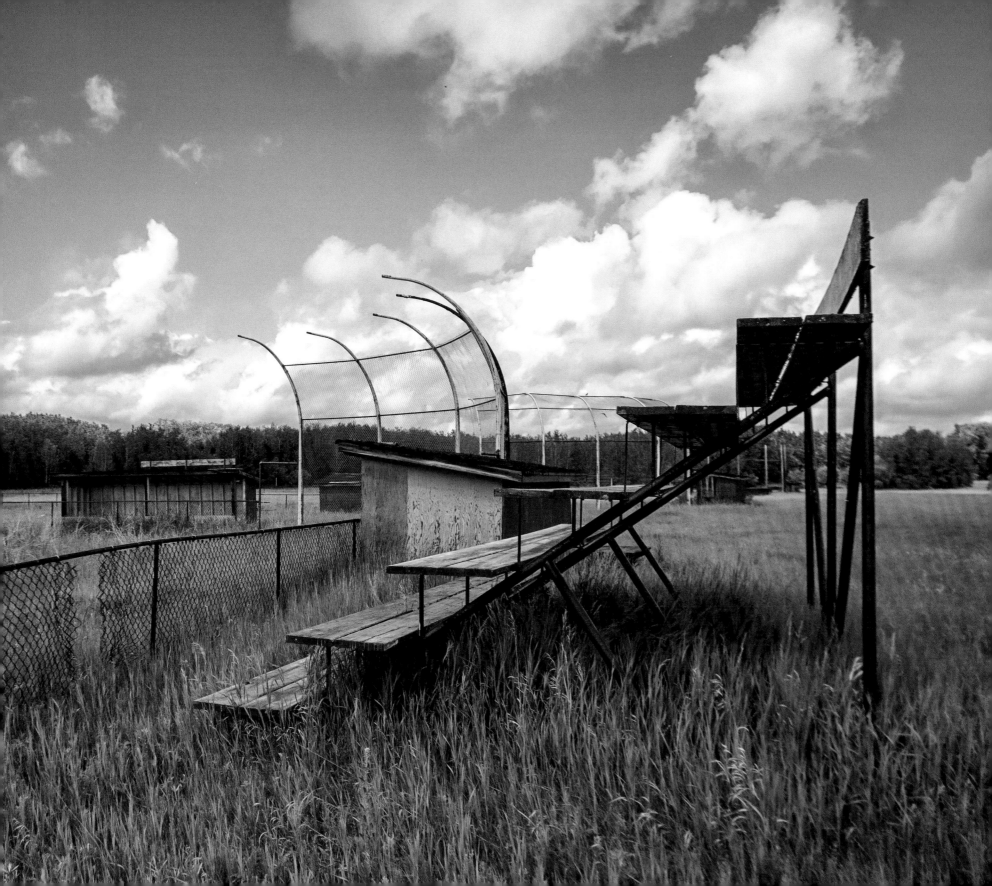

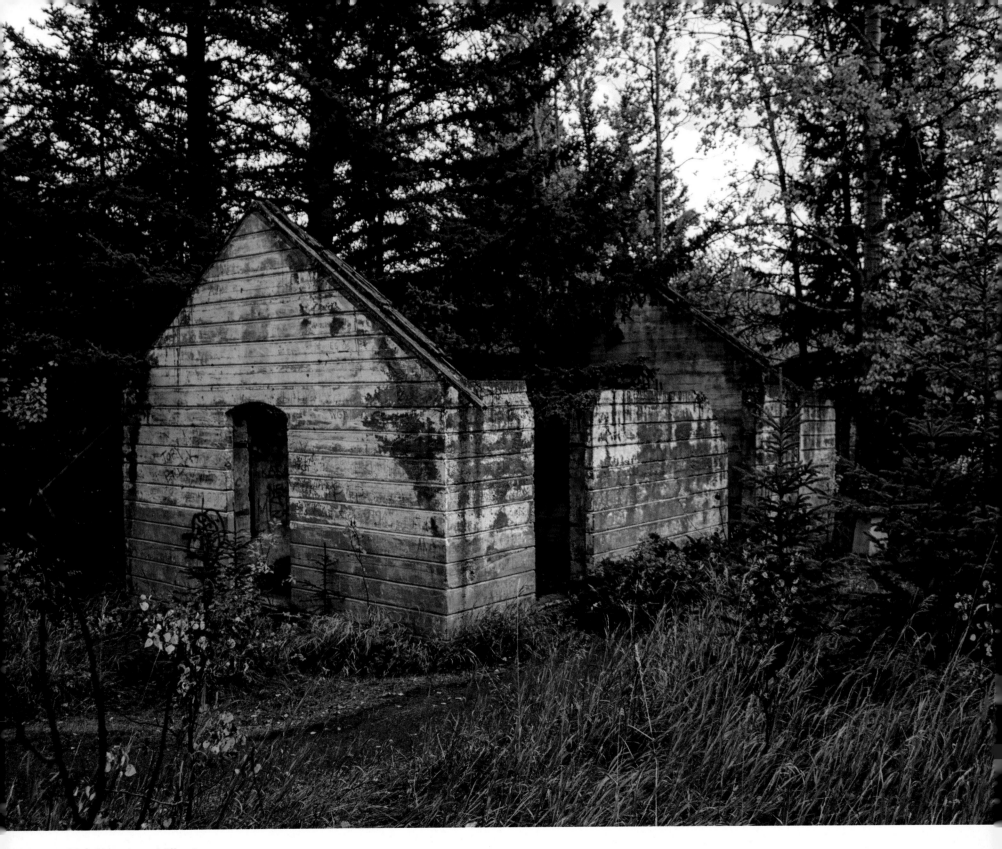

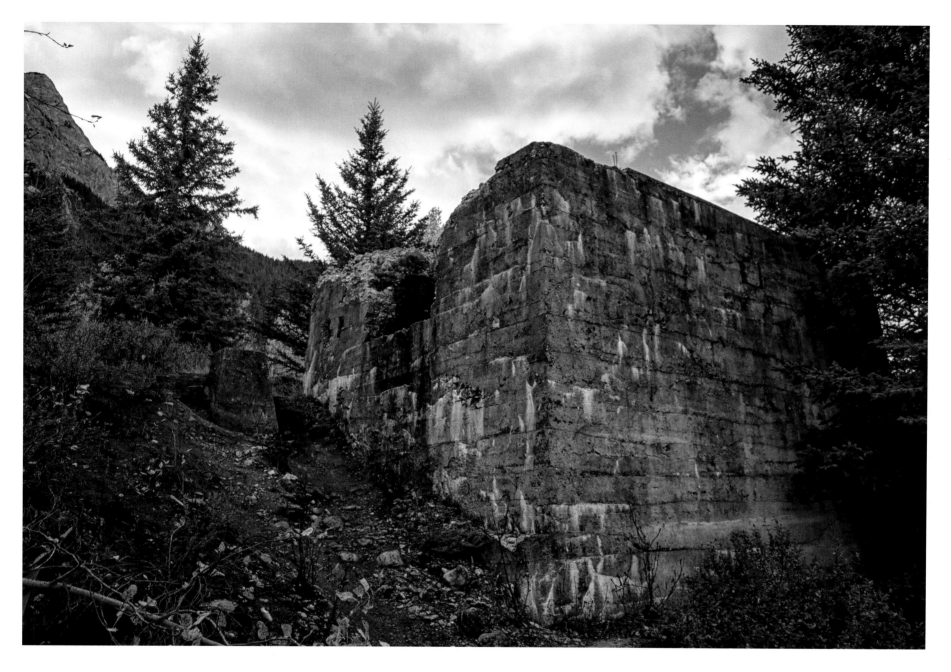

(Opposite) Welcome to Lower Bankhead in Banff National Park. Bankhead was a mining town that opened in 1903 to mine anthracite coal. At the height of mining operations, the town had 1,000 residents and upwards of 300 men worked in the mine pulling out 600 tons of coal. The mine closed in 1922 and today all that remain are the foundations of the buildings and many piles of slag. This is the old lamphouse where the men would pick up their miner's lamp.

(Above) The remains of the large tipple at Bankhead. The tipple stood approximately 30 metres tall.

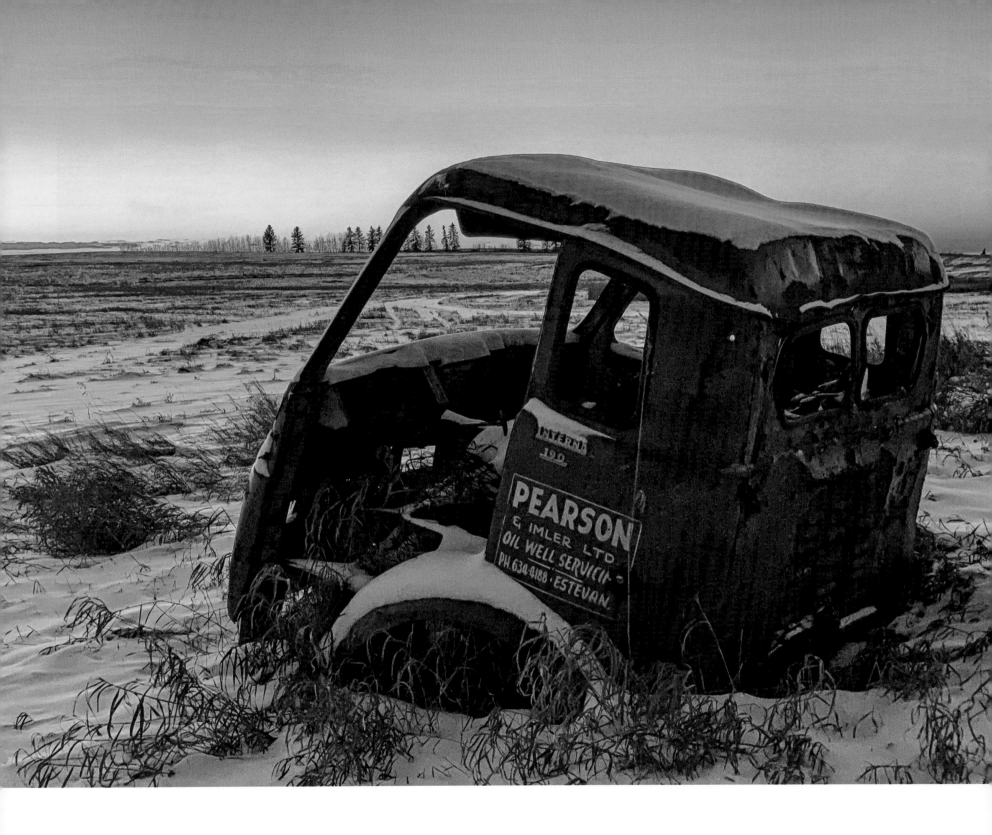

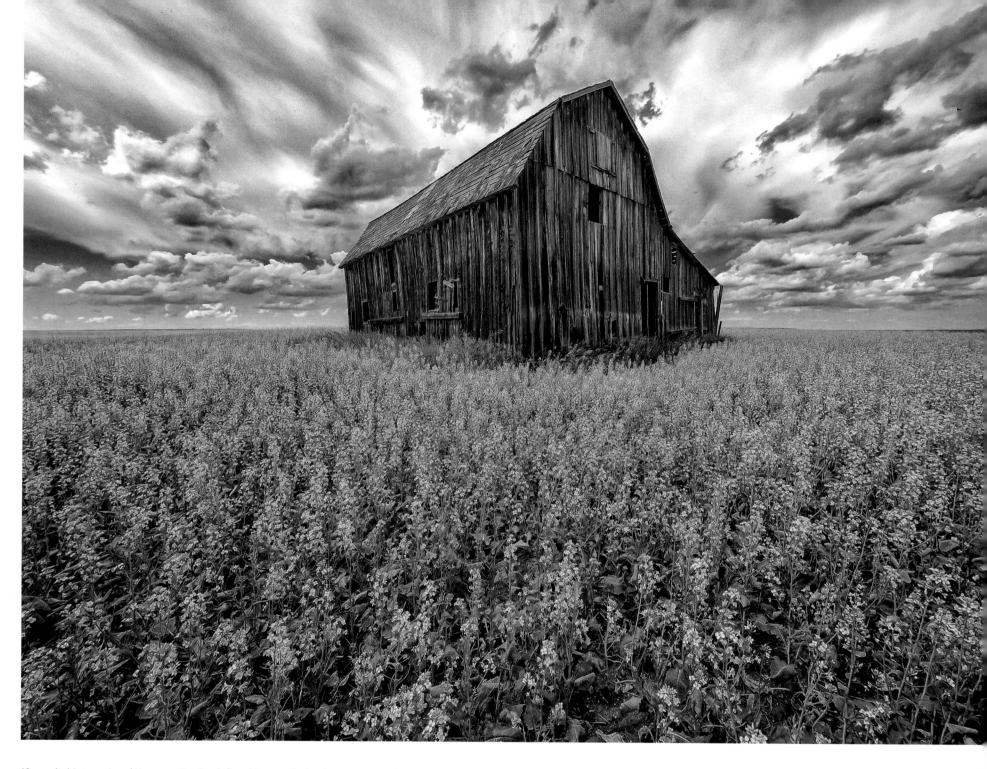

(**Opposite**) International Harvester Truck cab from Estevan, Saskatchewan, sits on the side of the road near Tofield.

(**Above**) A beautiful abandoned barn in a field of canola located near Trochu. Photographed with a hovering drone to give a different perspective of the barn and to keep the canola undisturbed.

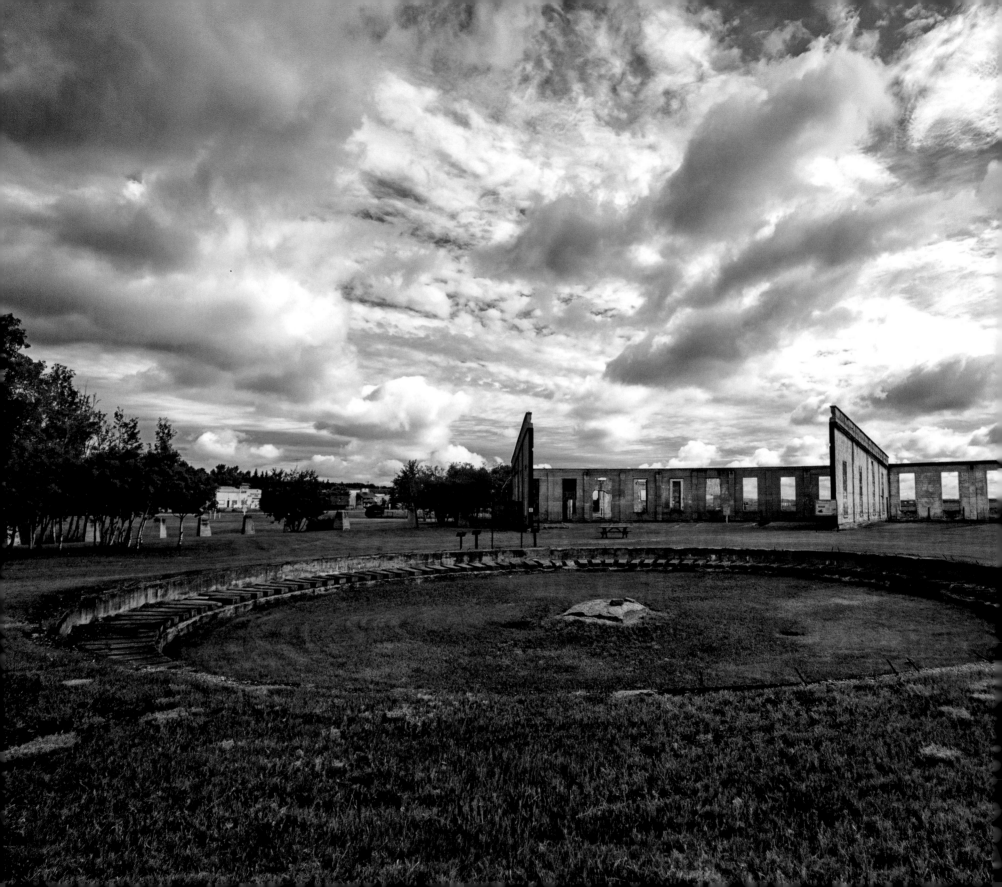

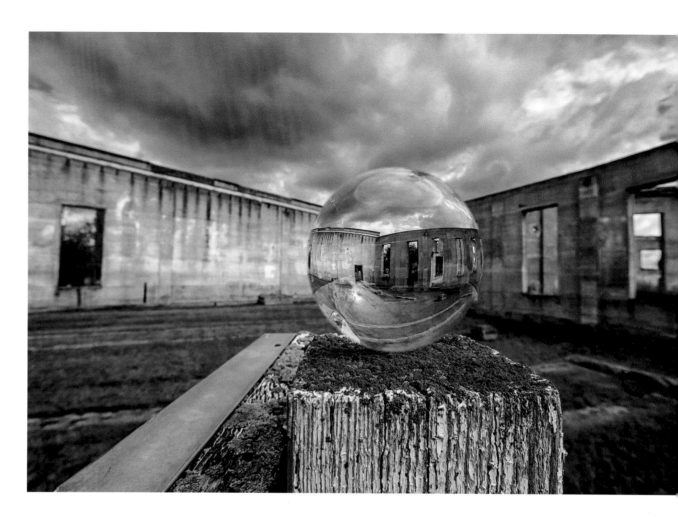

(**Opposite**) The remains of the roundhouse in Big Valley. Like many small prairie towns, the railroad was the engine that fuelled the community. Built in 1912 by Alberta Midland/ Canadian Northern Railway, the roundhouse and its 70-foot diameter turntable played an important part in the repair and maintenance of train engines. The complex employed 200 men during the height of its operations. Maintenance could be done on 10 engines at the same time. The roundhouse complex is an extensive collection of concrete ruins, pits and foundations once part of the switching yards and facilities designed to service steam locomotives. Remnants include an ash pit, mechanical coaling plant, sand house, stores building, water tank, turntable, and roundhouse with annexes and five-stall extension added in 1918. Abandoned in the 1940s.

(**Above**) Inside the Big Valley Roundhouse. The view with a lensball of the concrete bays.

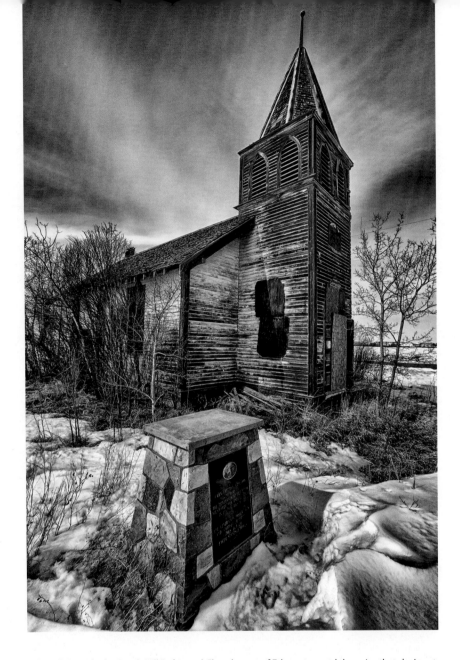

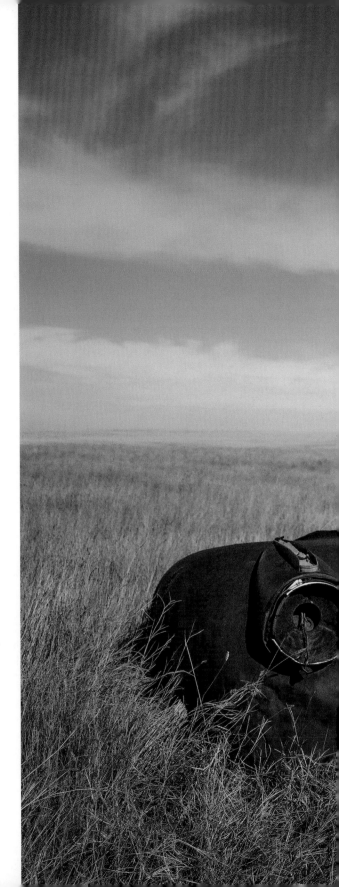

(Above) Outside the Brush Hill Reformed Church, east of Edmonton and the cairn that designates it as a Province of Alberta Historic Site. The Brush Hill Reformed was built by German-Russian immigrants to Canada in 1916. It has sat abandoned for the past few decades.

(Opposite) This post Second World War Chevrolet pickup was found in a remote corner of the province at the site of a former farm in Alberta's Special Area #3. Little remains but a handful of scattered buildings and these hunks of metal. The Special Area was created to serve a sprawling municipality with few residents. A panoramic view reveals nothing but fields and pasture as far as the eye can see. The nearest neighbour lives over the horizon. (Photo by Chris Doering)

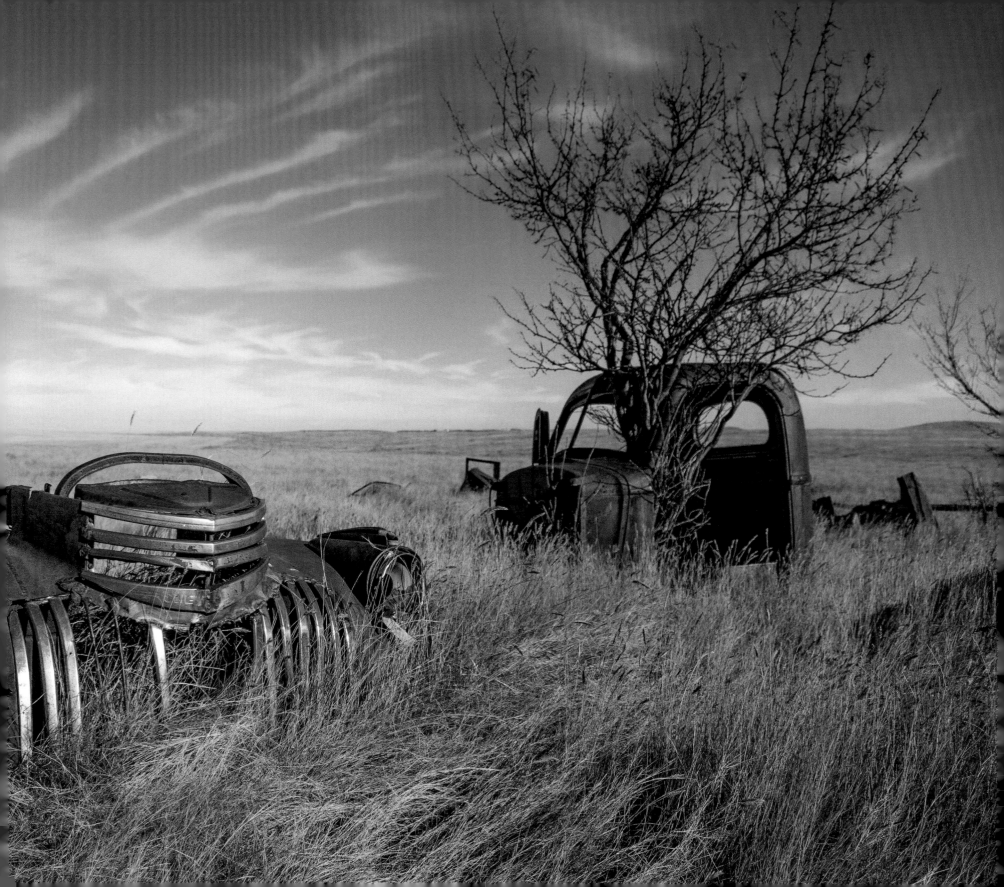

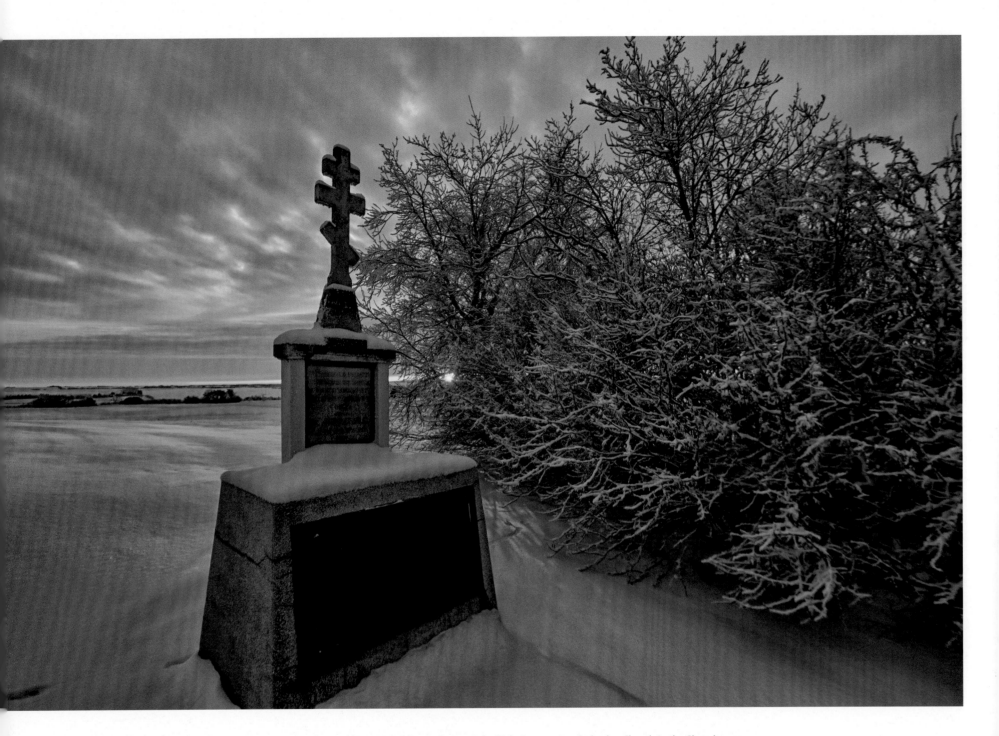

Lonely Cross during sunrise on a cold winter morning in December 2019. It is located next to the Holy Assumption Orthodox Church in the Shandro area.

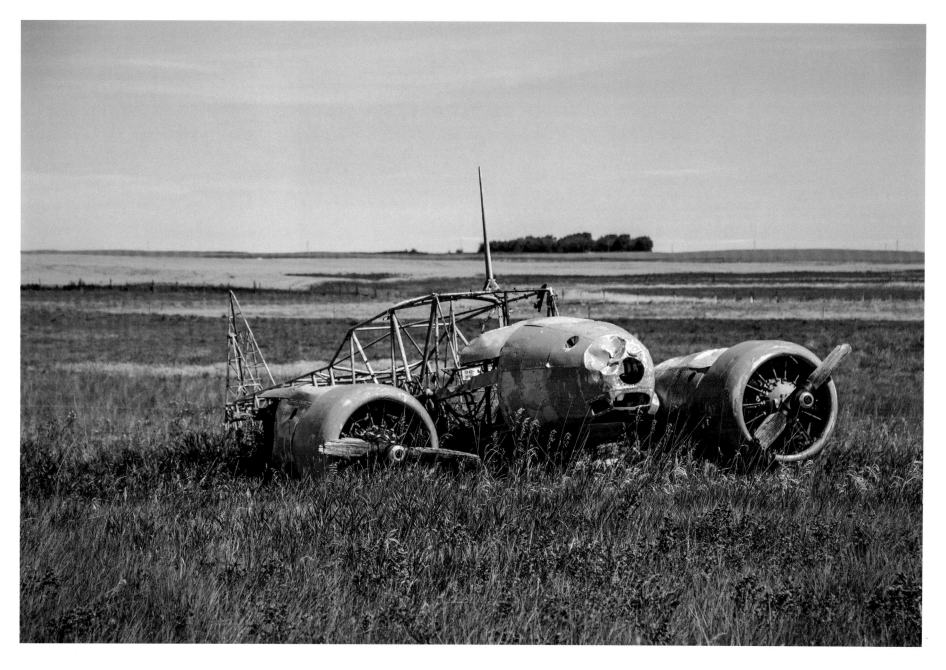

A fleet of Ansons much like this one were used to train Commonwealth air crews at bases throughout Alberta during the Second World War. Stripped of usable parts to help restore another plane, this artifact now languishes in a field near a museum back lot. It is part of a curious art installation that can only be seen from the air called Gravitas, located south of Calgary. **(Photo by Chris Doering)**

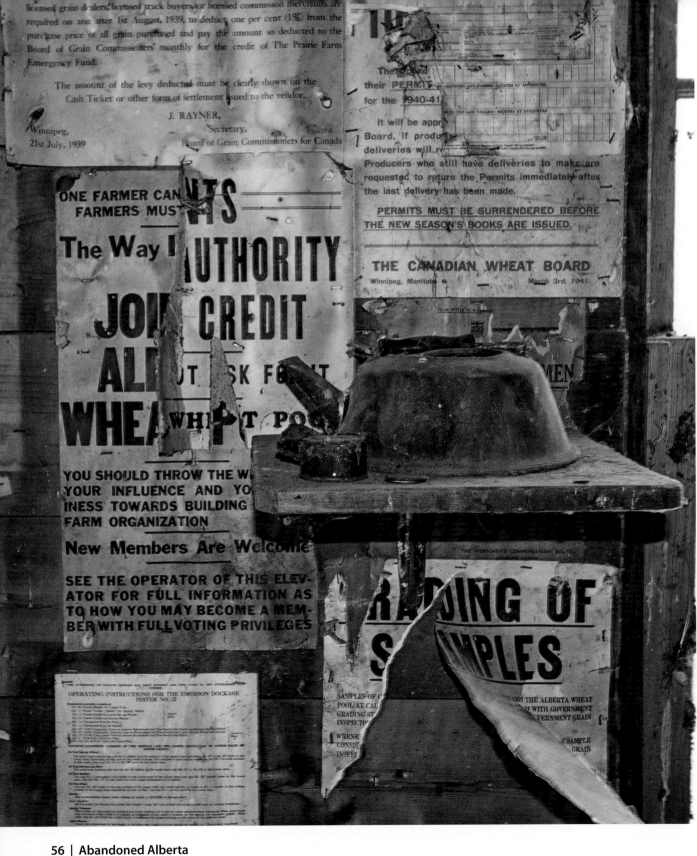

(**Left**) A kettle and remnants of Wheat Board signs and other postings inside the Bardo grain elevator. One of the signs is dated 1939 and one is from 1941.

(**Opposite**) Car graveyard on the side of a road northeast of Edmonton, a familiar sight in rural areas on the prairies.

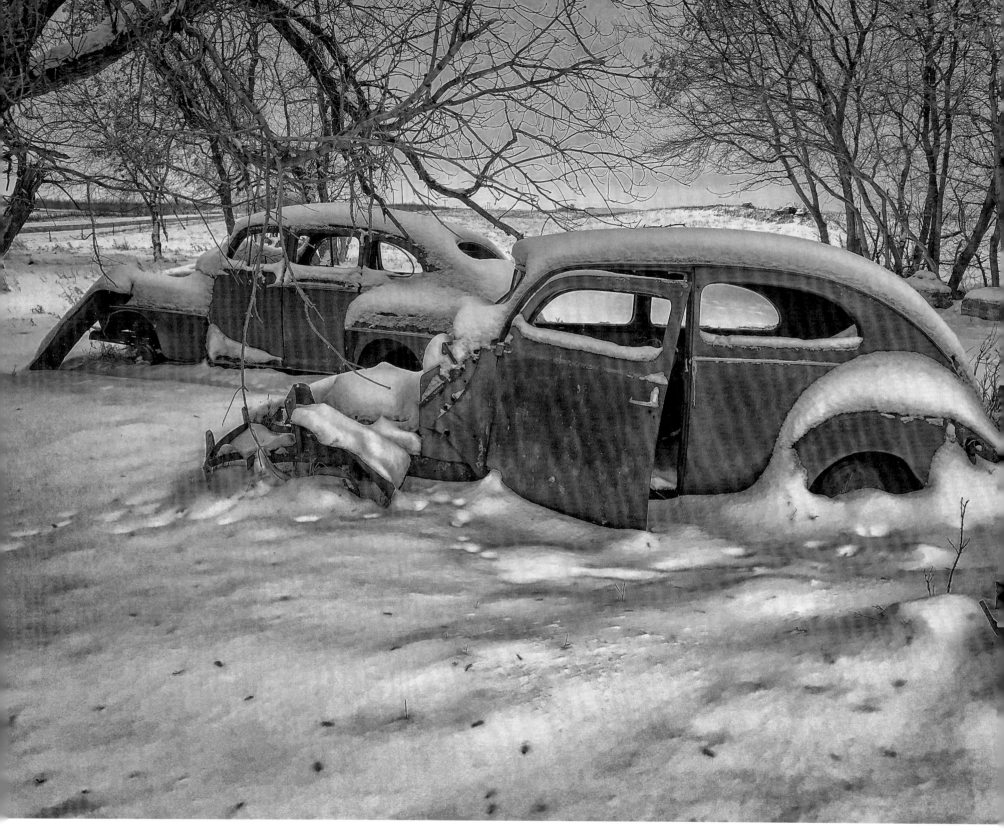

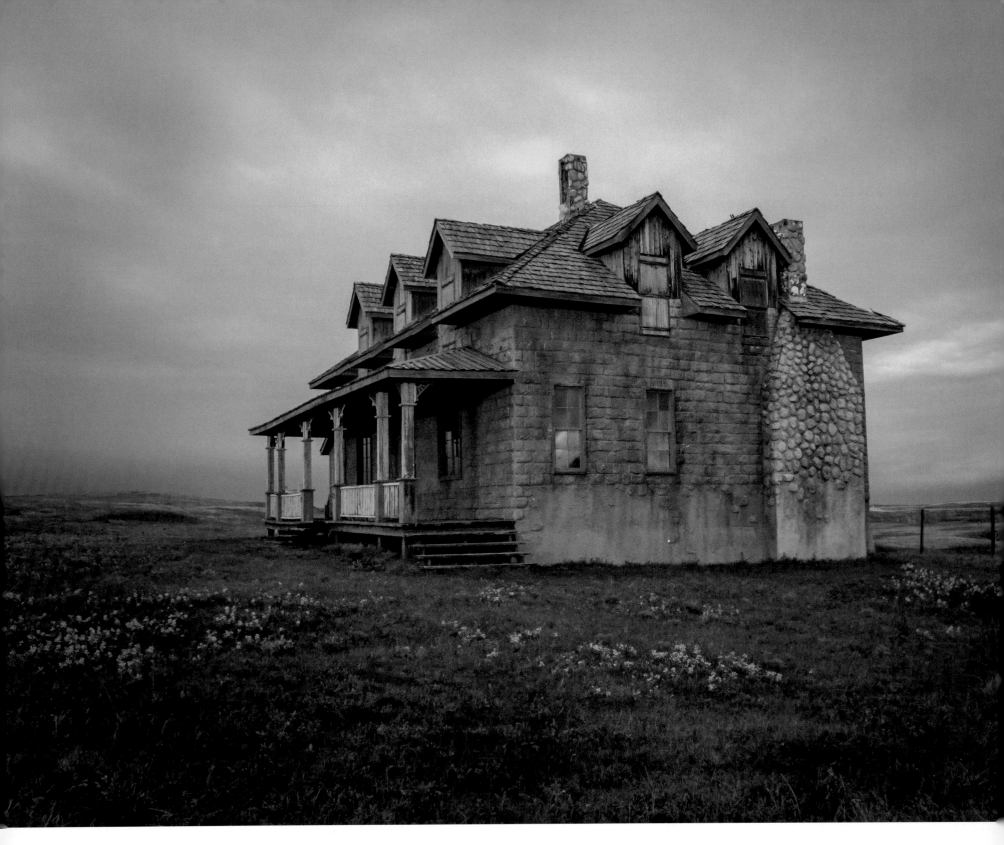

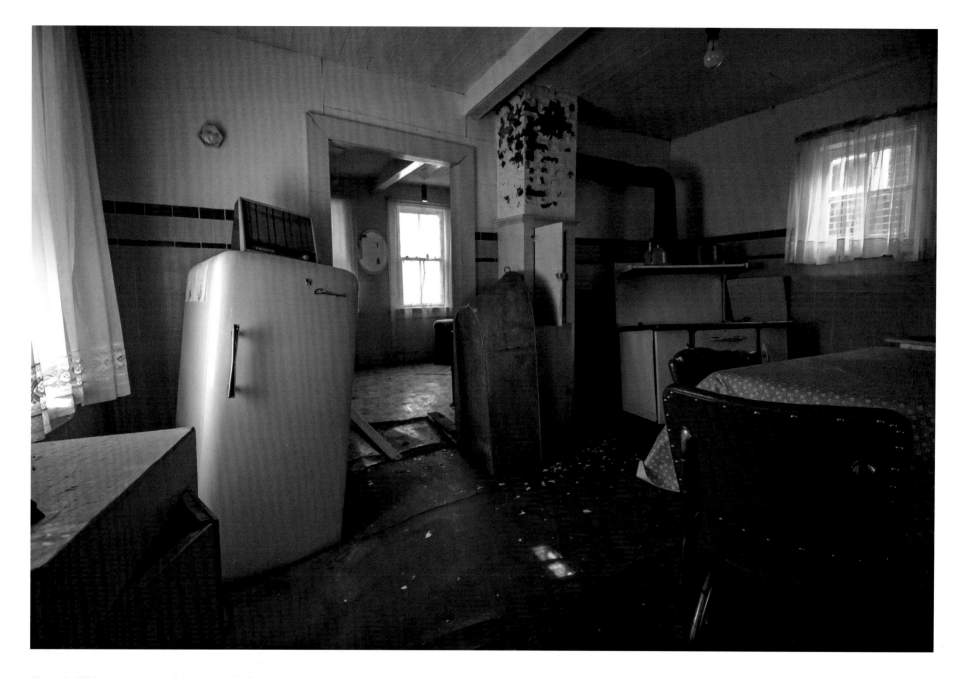

(**Opposite**) This impressive ranch house south of Calgary looks abandoned and forgotten. It is, in fact, a movie set that has been a backdrop for many Western themed productions. The rock fireplace has been built from modern faux materials and those stones are foam. (**Photo by Chris Doering**)

(**Above**) This 1920s era coal miner's home located in the Red Deer River Valley was shuttered, contents and all, after the owners died in the 1980s. The Humbler Miner's Cottage is a literal time capsule: indoor plumbing includes a cold water tap and there is an outhouse in the back yard; bulbs hang from the ceiling for illumination; the floor underneath the fridge is collapsing. Everything inside has since been removed and the house is now empty. (**Photo by Chris Doering**)

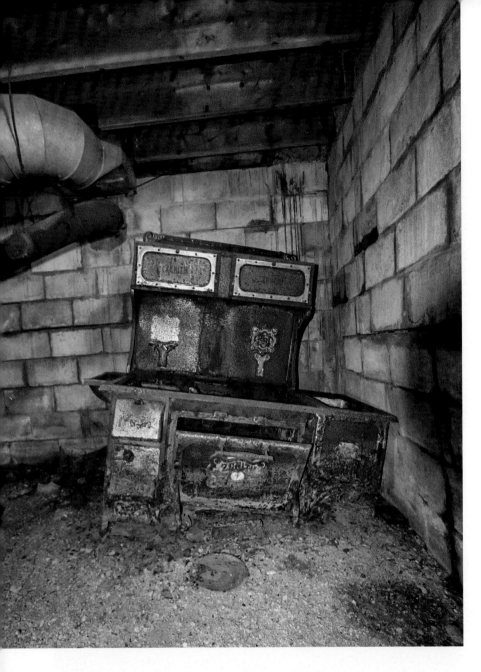

(Above) A stove ravaged by rust in the basement of St. Michael's Church near Wetaskiwin. The walls show signs of buckling and the extent of rust indicates that the basement has flooded frequently.

(Opposite) Old truck in southwest Edmonton on a cold day in December 2019.

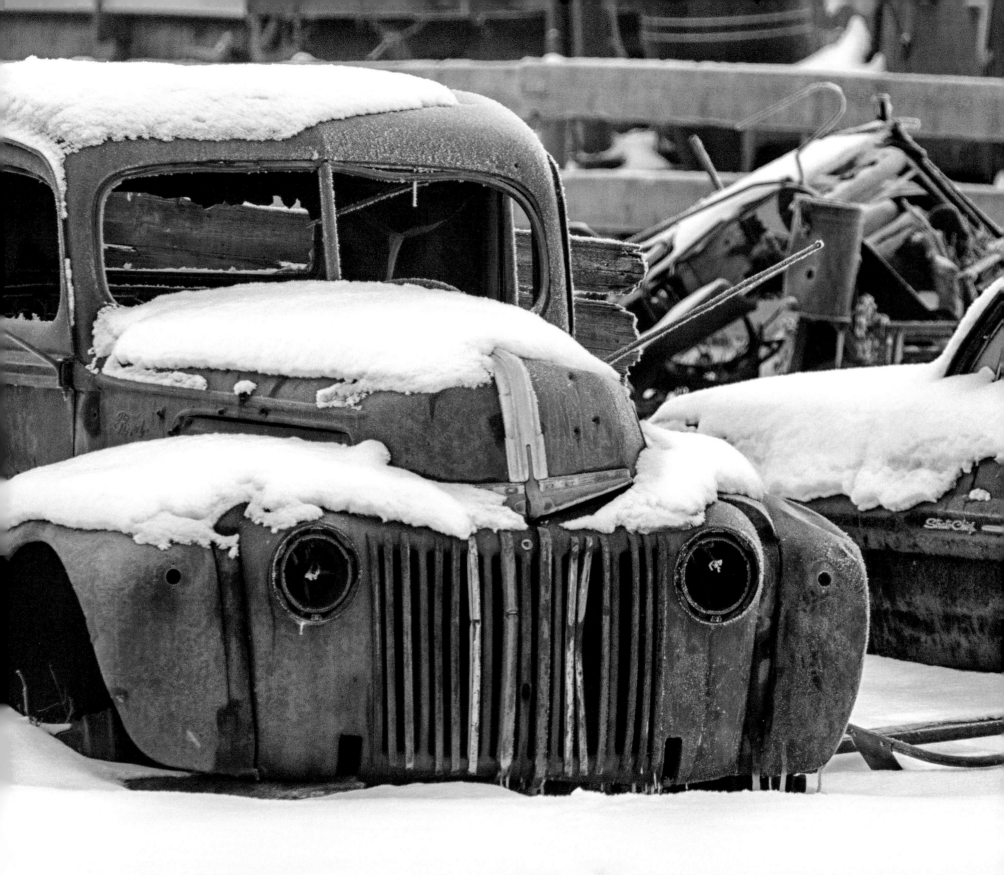

Think I'll go out to Alberta
Weather's good there in the fall

Ian Tyson, Four Strong Winds

(Opposite) In 1956, the Nordby family became owners of Dodds Coal Mining Company in central Alberta. The third generation still owns and operates the mine and is also responsible for the reclamation project of the original mine site into Coal Creek Golf Resort. This tipple was constructed in 1946 and was still operational when the last load of coal was removed in 2007.

Loads of coal would be hauled from the pits and unloaded onto the tipple. The large lumps of coal would pass through a series of screens and crushing mechanisms, which broke the coal into usable sizes. The crushed coal would travel up the conveyor belt to the hut where it would undergo further screening and separation. Customers would drive their trucks under the hut conveyor belt to be loaded with their coal size of choice.

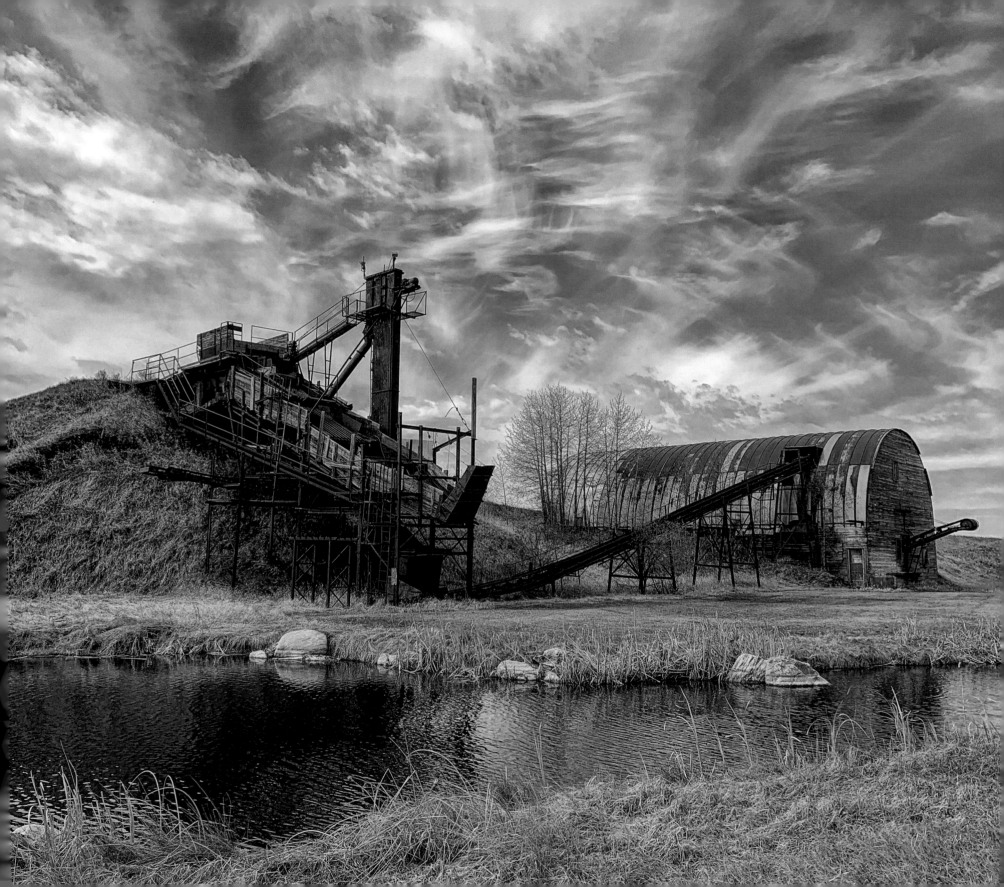

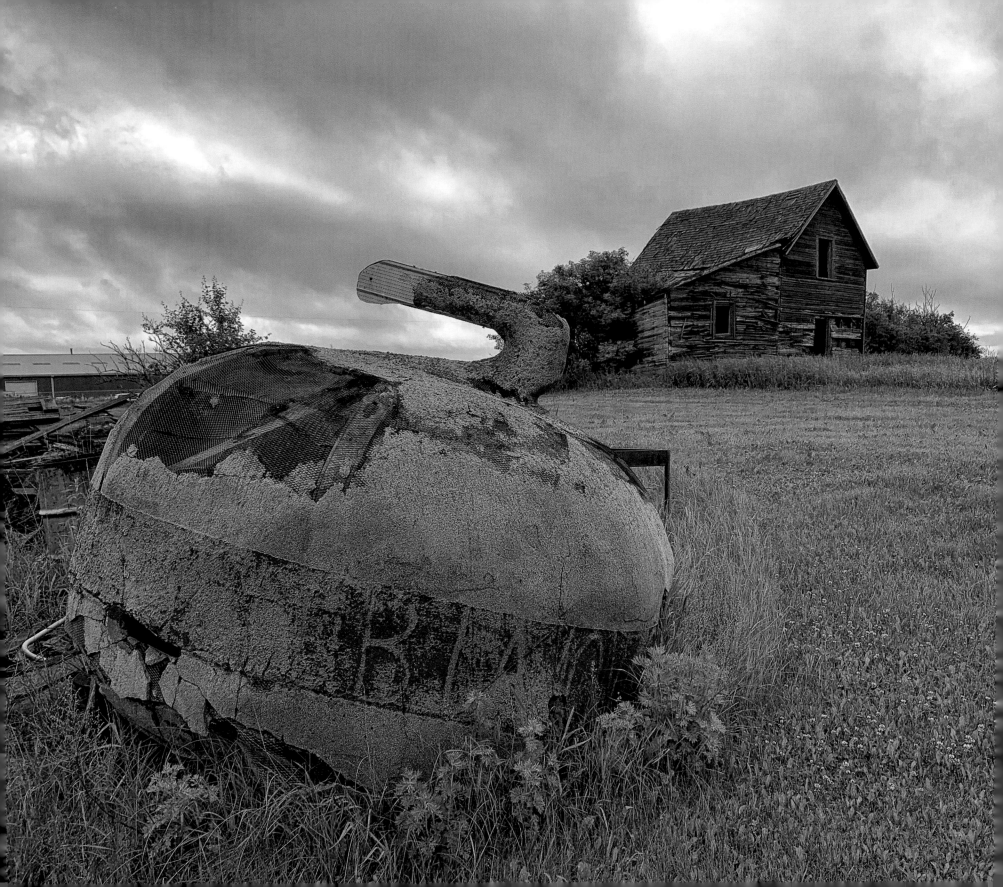

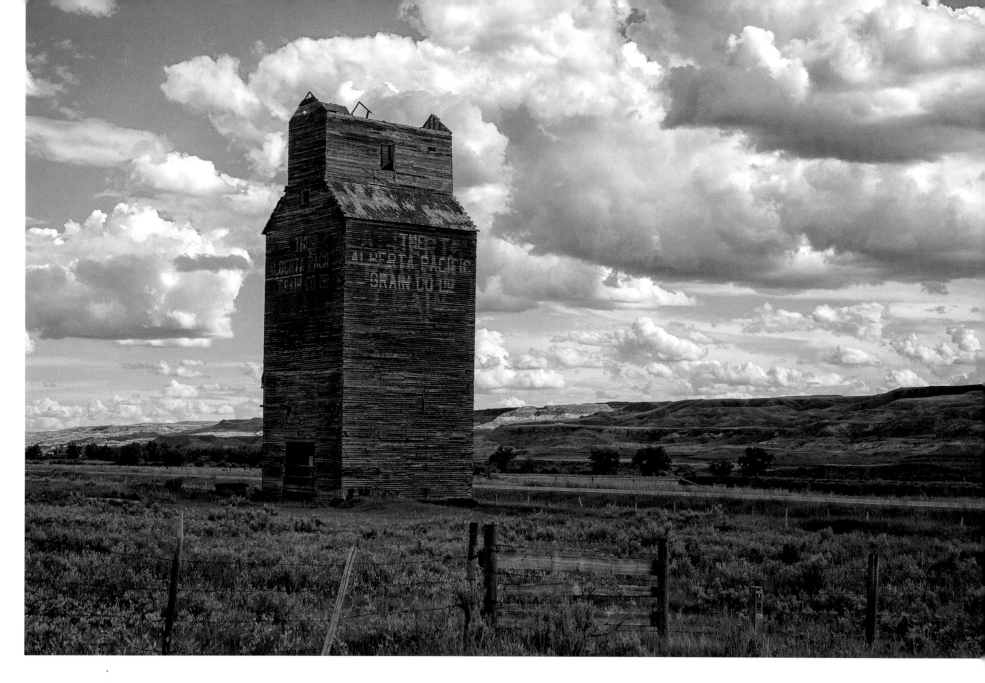

(**Opposite**) One of the oddest things I have seen in my travels throughout the province is this abandoned giant curling stone that appears to be from the Beaumont Curling Club. It now lies a 90 minute drive north of there.

(**Above**) The Dorothy grain elevator near Drumheller, one of the most photographed grain elevators in Alberta. Once, the tiny village had three elevators. This one was built in 1928 and was last used in 1951.

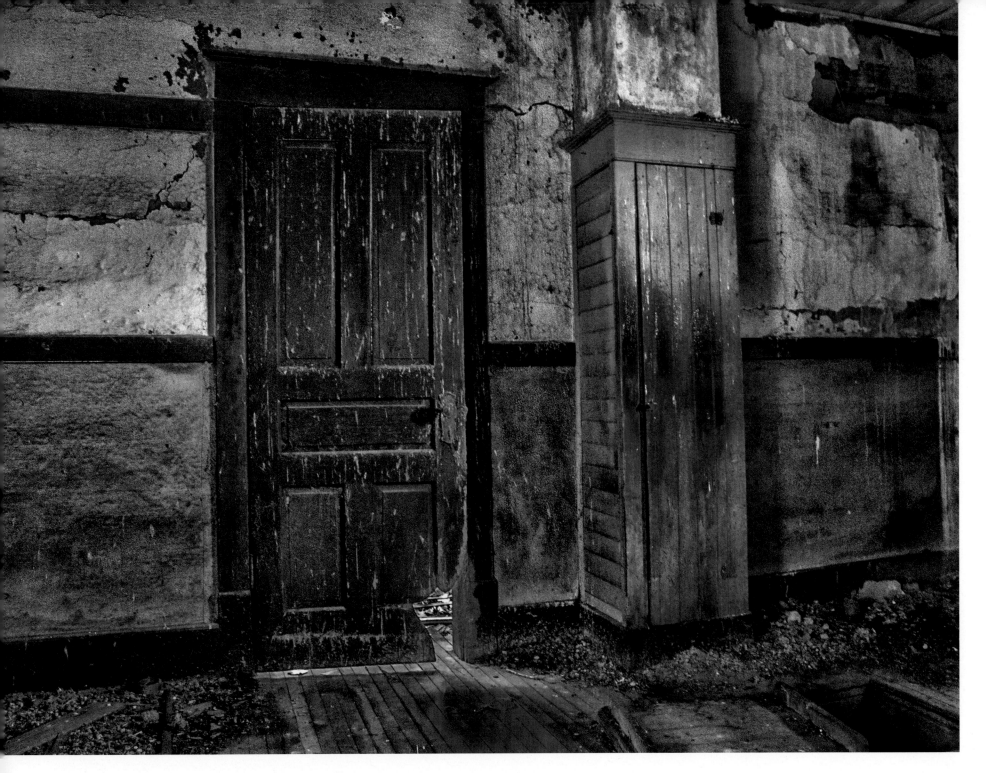

(Above) Inside an old home northeast of Edmonton. All these years later, the paint has retained its colour.

(Opposite) This beautiful old home in south central Alberta was built in 1908 and has possibly sat empty since 1950. There are divided opinions on the architecture. Some propose it was a kit home from a mail order company like T. Eaton or an American retailer. Others believe that it was a custom built home which would be truly unique for the times.

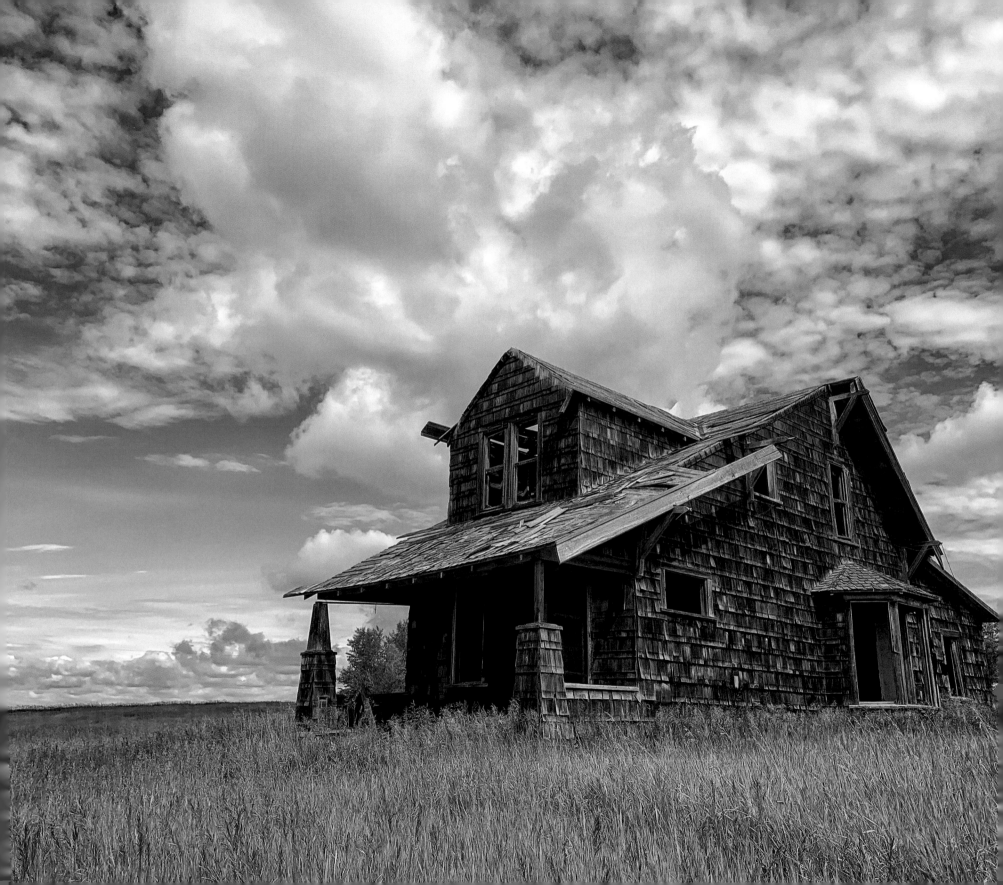

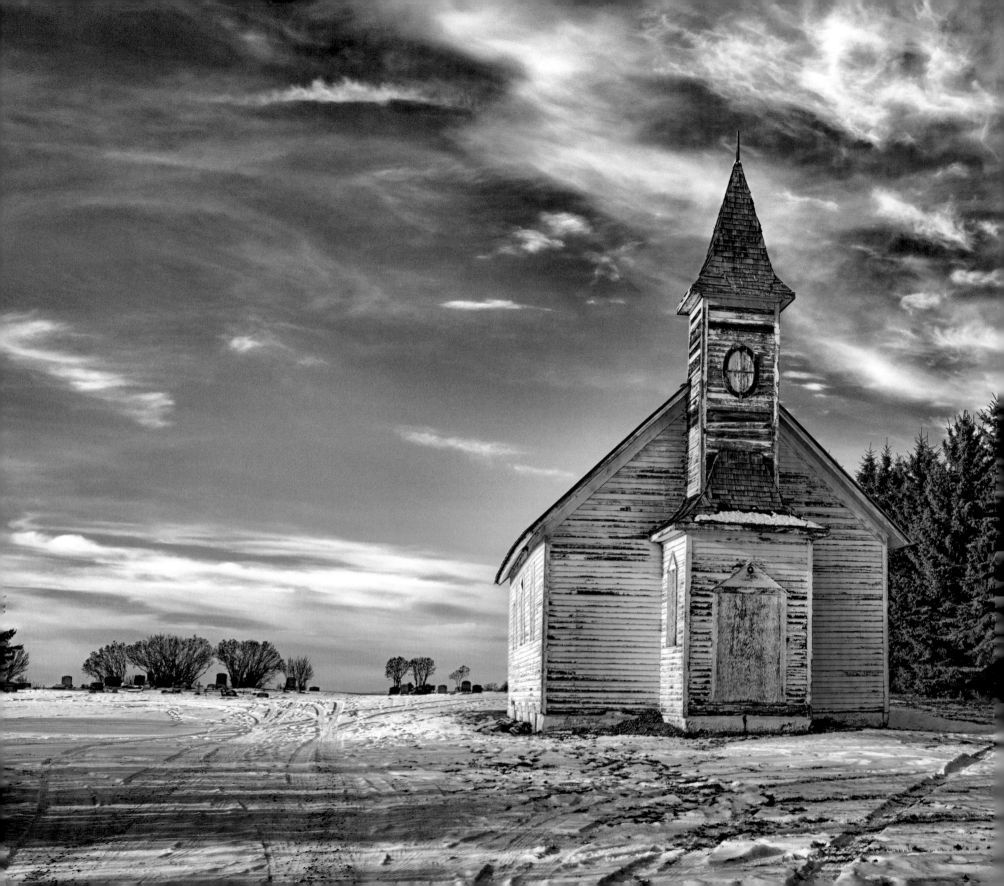

An abandoned church near New Norway in an area called Highland Park where settlers in 1898 built a store, post office, creamery and boarding house (which operated from 1900 to 1910). A school on the site was open from 1901 to 1949 and the church from 1905 to 1964. The church – no doubt a beauty in its day - now sits alone, slowly crumbling and damaged by vandals. Most of the contents inside have been removed or destroyed and the basement wall is buckling. An impressive furnace still sits in the basement.

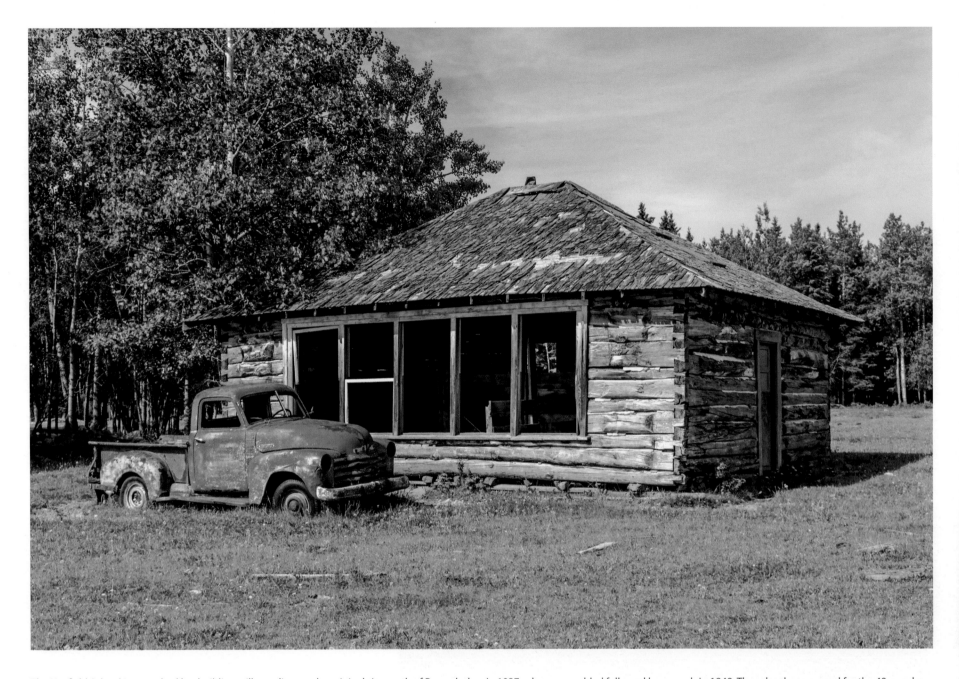

The Hayfield School is a notched log building still standing on the original site south of Beaverlodge. In 1937, a barn was added followed by a porch in 1940. The school was named for the 40-acre hay field within view of the building. The first teacher, Ruth Conley, taught 42 students in Grades 1-8. The school was closed in 1951 and students were bussed to Beaverlodge. (**Photo by Glen Bowe**)

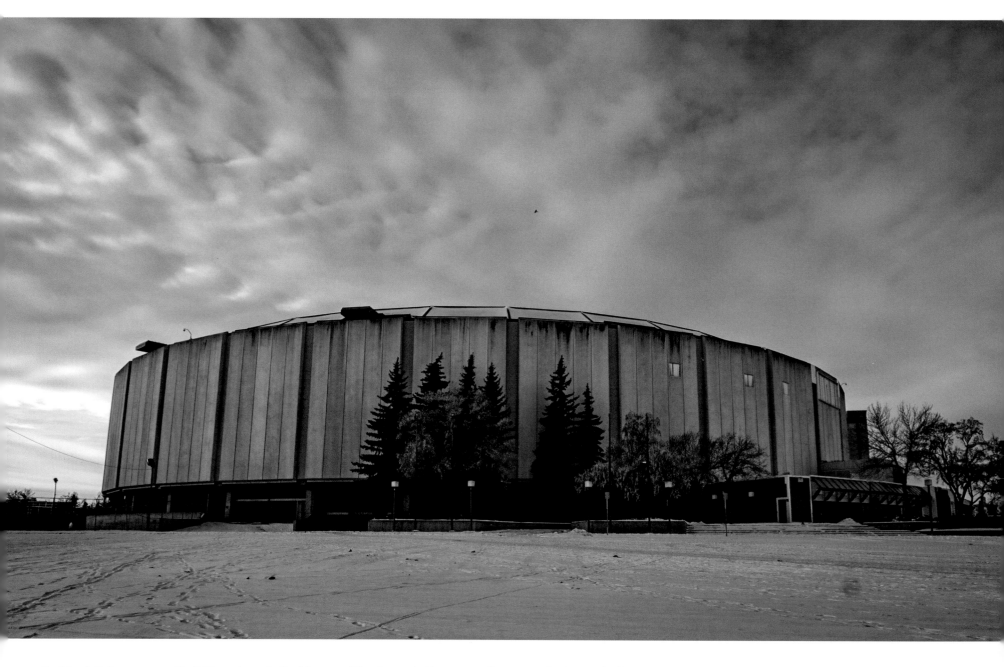

Northlands Coliseum, opened in 1974, was home to the Edmonton Oilers for nearly 40 years, as well as a venue for thousands of events until its closure in 2018. It was the first NHL building in Canada to have a center-hung scoreboard. It is scheduled for demolition at some point in the future.

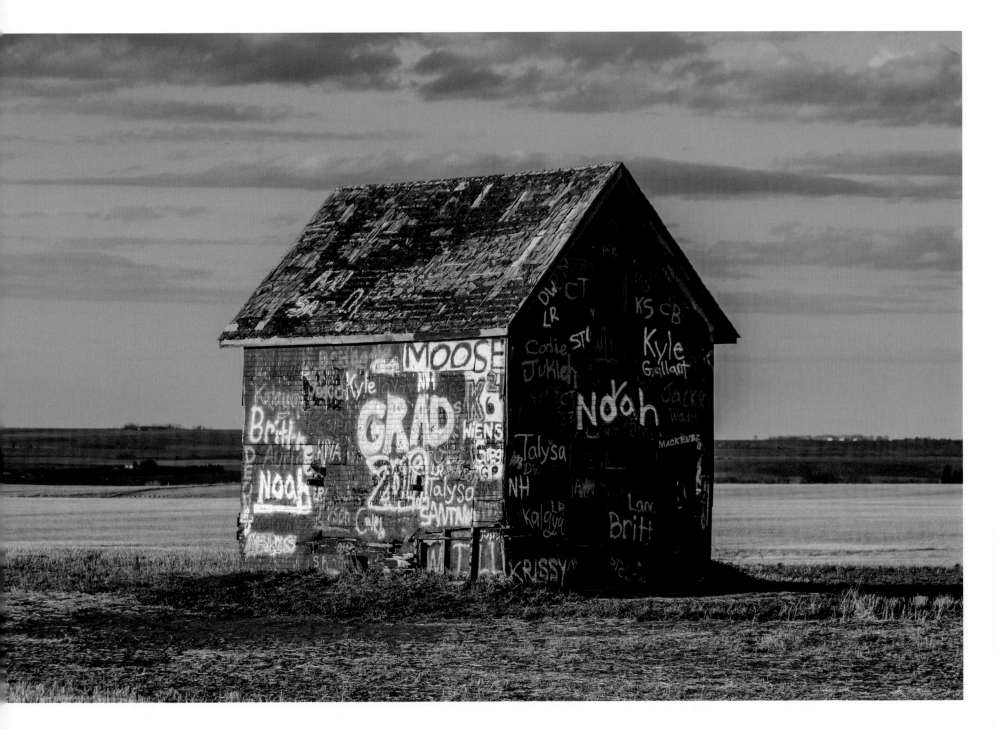

In Kneehill County, landowner Billy Taylor gives the high school graduates permission to use this old shack to express their joy in finishing school. Prior to the annual graduation ceremony, the building is freshly painted to provide a blank canvas for graffiti. One spot remains unchanged, containing four names — Moose, Ryan, Kyle and Greg. A former student said, "We had a student whose nickname was Moose (Ian Metzger) pass away in 2002 in a car accident, then K2 (Kyle Kostrosky) and Wiens (Ryan Wiens) pass away in 2004 when our high school basketball team got into a crash, and then GP (Greg Price) in 2012; he was a former student but was extremely active in the community and was the coach of the baseball team so the kids added him to the memorial." This is an important memorial as well as a rite of passage. **(Photo by Glen Bowe)**

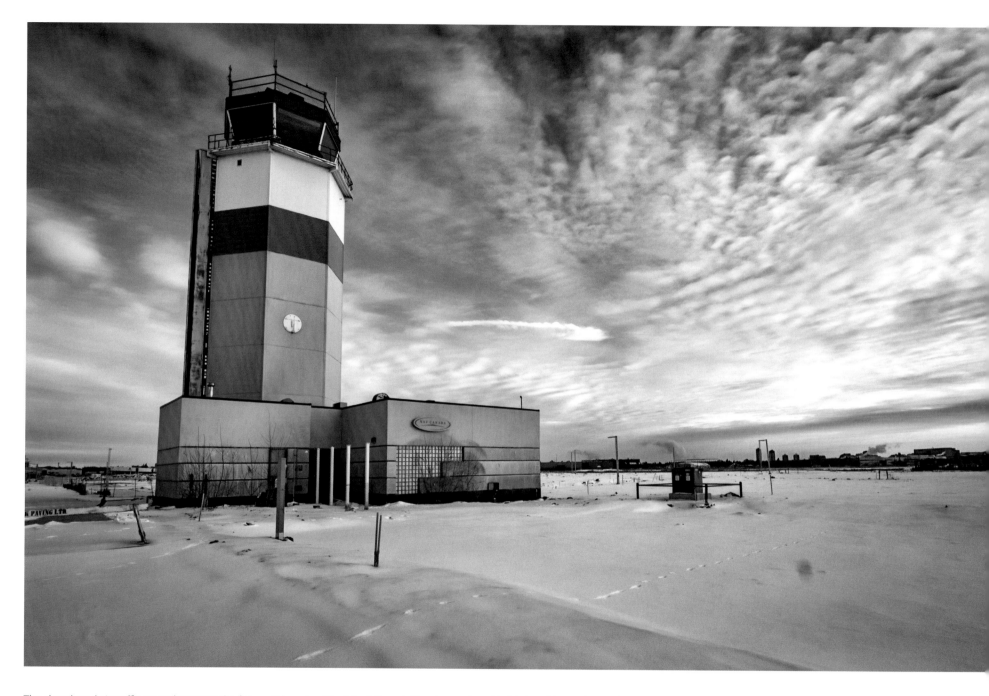

The abandoned air traffic control tower at the former Edmonton Municipal Airport. The airport closed in 2013 and is now being developed into a residential area north of downtown. The airport was also known as Blatchford Field, named after Kenneth Blatchford who had played a key role in establishing the airport in 1927. His son Howard was a fighter pilot in the Second World War. The air traffic control tower will be incorporated into the new neighbourhood.

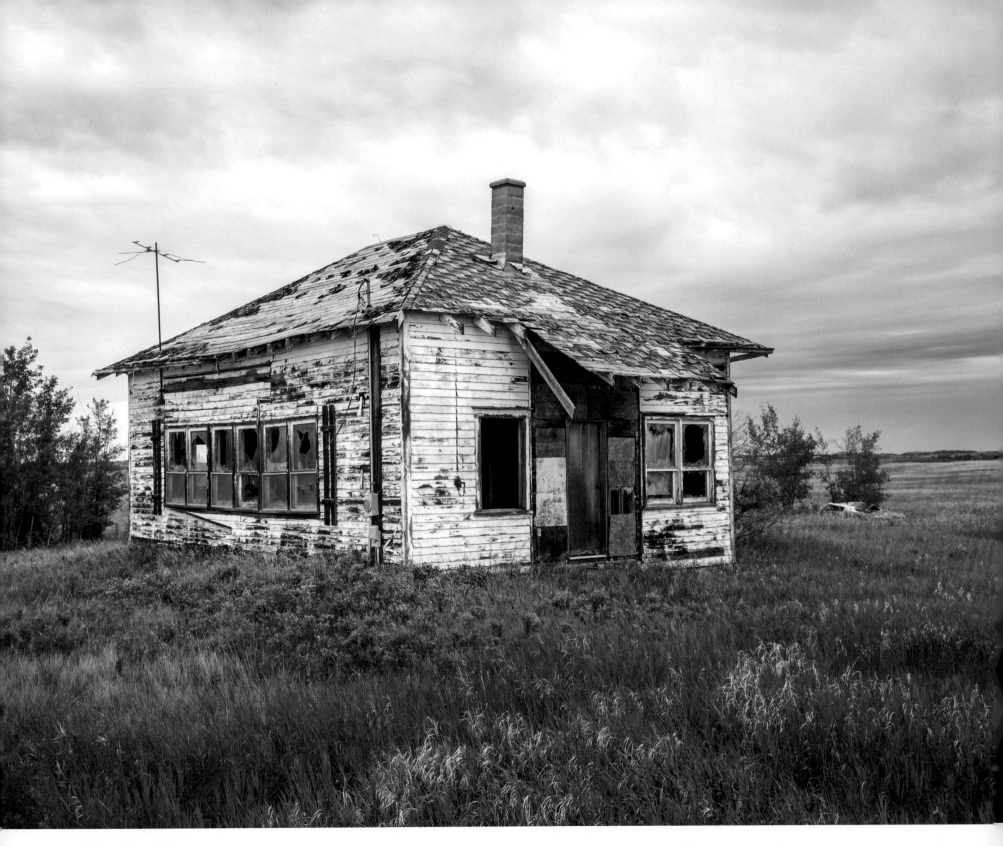

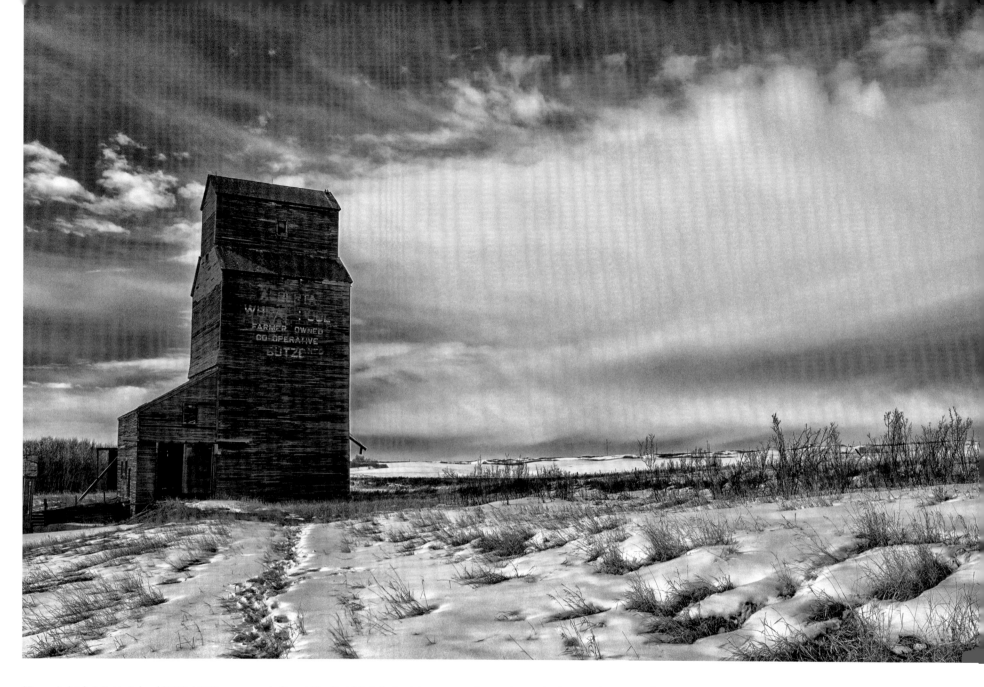

(Opposite) Jake's Butte School (1913-1950) was named after a hill called Jake's Butte. Jake was a cattle roundup cook who put a lantern on the top of the hill to help riders find the camp. The school was no longer needed when the Ozark School was moved nearby, and eventually the building was sold to the Jake's Butte Community Society. **(Photo by Glen Bowe)**

(Above) The grain elevator in Butze near Chauvin was built in the 1920s for the Alberta Wheat Pool and was situated near the Alberta-Saskatchewan border. In 1928, the Pool had over 300 elevators across Alberta. The Butze elevator closed in the 1970s.

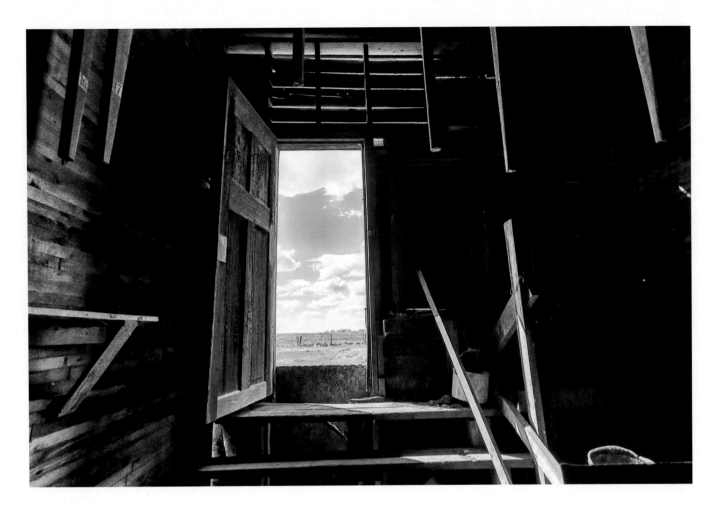

(**Above**) Looking out of the Bardo grain elevator to the fields.

(**Opposite**) The Rowley grain elevators, once the heart and soul of the town. When the railway left, they even took the rails.

Rowley is my favourite place to visit as there is so much charm and history in this little town. I stumbled upon this hidden gem by complete accident and was blown away. If you are ever in the area, check out Rowley, especially on the last Saturday of the month, any month. On that day, the saloon opens, the beer flows, the pizza ovens are fired up and the stories begin.

Less than a year before the new millennium, the last train passed through Rowley and now the Alberta prairie town's future may once more belong to the ghosts. Rowley was founded about 1910 to 1912 and boasted a population of approximately 500 people in the 1920s. In the mid-1970s, it was a beaten, dying community, with rows of empty houses and businesses, and inhabited by only a few dozen prairie-hardened souls. One night, a few party happy locals with a fast dwindling liquor supply, decided on a quick solution – a "B & E Party" at a boarded old saloon. The bar was restored and re-named Sam's Saloon, after one of the previous owners who had been a respected member of the community. The brazen men then started talking about improving the pioneer community to make it a heritage stop for tourists. Over the next quarter century, locals reclaimed old homes and businesses and soon visitors were attracted from all over Alberta, as well as throughout Canada and the USA.

The highlight of the community's new fame came in 1988 when a cinema production team used Rowley as the set for the hit Canadian movie Bye Bye Blues. Part of Rowley's charm is that while locals have spent thousands of dollars restoring many of the community's homes and buildings to reflect the town's pioneer days, there are still many others left abandoned, and offer ghost towners wonderful photo opportunities.

The regional train service through Rowley ended in 1999, and locals are worried about the community's future.

However, the town, which now has an official population of eight, is still hoping word of mouth will keep tourists coming. Locals meet at the community hall year round, and gladly offer visitors a tour even in the cold winter months. (**Source: Rowley Facebook Page**)

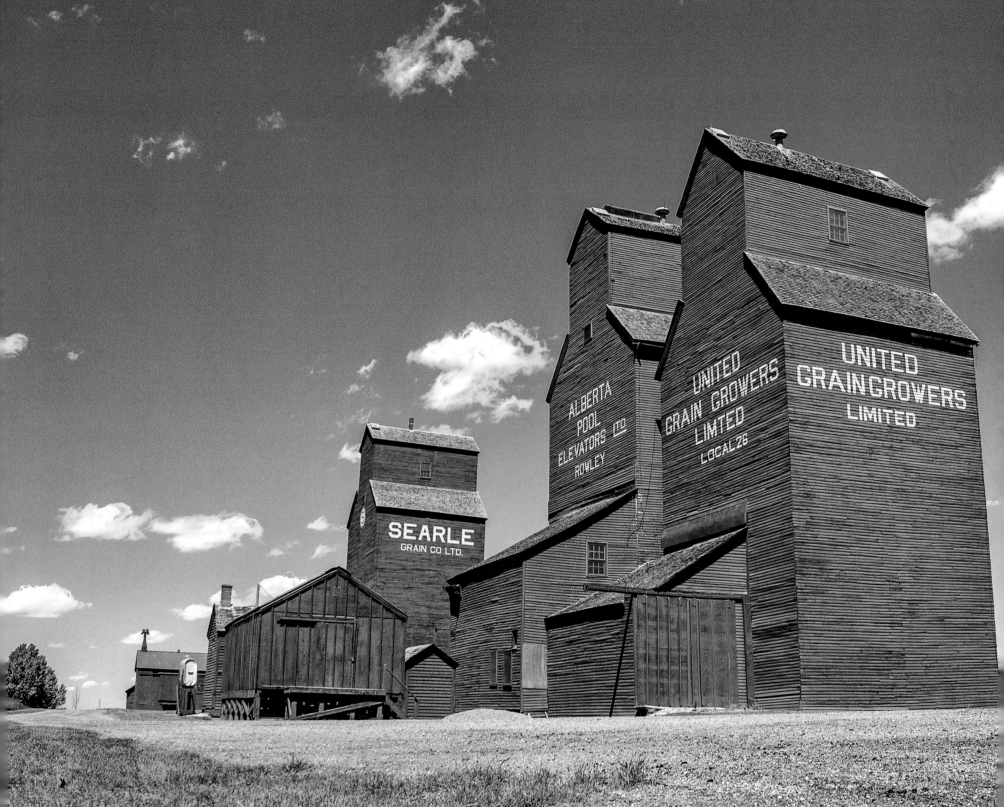

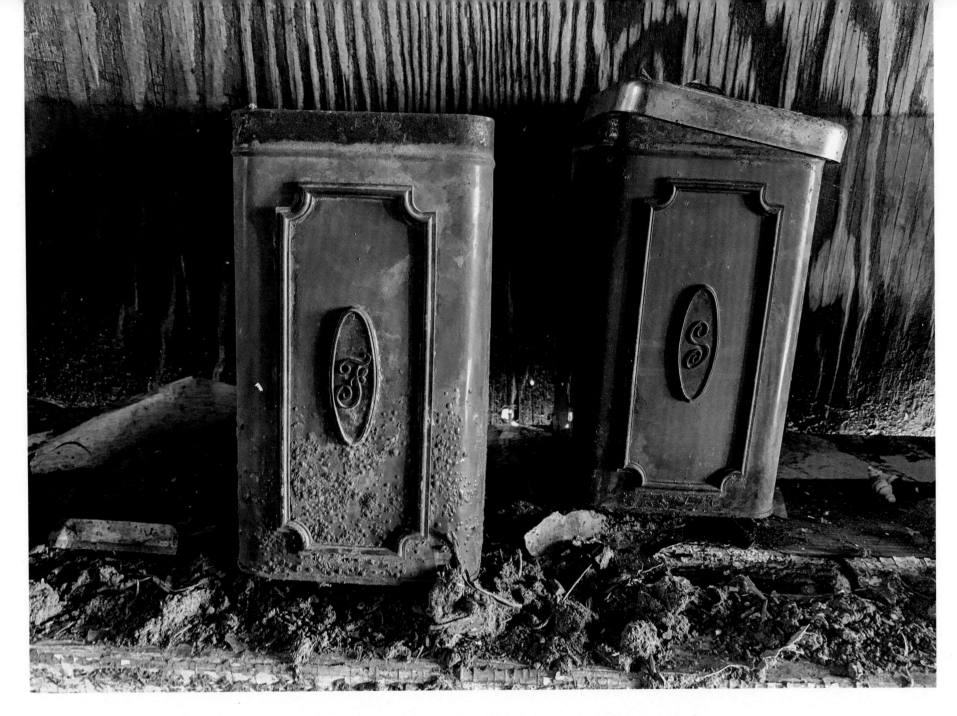

(Above) As of May 2019, the flour and sugar canisters are still sitting on the counter where they were left by the homeowners in this house in Mundare.

(Opposite) The Seymour Hotel in Hanna was built approximately 1912 to 1915 and closed about 2011. A few decades ago, the future members of the band Nickelback would frequently be seen in the hotel bar and its sister hotel, The New National (no longer standing). One night, a bus pulled into town with Waylon Jennings and Willie Nelson on board. They entertained the Seymour Hotel bar crowd for hours.

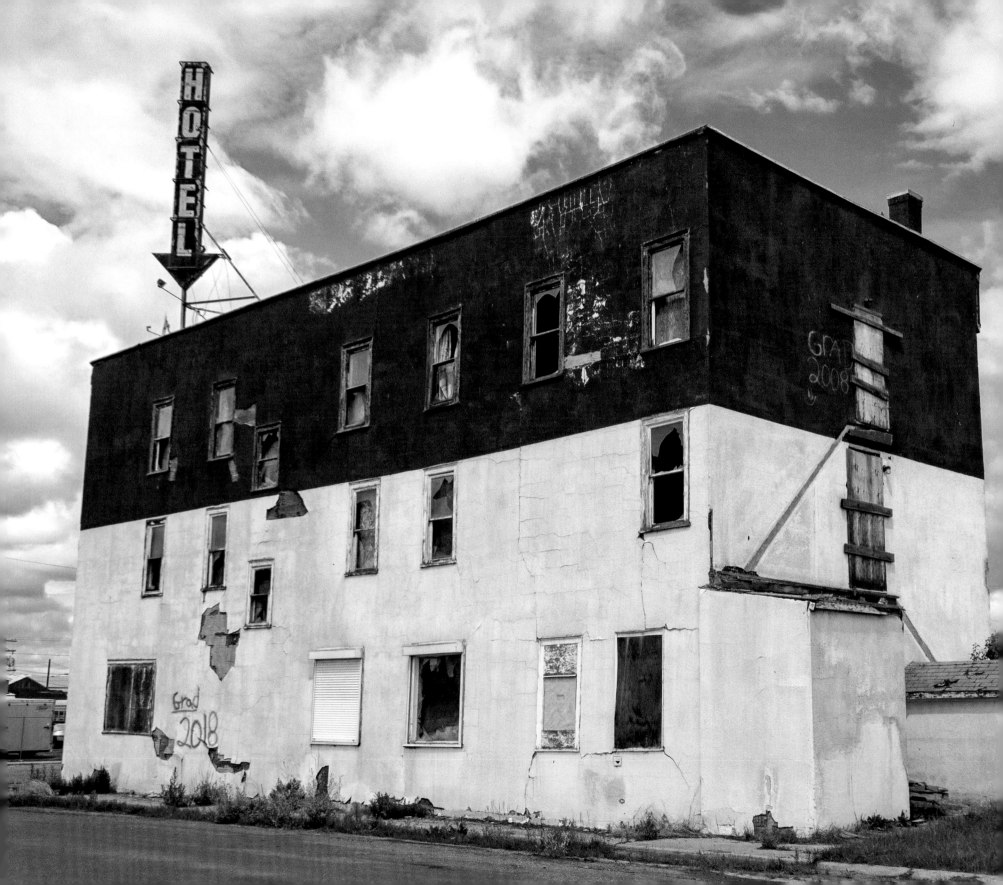

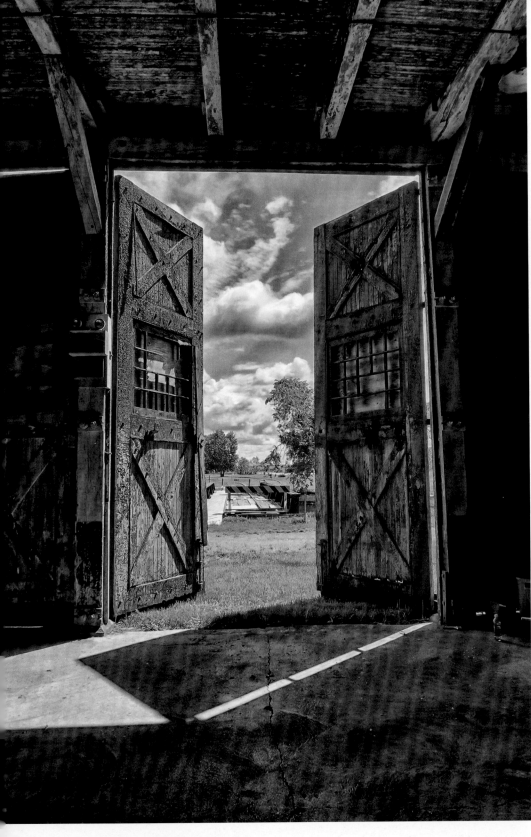

(Left) Looking out of the roundhouse towards the turntable.

(Opposite) The view from the train as the engineer approached the Hanna turntable and roundhouse complex. Considered to be the halfway point between Calgary and Saskatoon, the first passengers pulled into Hanna in November 1913.

This rail line was known as the Goose Lake Line and connected 28 towns and communities. The luxury train consisted of eight cars (two first class, two second class, baggage, express, mail and a dining car). On July 26, 1980, the last of the "iron horses" left the Hanna Yard on its way to Transcona, on the east side of Winnipeg, where it was to be scrapped.

The roundhouse was an important part of the rail system in Alberta. Canadian Northern Railway started construction in June 1913 and by September the original 10 bays were completed. The building is almost solid concrete and is believed to have been completed in a single pour.

When the doors opened, there were pits where employees could work under the locomotives. The original 70-foot diameter turntable was replaced in 1941 with an 86.5-foot turntable to accommodate large locomotives. With the arrival of the diesel age, steam locomotives and roundhouses became obsolete. The doors were closed in 1961. The rail yard was last used in 2010, when the last engine through Hanna was driven by engineer Gerald (Brass) Campion. (**Source: Hanna Roundhouse Society and Sandra Beaudoin**)

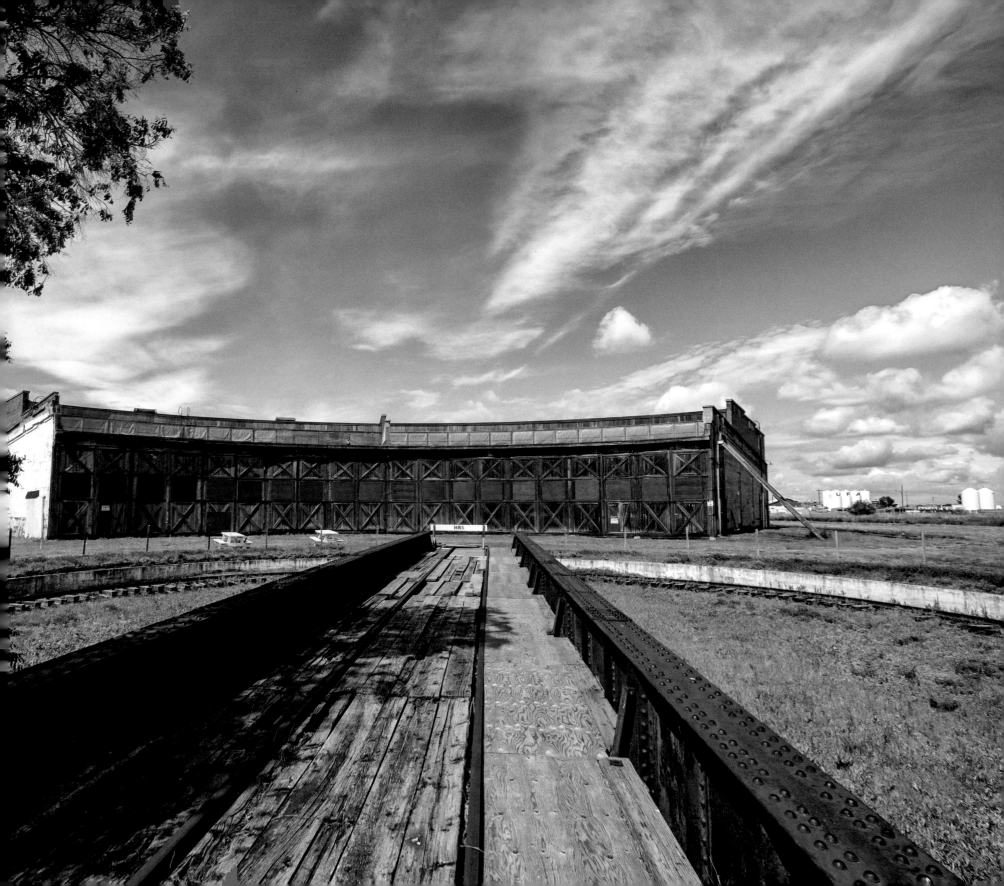

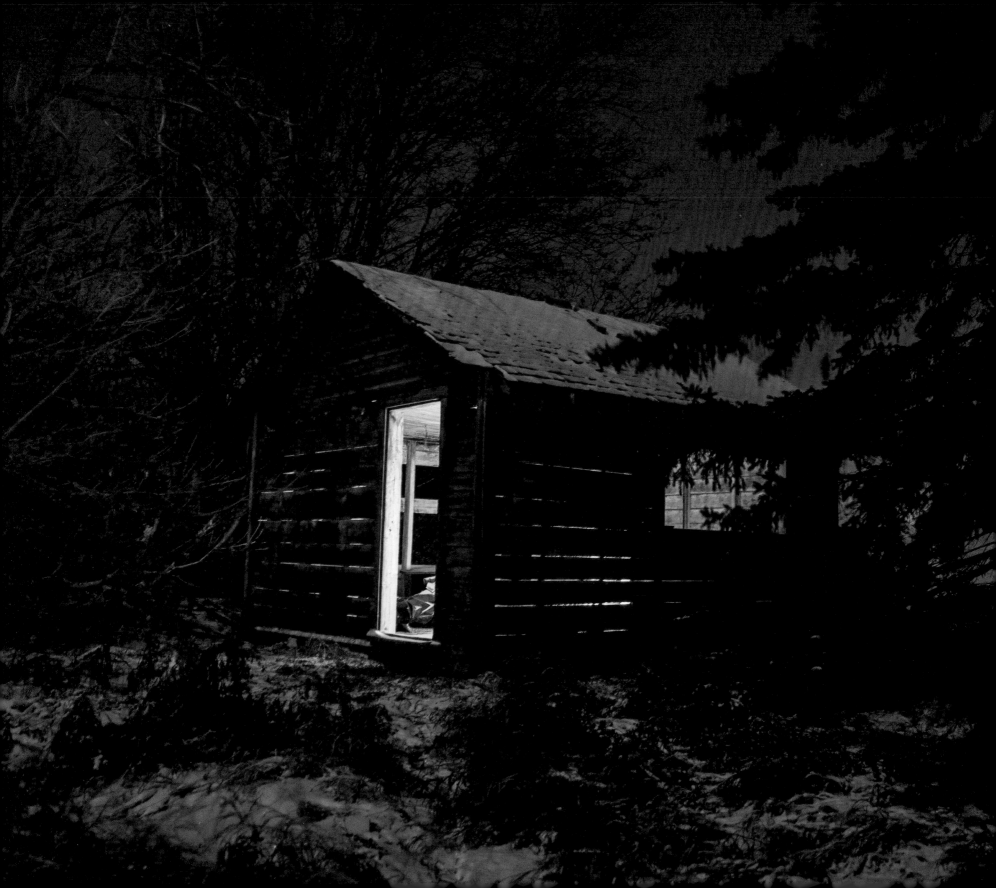

Oh the prairie lights are burnin' bright
The Chinook wind is a-movin' in
Tomorrow night I'll be Alberta bound

Gordon Lightfoot, Alberta Bound

(**Opposite**) One of the catalysts that started this Abandoned Alberta journey was this small, one room farm building on the outskirts of Devon. Photographed on a cold, winter night in February 2018.

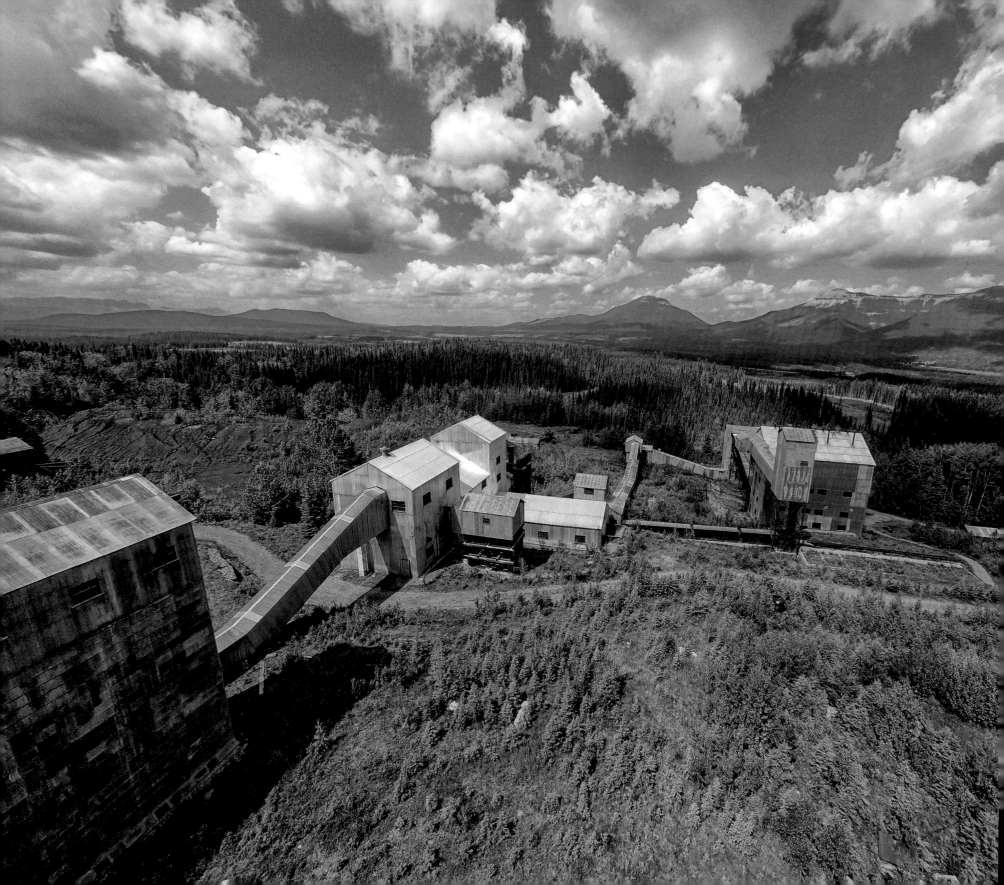

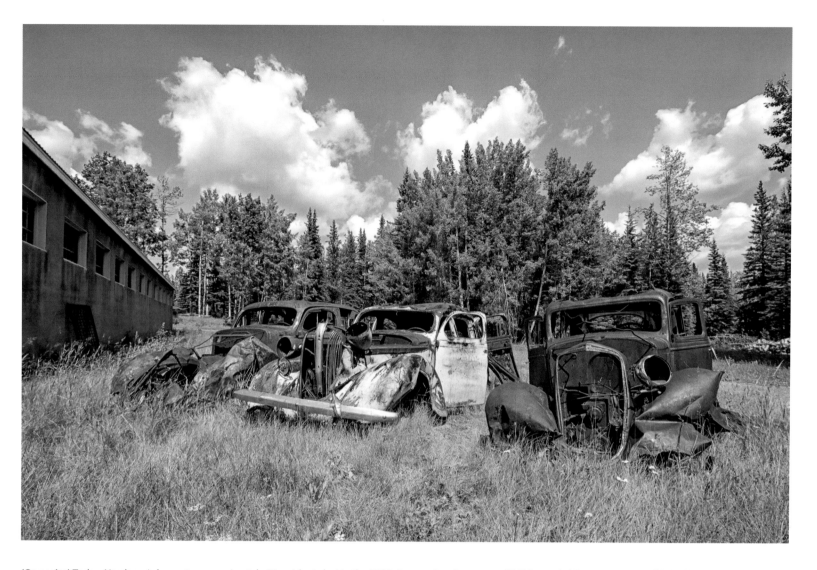

(Opposite) Today, Nordegg is home to approximately 80 residents but in the 1940s it was a bustling town of 2500 people. The town was established by a German man named Martin Nordegg who was recruited by Sir Wilfred Laurier to invest money into one of Canada's resources — coal.

Nordegg was home to the Brazeau Collieries coal mine, which began production in 1911. In January of 1937, the first shipment of briquettes left Nordegg and became a prime fuel source for the Canadian Northern Railway that contributed to the Brazeau Collieries' title as one of the biggest briquetting operations in North America.

On October 31, 1941, a large underground explosion in the No. 3 Mine, Chamber 13, killed 29 miners. Mining resumed six weeks later. In the 1950s, when diesel emerged, the market crashed for Brazeau's briquettes. By June of 1955, Brazeau Collieries closed its doors forever. During the mine's operations, it is estimated that it produced 9.6 million tonnes of coal.

The Province of Alberta seized the land in the 1960s and turned the area into a minimum-security prison. The prison closed in the 1980s. It was designated as a Province of Alberta Historic Site in 1993 and as a National Historic Site of Canada in 2002. This is the industrial complex, coal slag pile and briquette facility photographed from above by drone.

(Above) Three cars found abandoned among the trees on the Nordegg mine site hauled out to languish near the mine buildings.

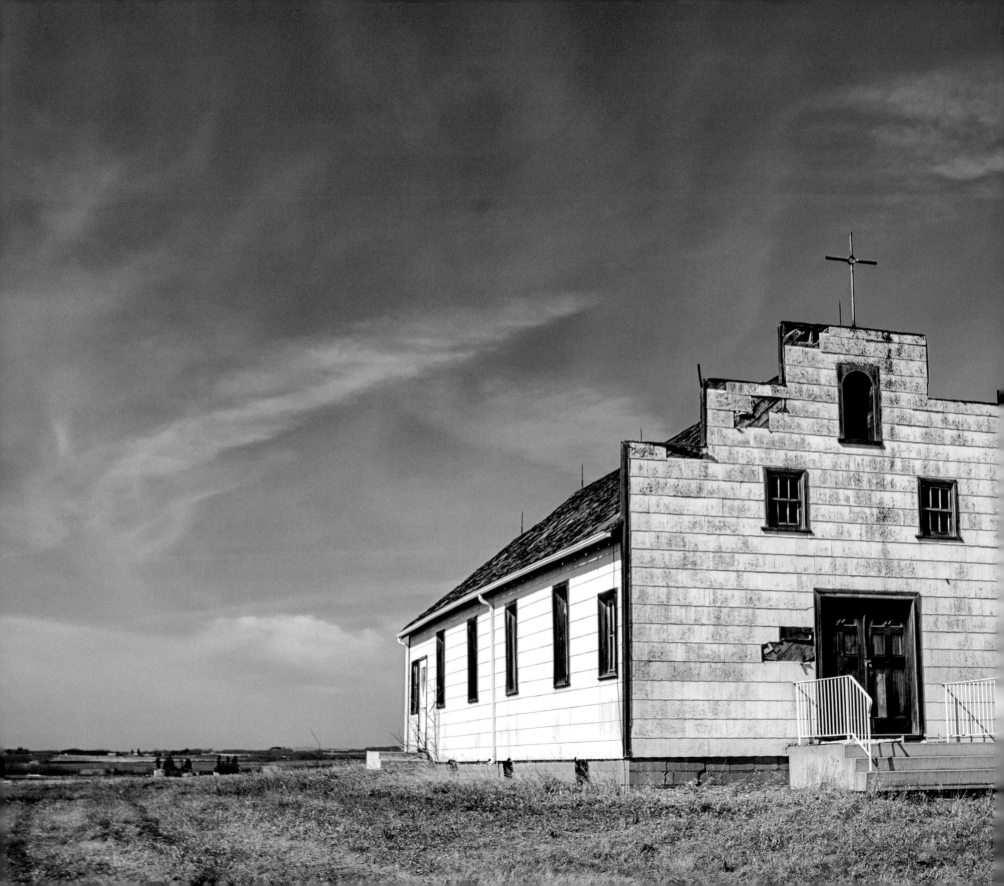

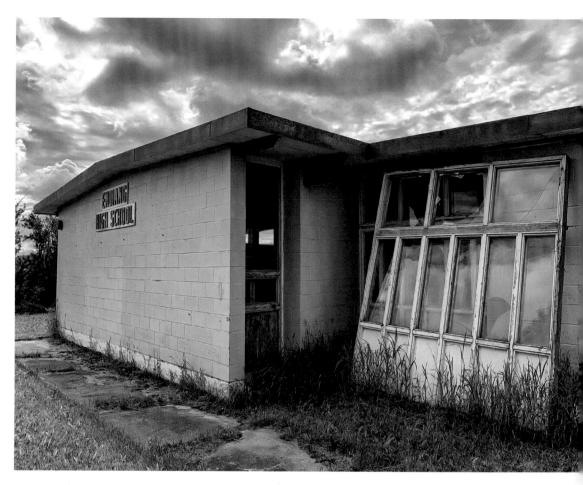

(**Opposite**) This simple looking church known as both St Michael's Catholic Church and Manfred Hungarian Church was built in 1910 and sits atop a hill in central Alberta in the Wetaskiwin area. In 1925, the church steeple was hit by lightning and was lost. The church was closed in about 1975, and was slated to be torn down in the summer of 2019.

(**Above**) Endiang is a small hamlet in central Alberta with a number of abandoned buildings including the high school. Endiang is also home to the Shaben family, some of whom were involved in the establishment of the first Mosque in Alberta.

During the cold war, Endiang was considered the place most likely for conflict to begin between the USSR and the USA, according to internet research. If the Soviet Union fired a missile first, and the American military responded, it was suggested that the two missiles would collide over Endiang, a notion immortalized in the poem *Armageddon at Endiang, Alberta*.

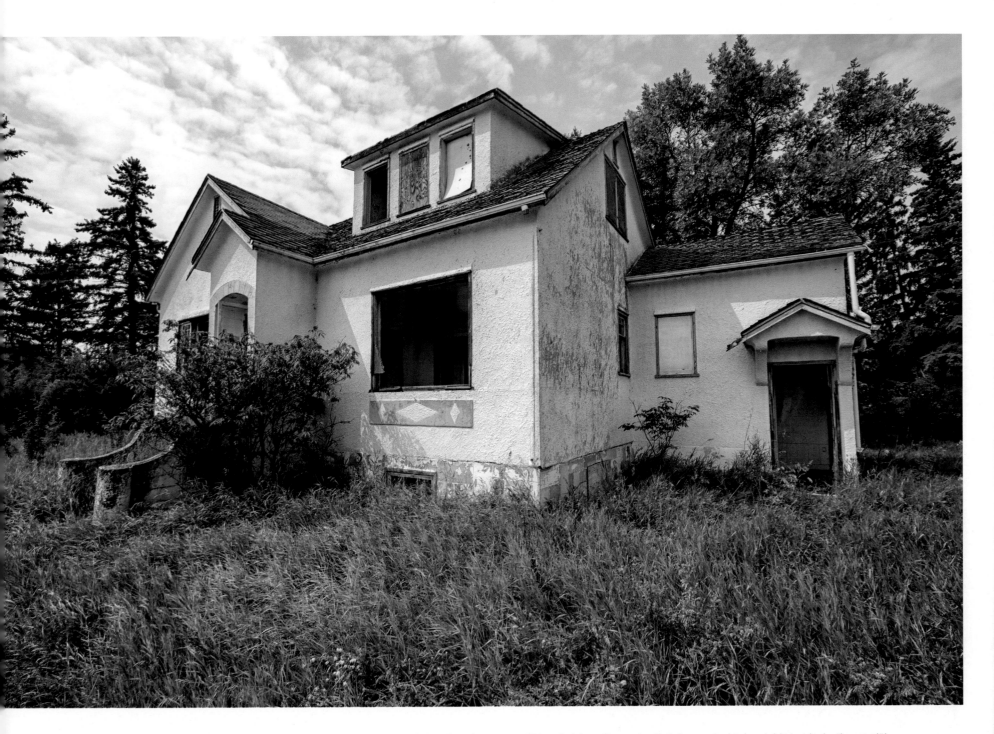

(Above) A house that must have been beautiful in its day, now sits empty and abandoned at an undisclosed location in north central Alberta. Little is known about the home. Some say it is haunted and it has been featured in the book, *More Ghost Stories of Alberta*. To be honest, I felt there was something eerie about this property.

(Opposite) A toy fire truck still sitting on the kitchen table inside the "haunted" house.

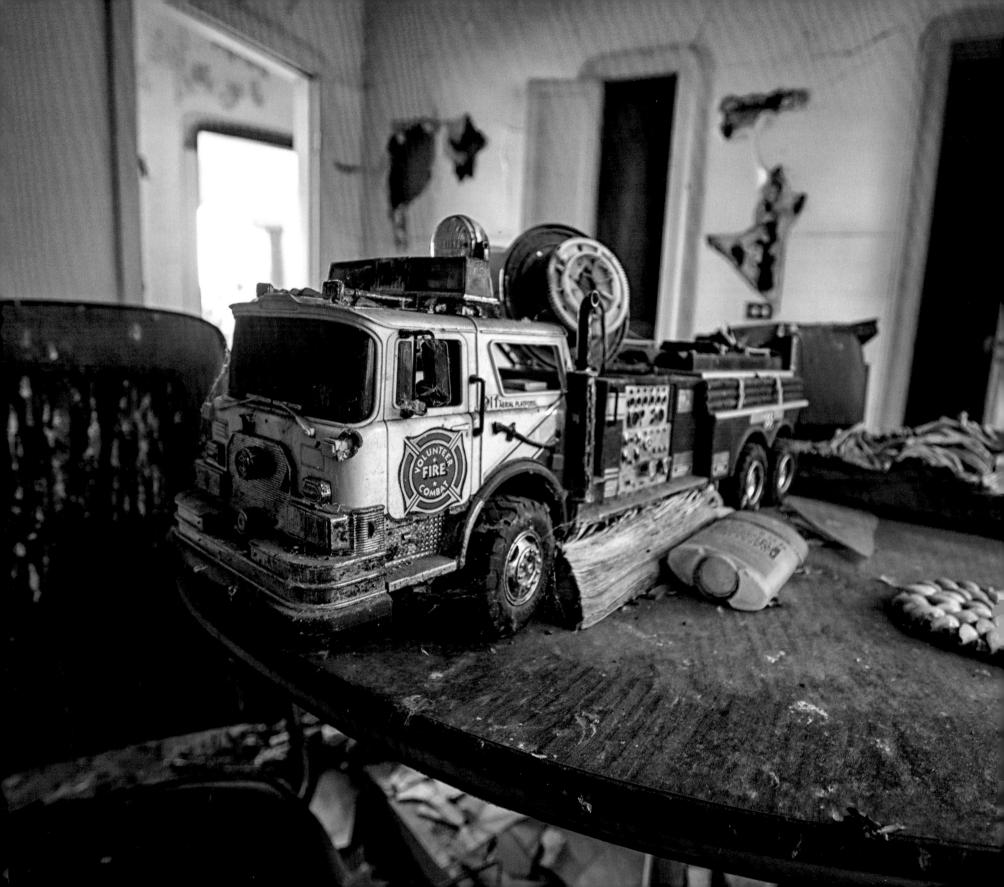

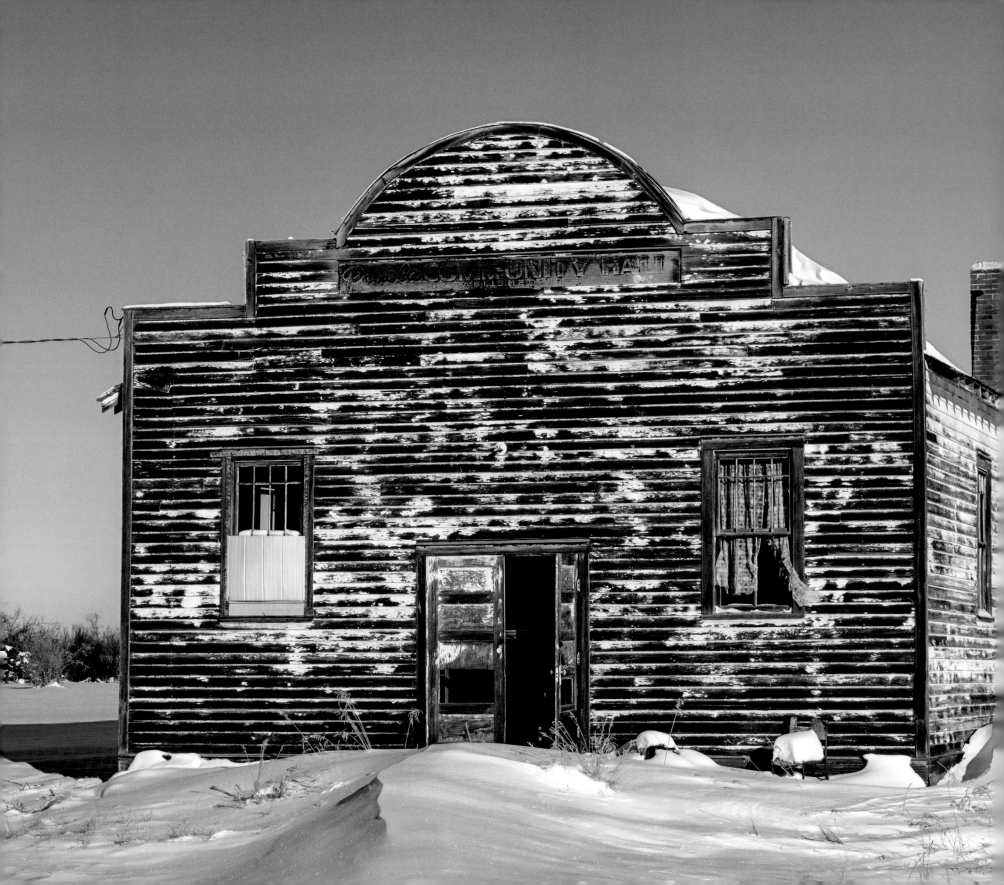

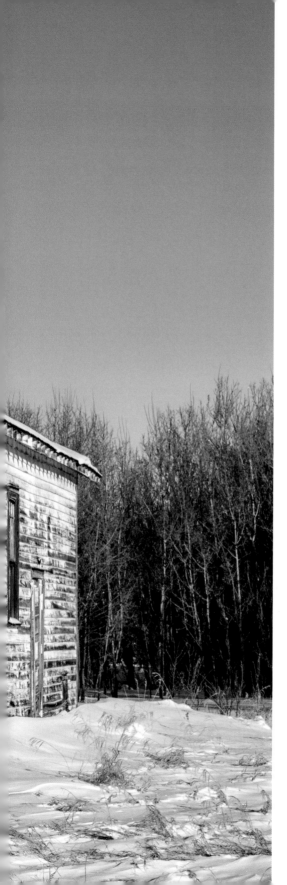

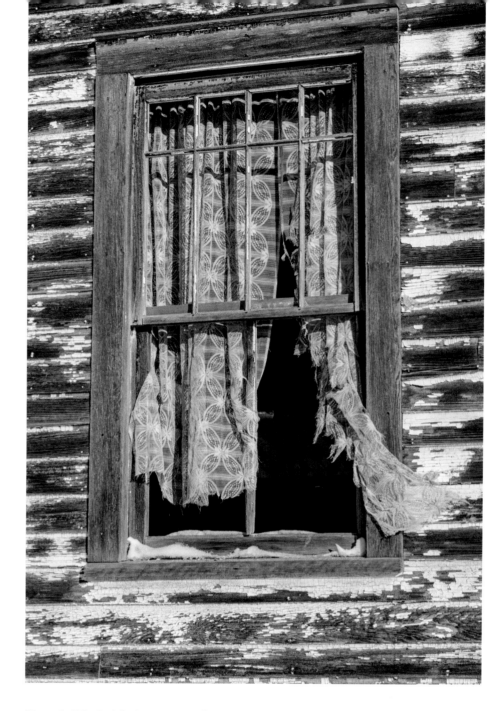

(**Opposite**) The Podola Community Hall was established in 1933. Not a lot of information is known about this hall but over the years it was a venue for family and community gatherings, dances, weddings and bingo games. There were still bingo cards on the floor. There was also a school district in the area with the same name. Podola is believed to be the polonized spelling of the Ukrainian region of Podillia.

(**Above**) Curtains still hanging in the window and billowing in the wind at the Podola Community Hall.

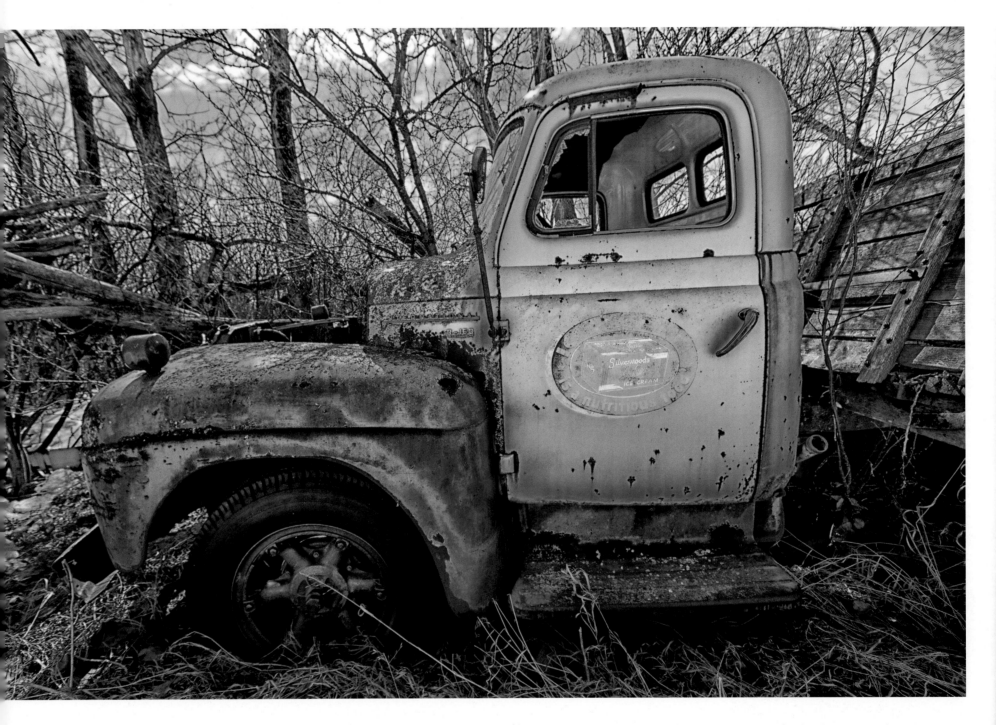

This 1953 International Harvester R-160 Series Truck was an ice cream truck for Silverwood's Deluxe Ice Cream. The truck's odometer reading was almost 174,000 miles. The ice cream slogan is awesome — "Ice cream is a nutritious food." Silverwood was an Ontario dairy started in the 1920s and disappeared from the market in 1999.

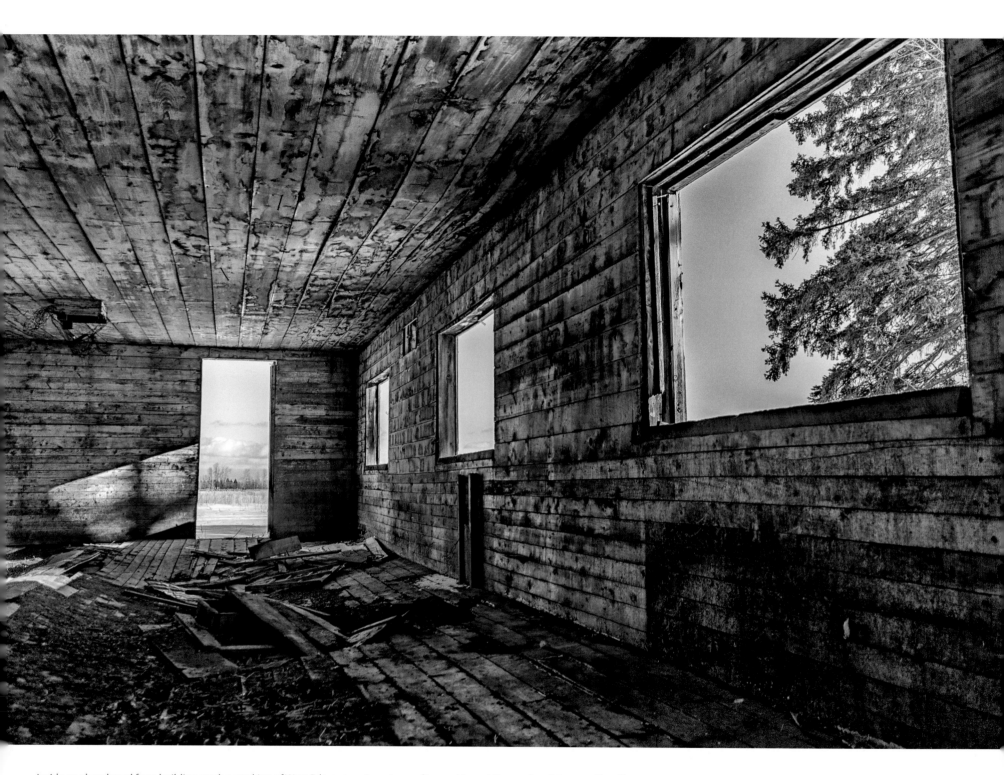

Inside an abandoned farm building on the outskirts of West Edmonton. Amazing craftsmanship and the quality of the wood is still apparent.

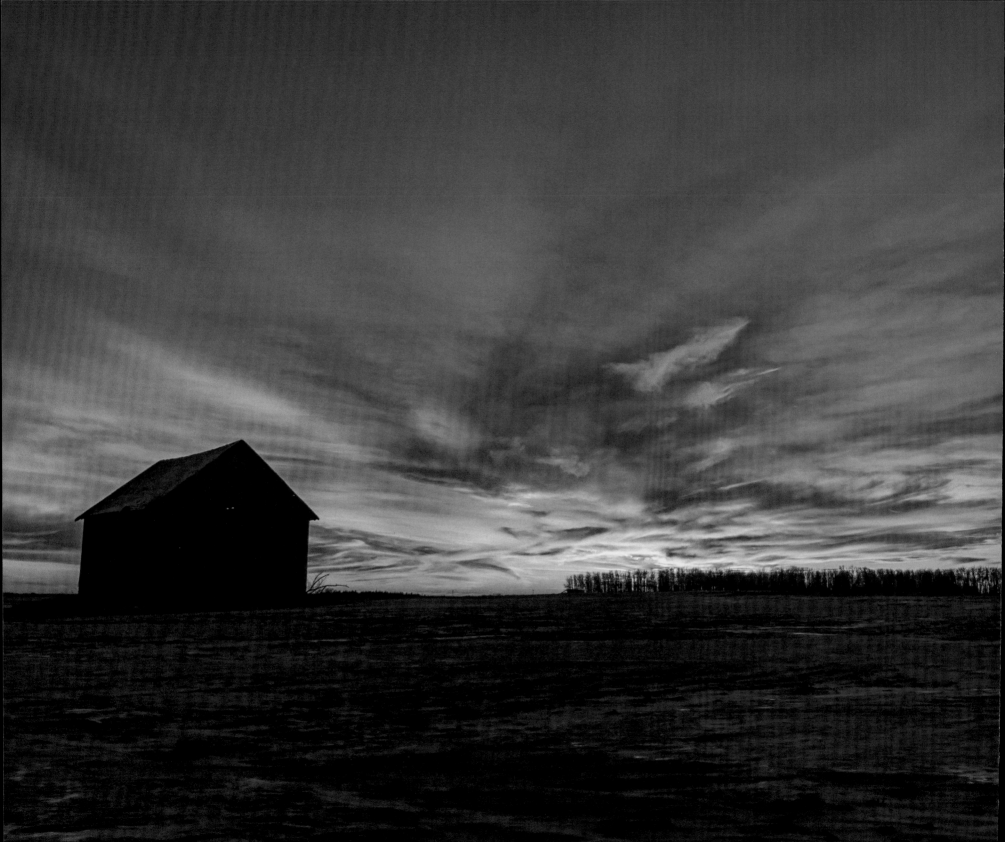

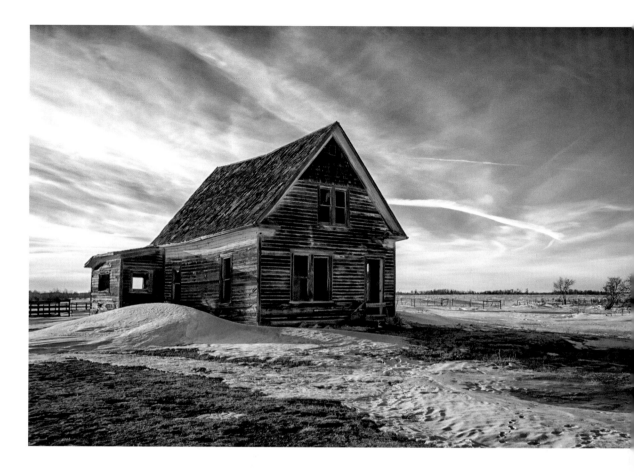

(**Opposite**) The sun sets on an abandoned farm building near the Edmonton International Airport.

(**Above**) Old house in the Halkirk area built in approximately 1904. The house is owned by the fifth generation of the original family and has been passed down through female family members.

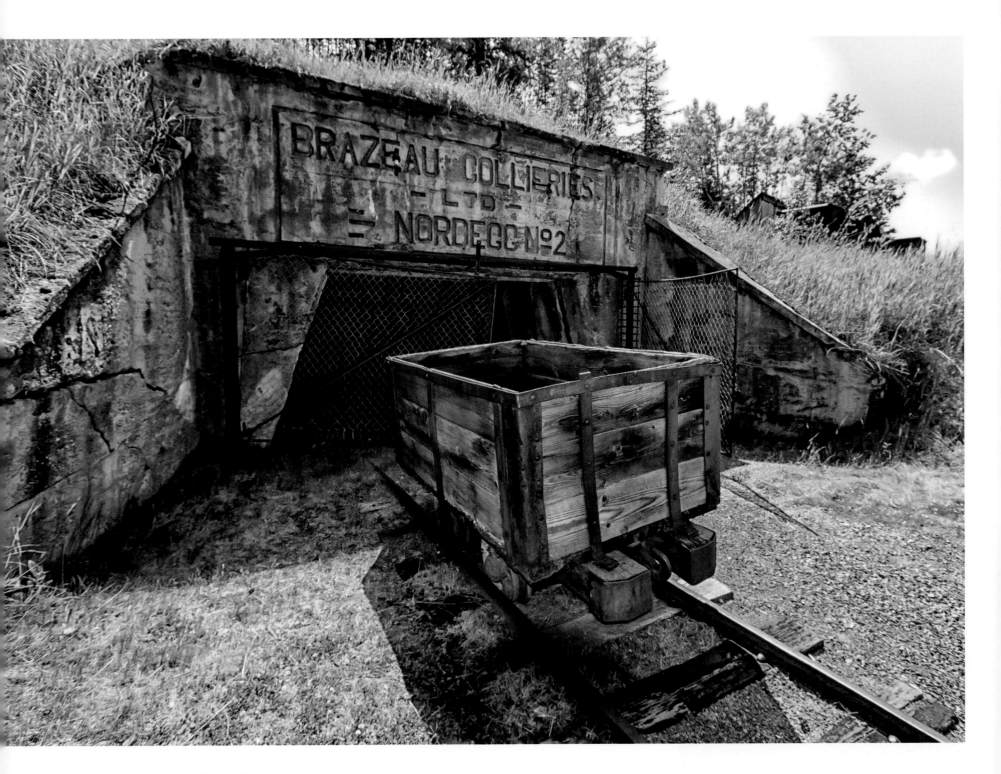

Entrance to Mine #2 at the Nordegg coal mine.

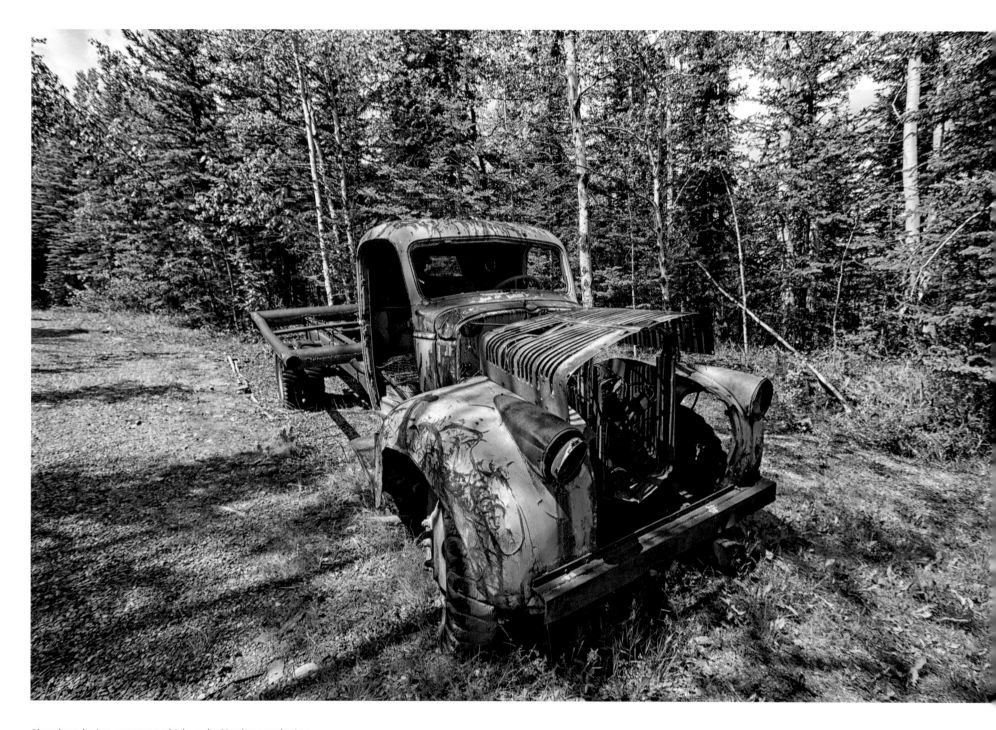

Abandoned mine company vehicle at the Nordegg coal mine.

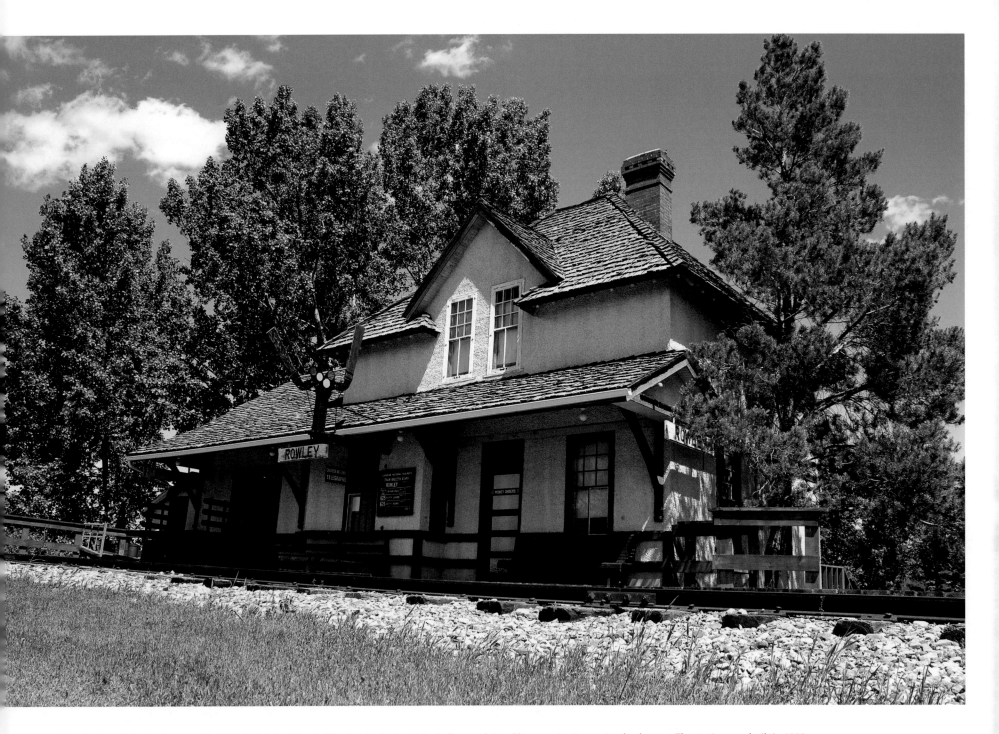

Rowley's Train Station last used in 1999. Inside it still looks like the day it closed, including unclaimed luggage in storage in a back room. The station was built in 1922.

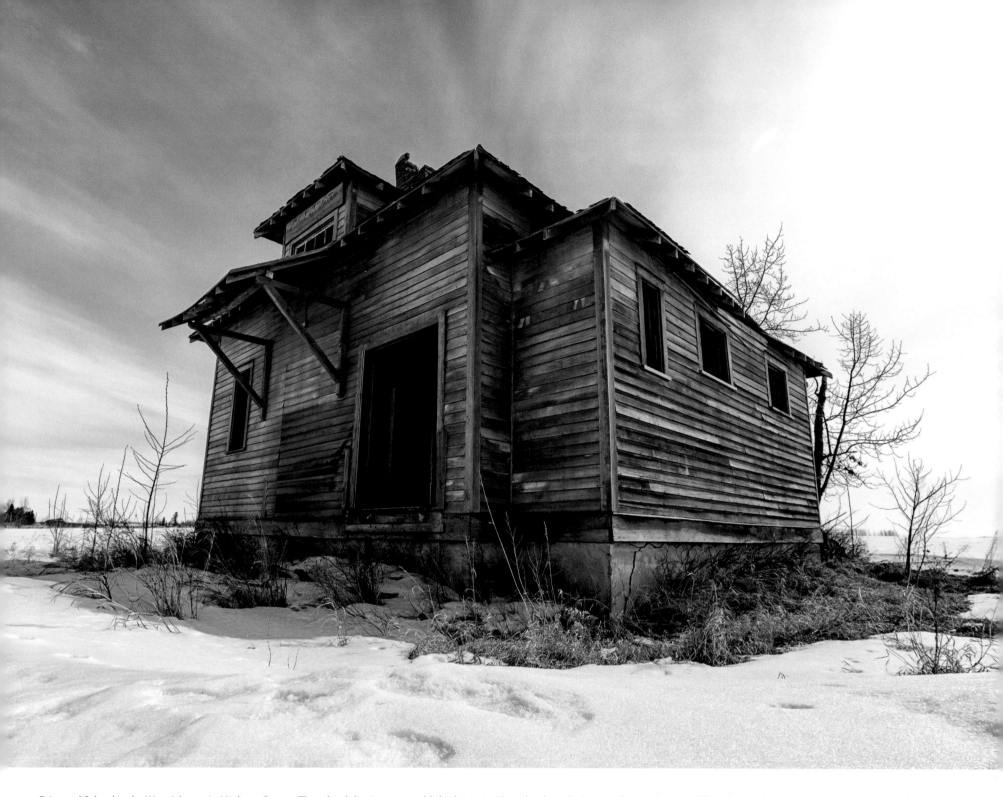

Fairwood School in the Warwick area in Minburn County. The school district was established in 1902. This school was built around 1928 at a cost of $4,000 after the original school was destroyed by fire. When the school closed in 1954, students were bussed to Vegreville. The school was used as a community centre for several years after.

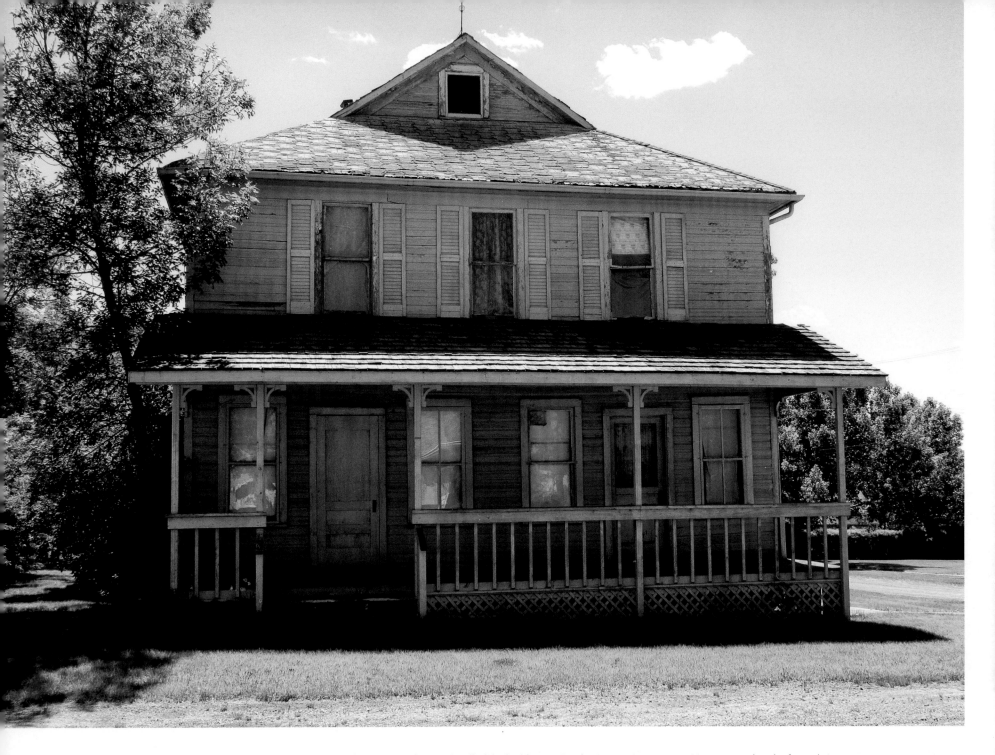

This beautiful, two-story house in Rowley was the local hospital for a period of time. Like all of the buildings in Rowley, it now sits empty waiting to see what the future brings.

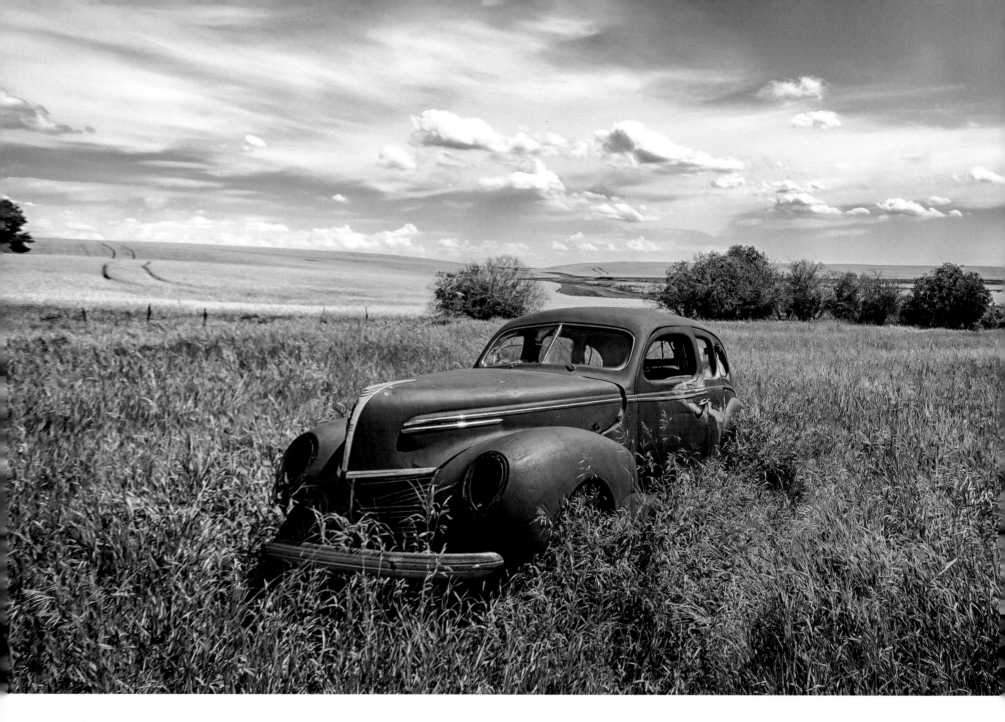

On one of my many adventures in July 2018 searching for abandoned buildings, this vehicle stopped me in my tracks — a 1939 Mercury. From its beginnings as a medium priced automobile in late 1938, Henry Ford denied that the Mercury existed. The 1939 model (first in the series) had a V-8, flathead, 239 cu in, 95 hp engine with an impressive 20 mpg. In 1939, $990 would have made you the proud owner of one of these beauties.

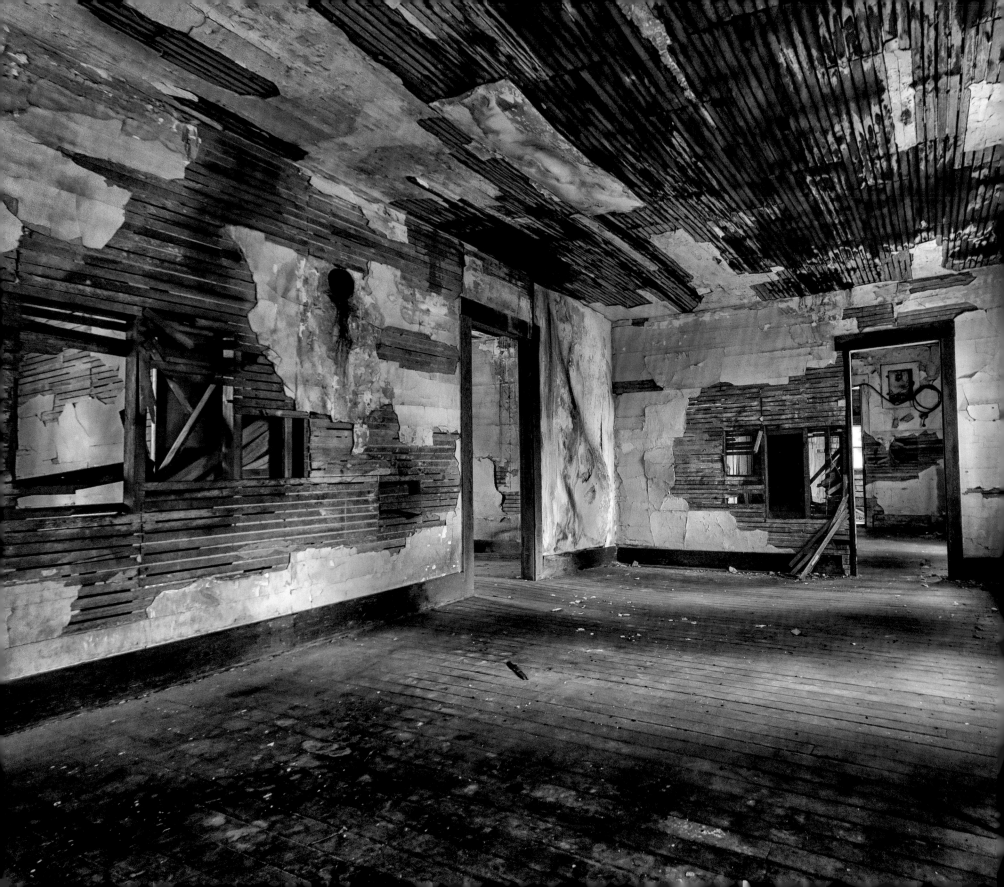

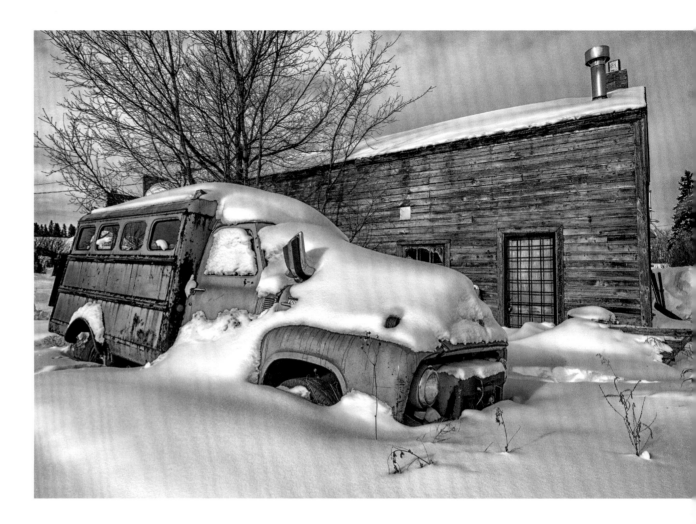

(**Opposite**) Inside the house for single women at the Nordegg mine site.

(**Above**) An abandoned 1950s era school bus sits beside the old welding shop in Beauvallon.

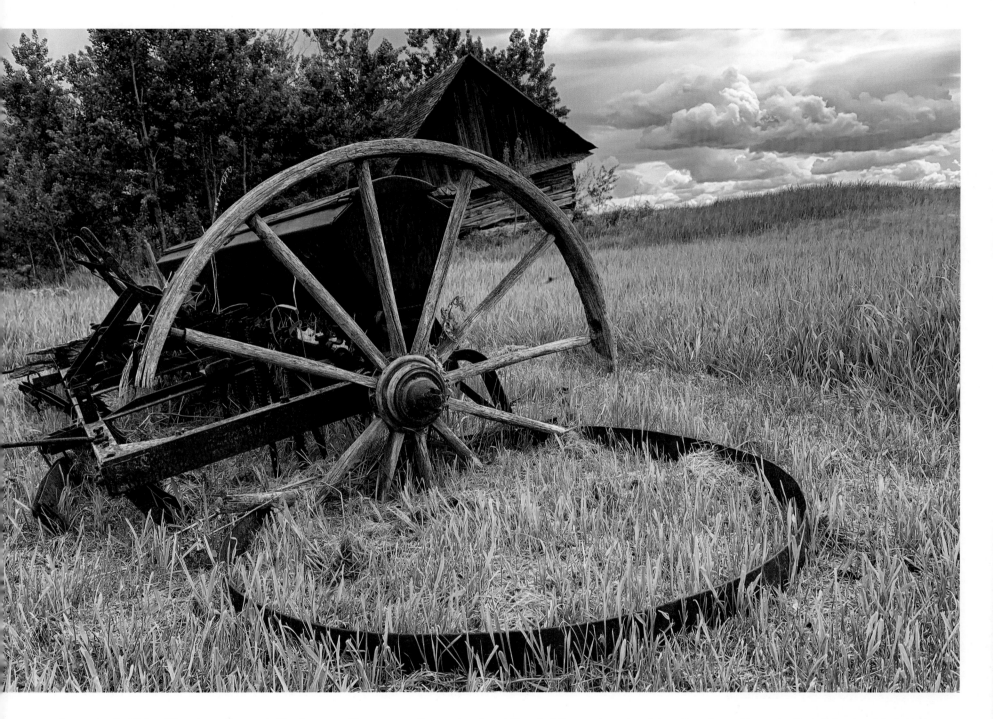

As you play the Whitetail Crossing golf course in Mundare, you will come across the remains of an old farm building, equipment and stove. Over the past few years, the building has deteriorated quickly and has now almost collapsed.

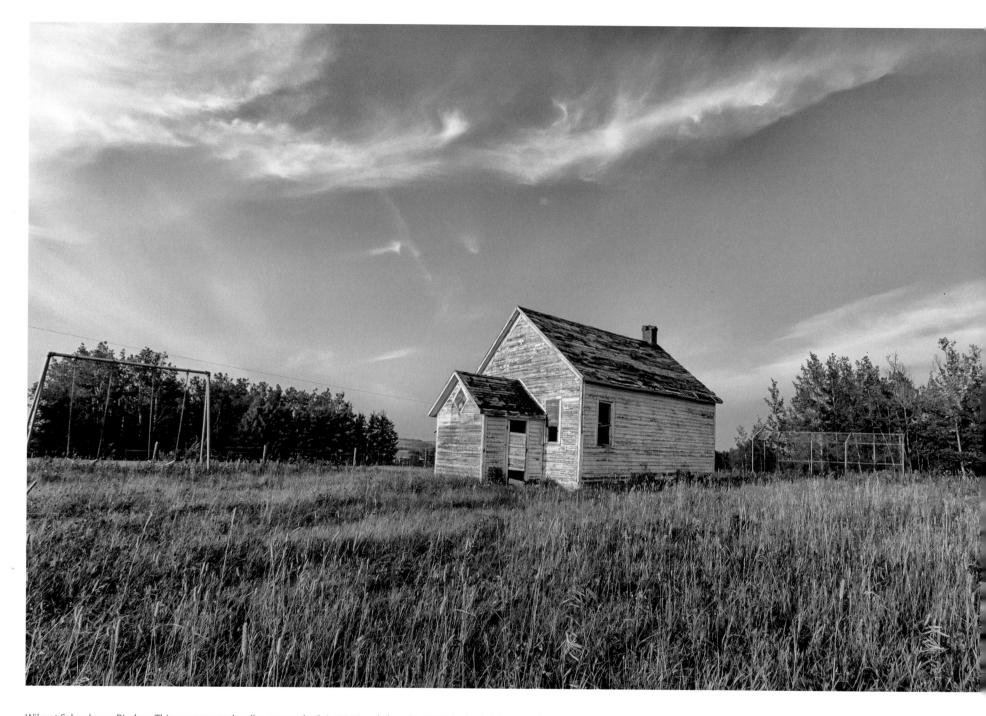

Wilmot School near Rimbey. This one room schoolhouse was built in 1912 and closed in 1953. It also briefly served as a community centre but it has been quite some time since the playground was used and the ball diamond heard the crack of a bat.

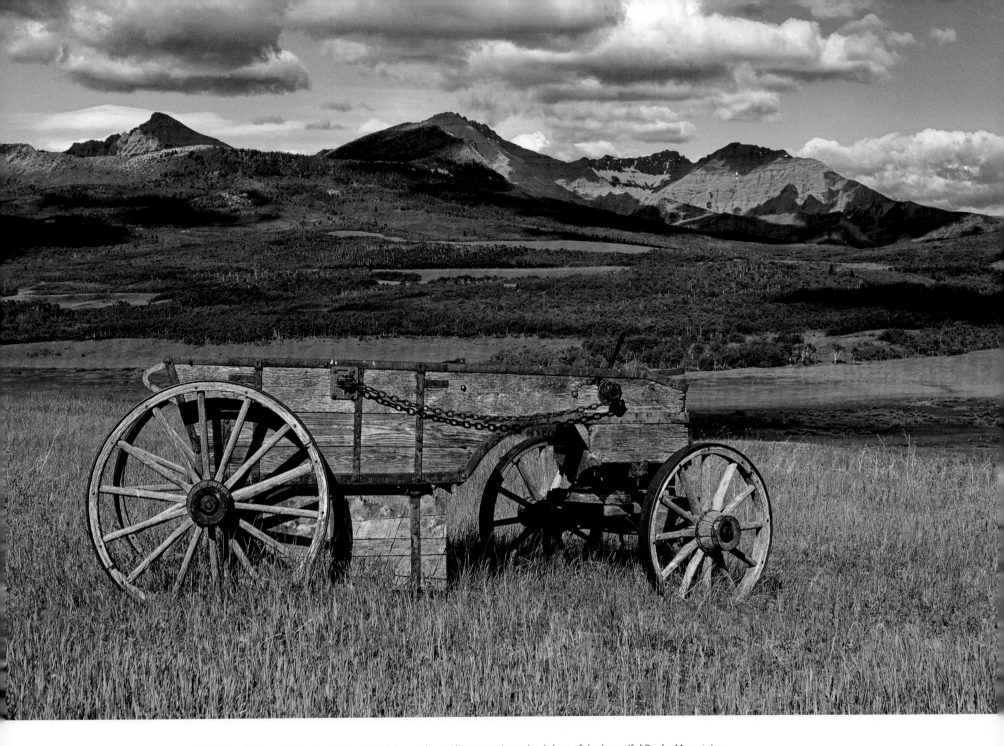

A wagon sits where its owners left it in a field near Waterton National Park in southern Alberta against a backdrop of the beautiful Rocky Mountains.

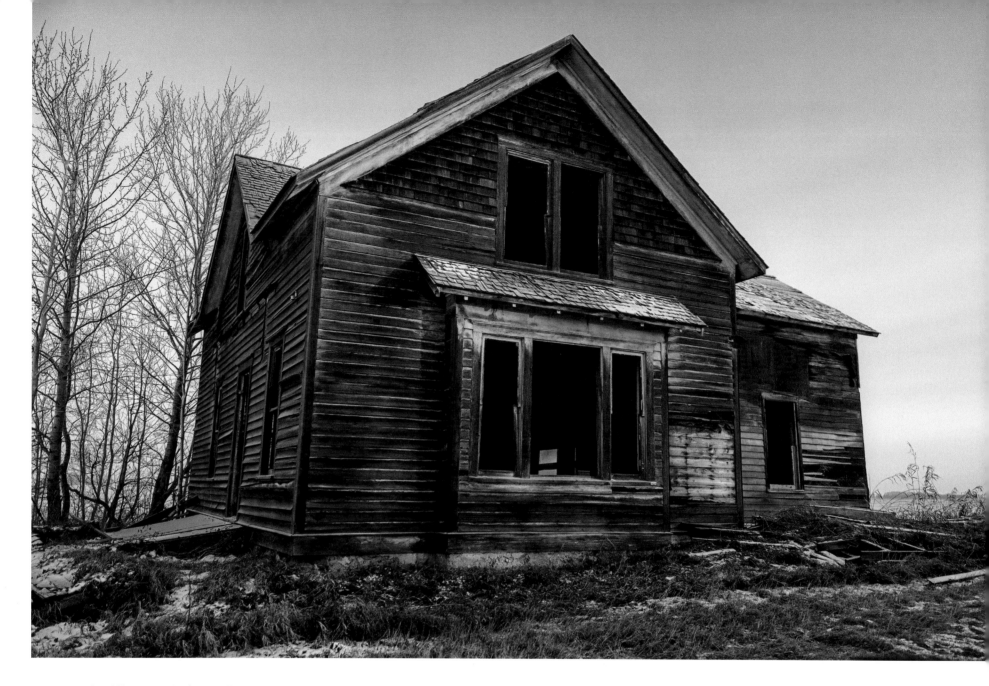

In its prime, this old house north of Vegreville would have been stunning. This is one of my earliest abandoned building photos.

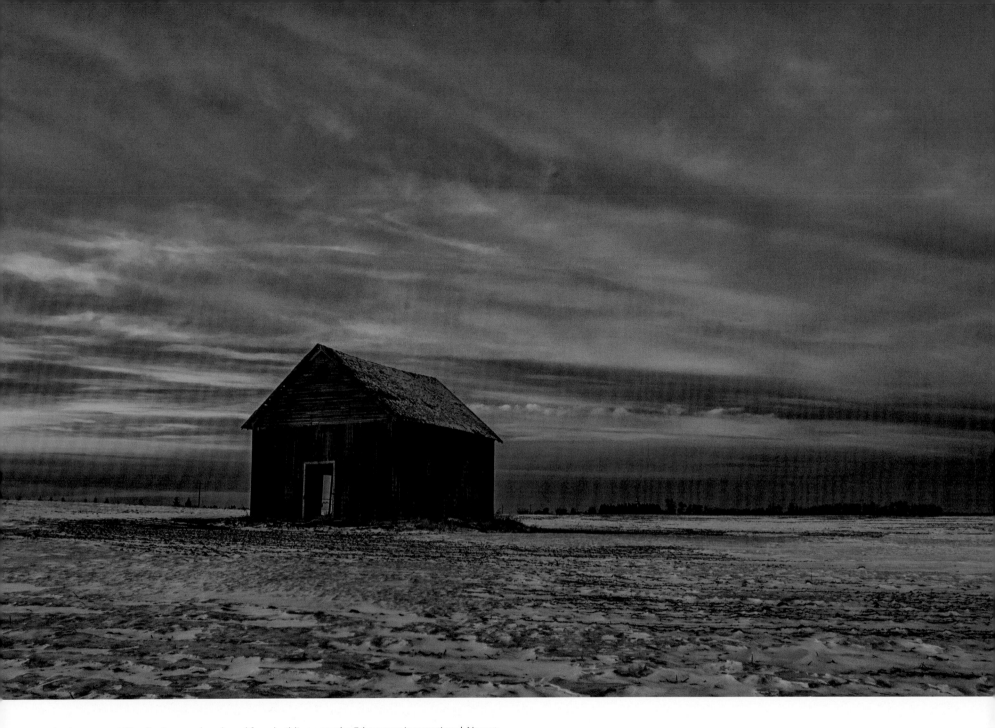

A winter sunset illuminating an abandoned farm building near the Edmonton International Airport.

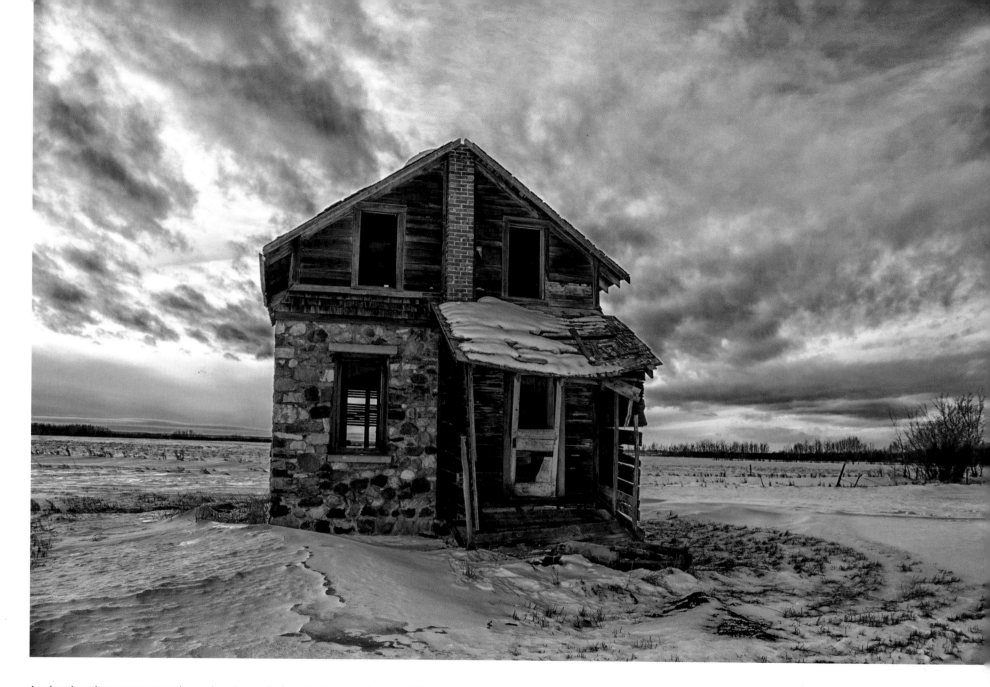

An abandoned two-storey stone house, location undisclosed at the owner's request. The house dates from about 1925. Records suggest it was the first structure on the unbroken land but all we know about the builder is that the original owner's last name was eastern European and that he was a bachelor who lived in the house for a very short time. The next owners acquired the property in the 1930s but it is believed the house was empty and unlived in by then. Over the next few decades it was occasionally rented to single men. The last person known to occupy the house was described as a hermit or a "mad trapper." He allegedly lived here for a year or so in the late 1960s and then left. Ever since, the place has been empty and forgotten. (**Text source: Chris Doering, thebigdoer.com**)

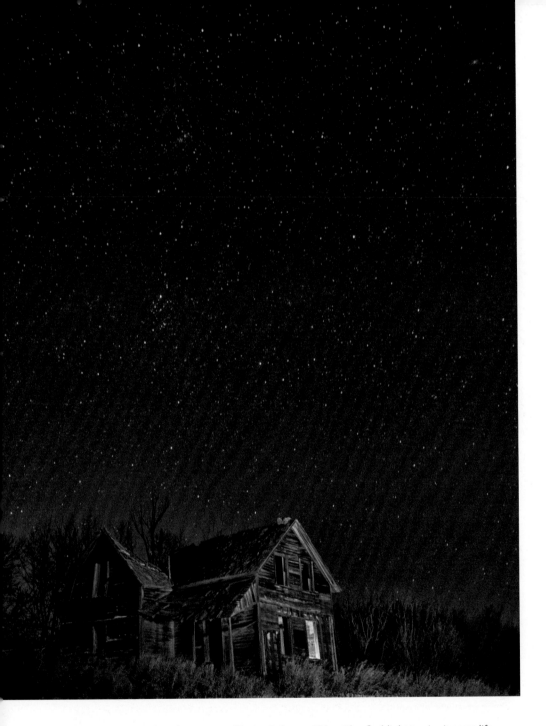

(**Above**) A ghostly looking house east of Leduc lit from within with a flashlight to give it some life under a moonless sky.

(**Opposite**) I call this the tilted house, so simple yet so beautiful. Located in north central Alberta, in a few more years, the only record of this home will be a pile of wood and memories.

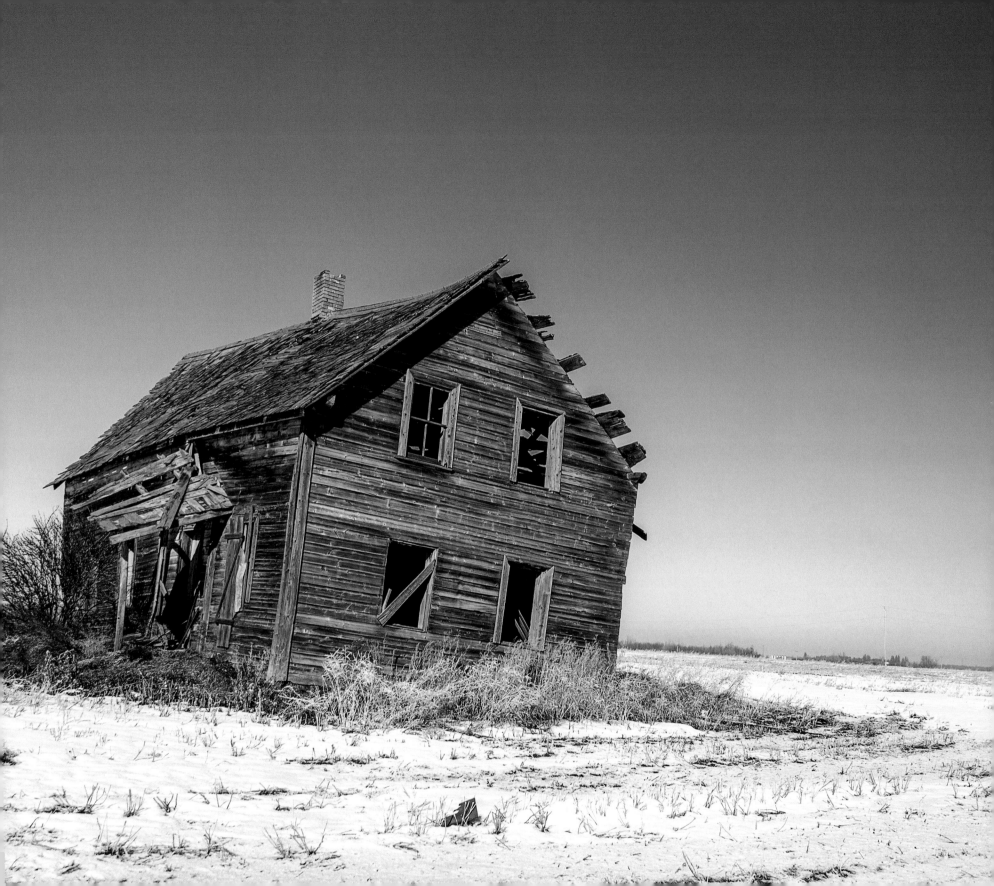

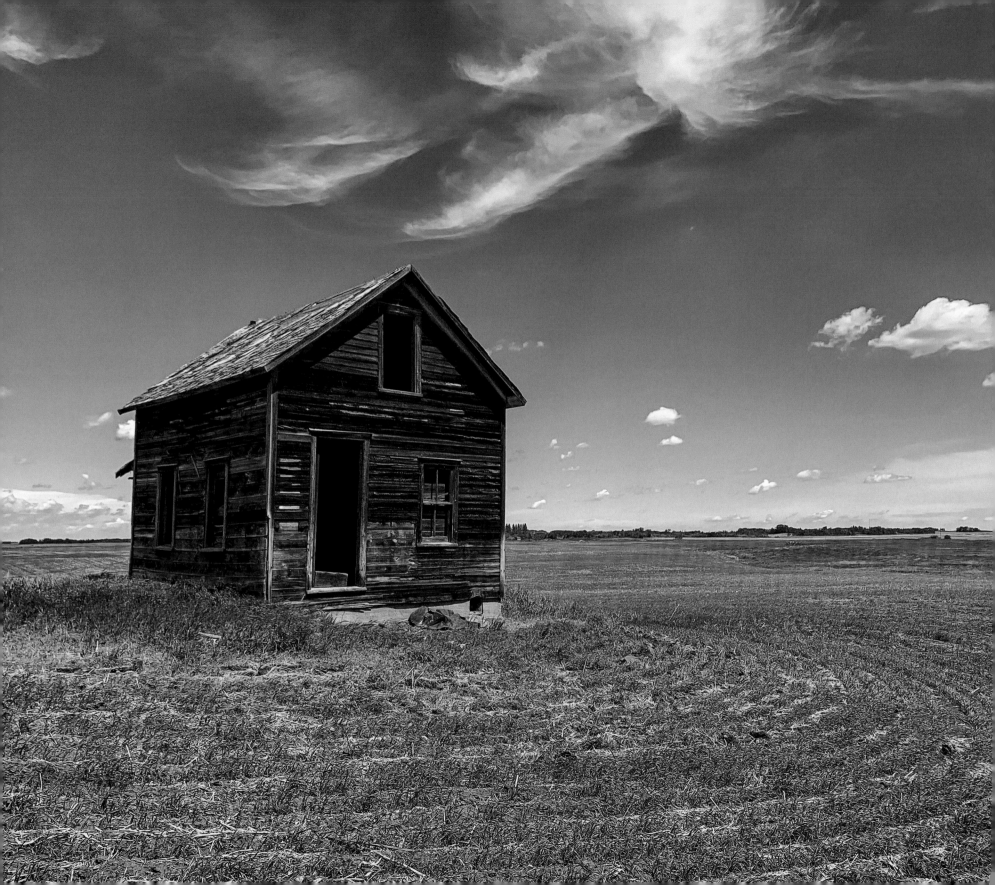

(**Opposite**) A small house southeast of Edmonton sits alone in a field. A peek inside indicated it had one room on the main floor, likely with a bedroom upstairs and a little porch out back

(**Right**) A view through a one-room house of the farmland it once anchored.

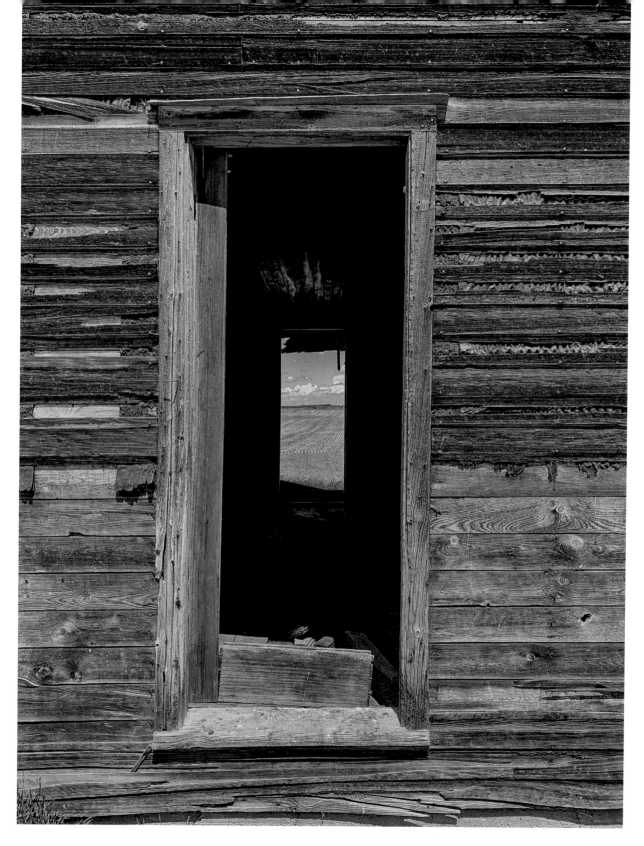

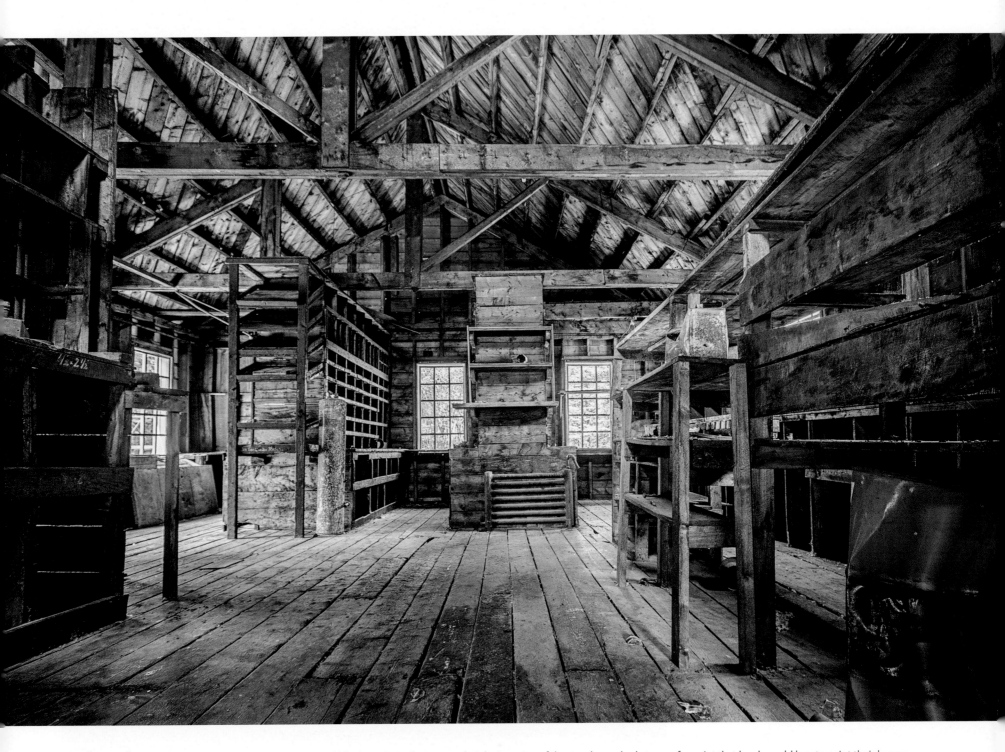

Inside the mine's warehouse at Nordegg, where workers could find a variety of a parts and tools. A section of the warehouse had storage for paint that locals could buy to paint their homes. The colours available were the only colours allowed in the town.

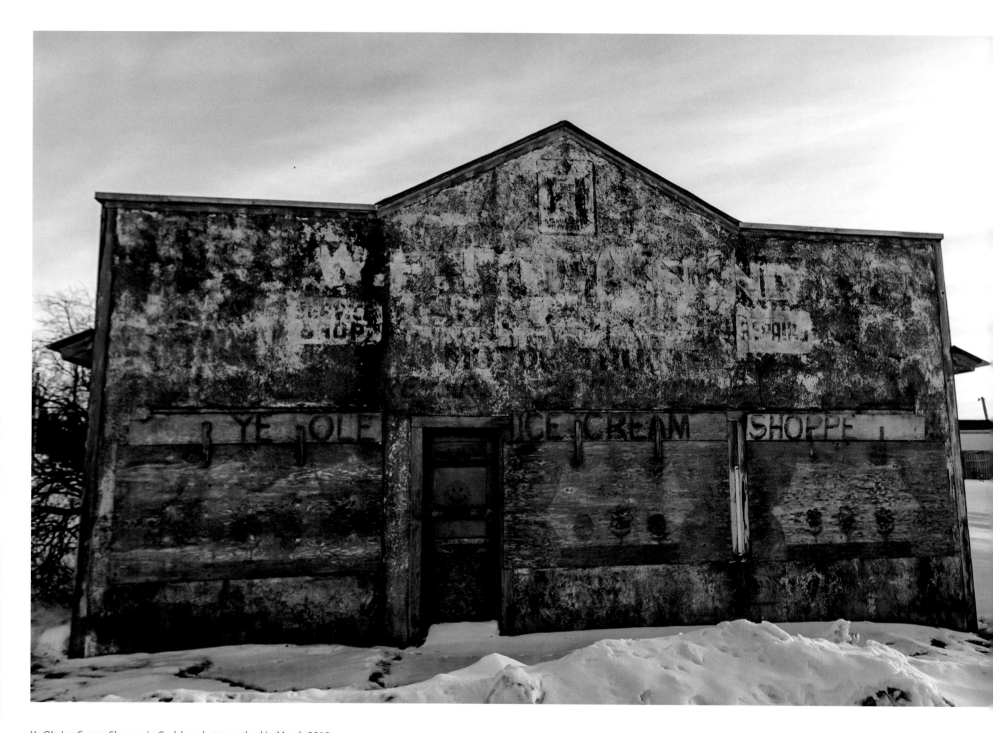

Ye Ole Ice Cream Shoppe in Gadsby, photographed in March 2019.

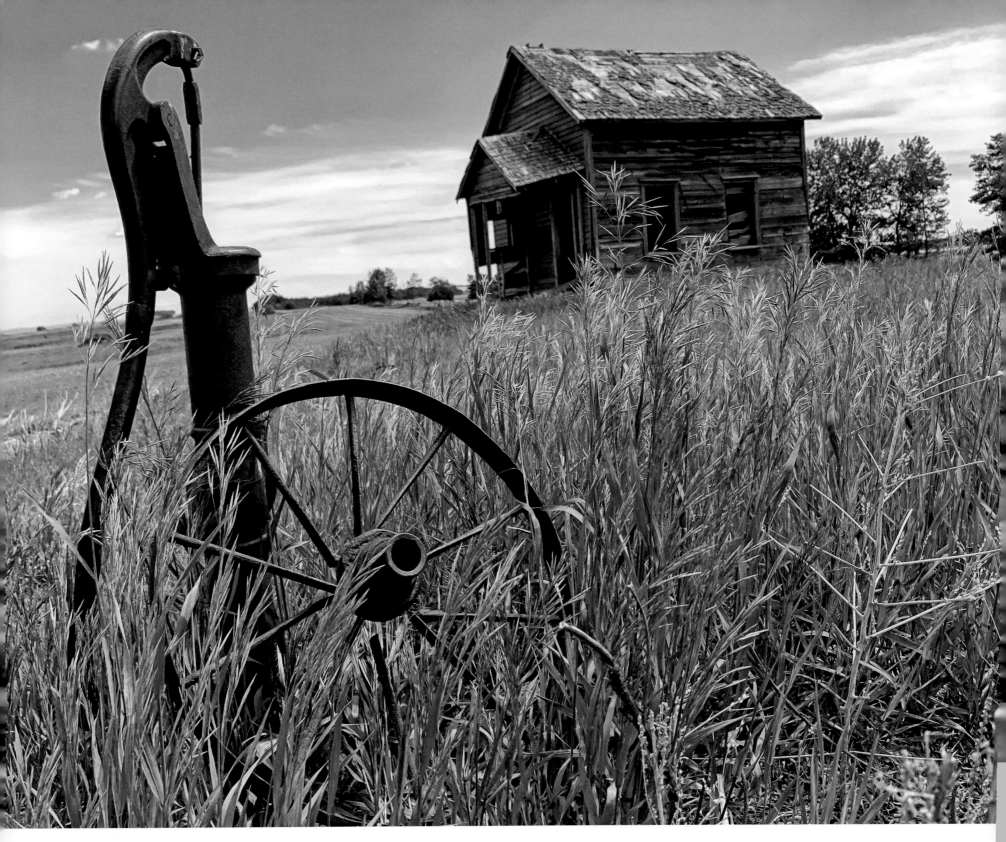

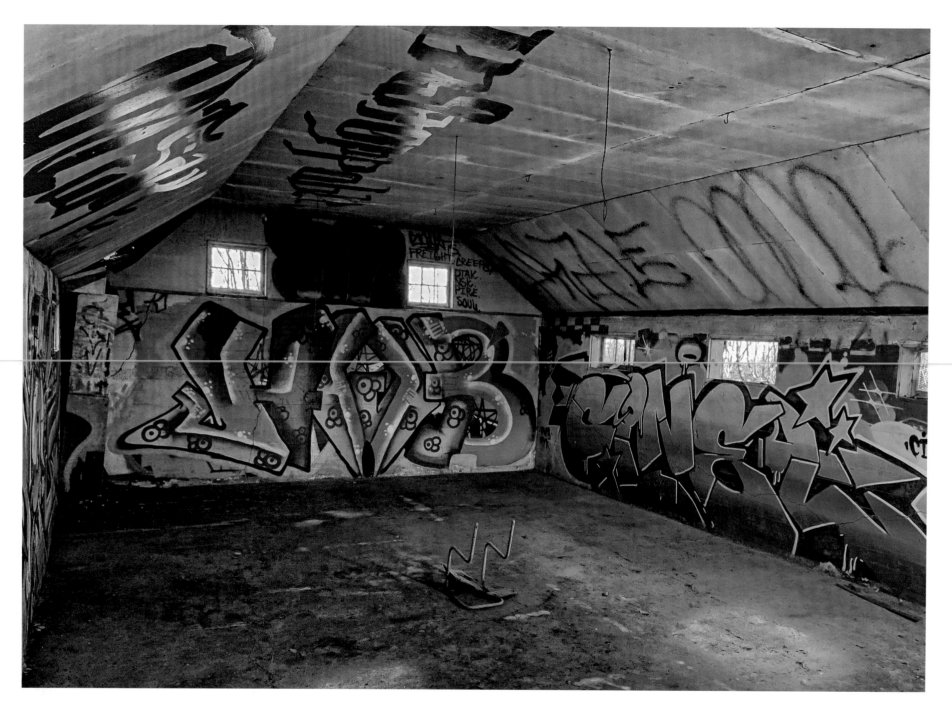

(**Opposite**) Old water pump and wheel near an abandoned one-room home. In much simpler but harsher times, if you needed water, no matter the weather, you headed out to the pump and hoped it wasn't frozen.

(**Above**) Inside the Hover Community Hall in January 2018.

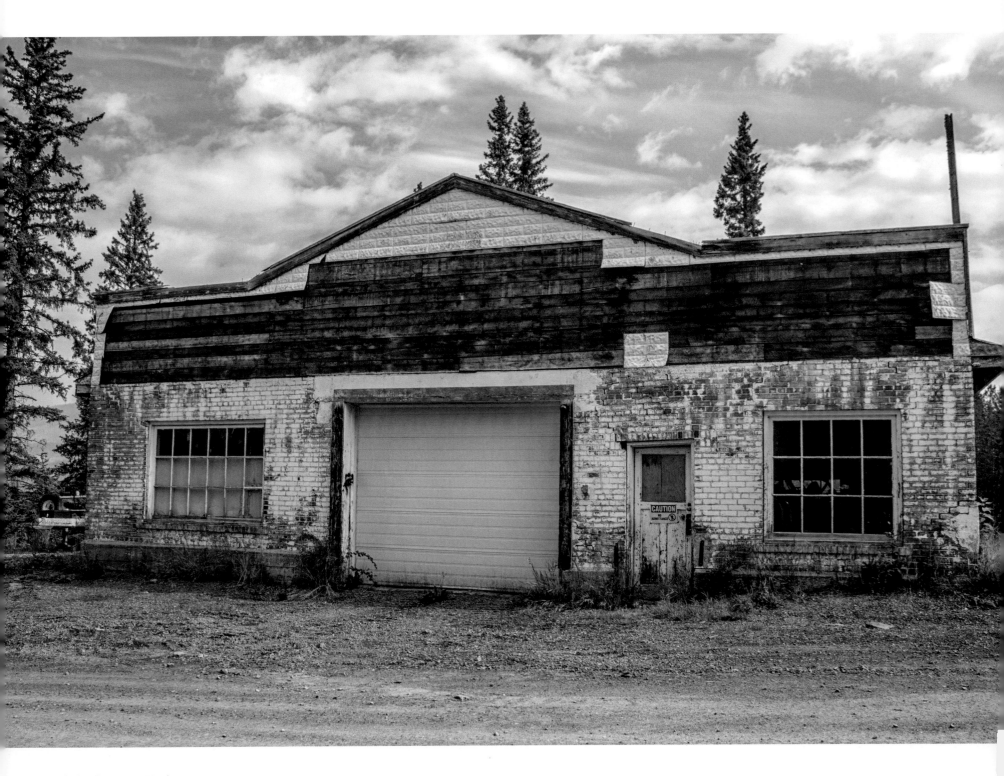

The local garage in Nordegg.

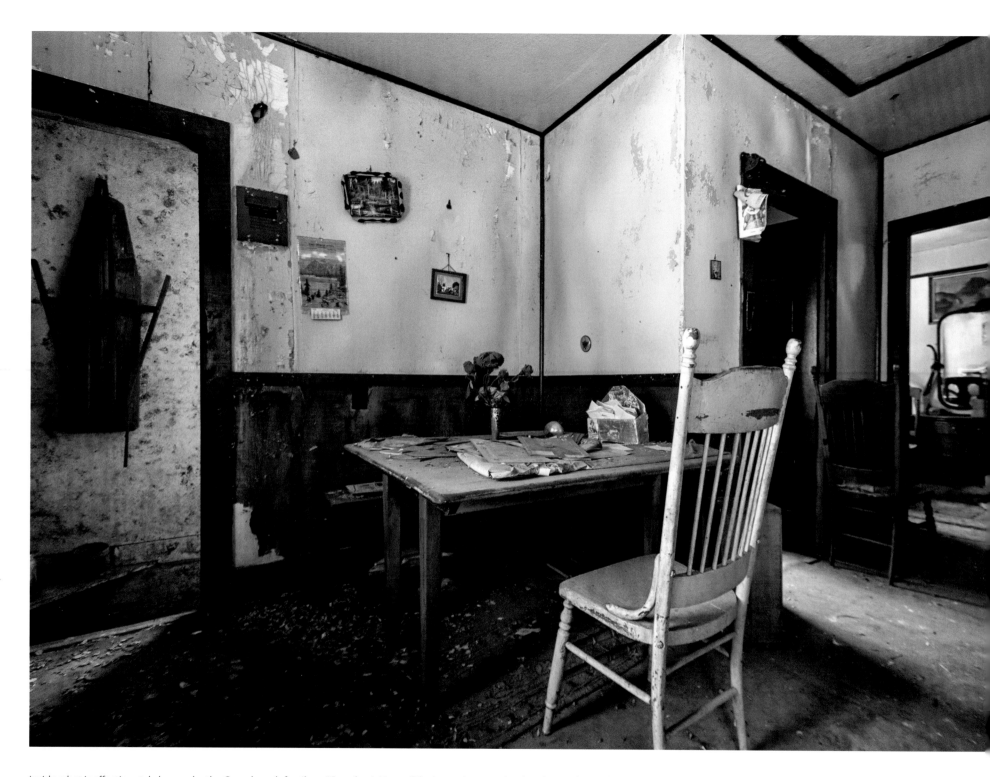

Inside what is affectionately known by the Greenhough family as "Grandma's House." The house has remained unchanged since her departure in early 1960s. The approximately 1,000 acres of land is still farmed as of January 2020, and the house is roughly 100 years old.

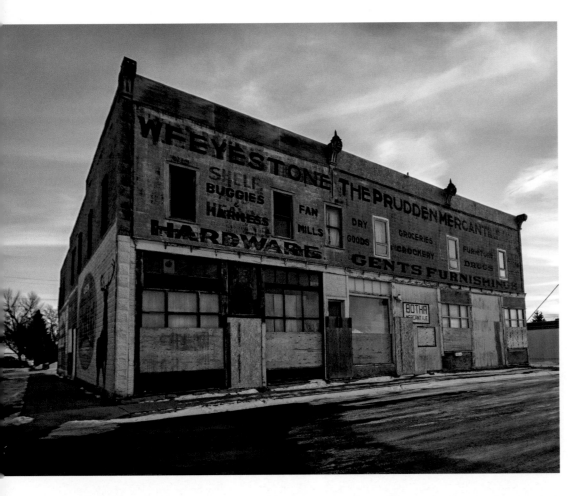

Botha Mercantile built in 1909, originally housed a hardware store operated by Lou Bastler, and a general store operated by E.H. Prudden. According to the signage on the front of the store, the Prudden Mercantile Company specialized in dry goods, groceries, crockery, furniture, drugs, boots, shoes and gents furnishings. The hardware store later managed by W.F. Eyestone, also carried such items as buggies, harnesses and fan mills.

E.H. Prudden was one of the first businessmen in Botha who also ran a store in the nearby community of Red Willow. He operated his businesses in partnership with his sons until 1928, when his eldest son, Willis, died. Prudden then went into partnership with a Jim Gibson. Subsequent owners of the business included Gibson, Joe Johnson, and the Grove brothers.

The Mercantile Building was the oldest store and is the oldest surviving commercial building in Botha. Constructed during the first flush of optimism concerning Botha's prospects as a rural service centre, it is typical of the early business history of the region. Like most country general stores, it served as a social and community centre as well as a place to purchase necessary goods. The Botha Mercantile Building reflects the early settlement history of east central Alberta, the development of communities by railway companies on their branch lines, and the role of early businessmen in supplying local farm populations with the wide variety of consumer products area residents had come to demand by 1909. **(text source: https://hermis.alberta.ca/)**

(Opposite) Main Street in Rowley and Sam's Saloon. The walls are lined with posters and artifacts. The floor is warped, but the beer is still cold on the last Saturday of the month.

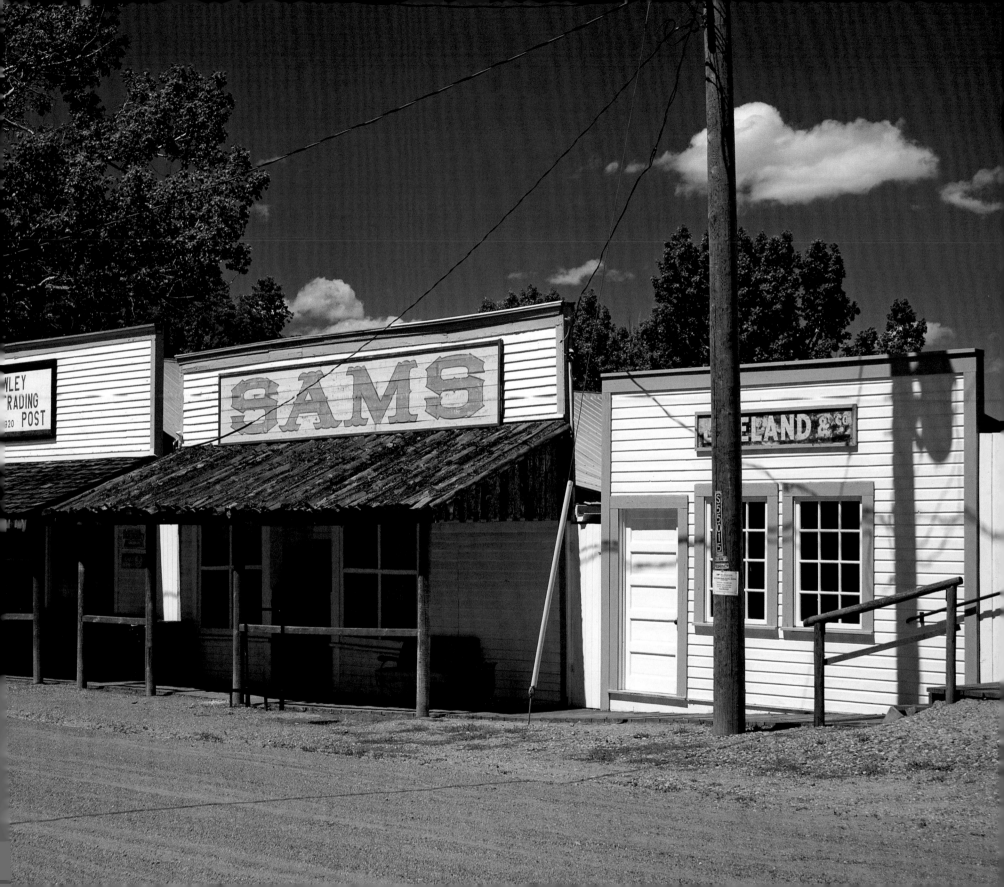

At the edge of the town they turned and stood looking out over the prairie to its far line where sheet lightning winked up the world's dark rim.

W. O. Mitchell, Who Has Seen The Wind

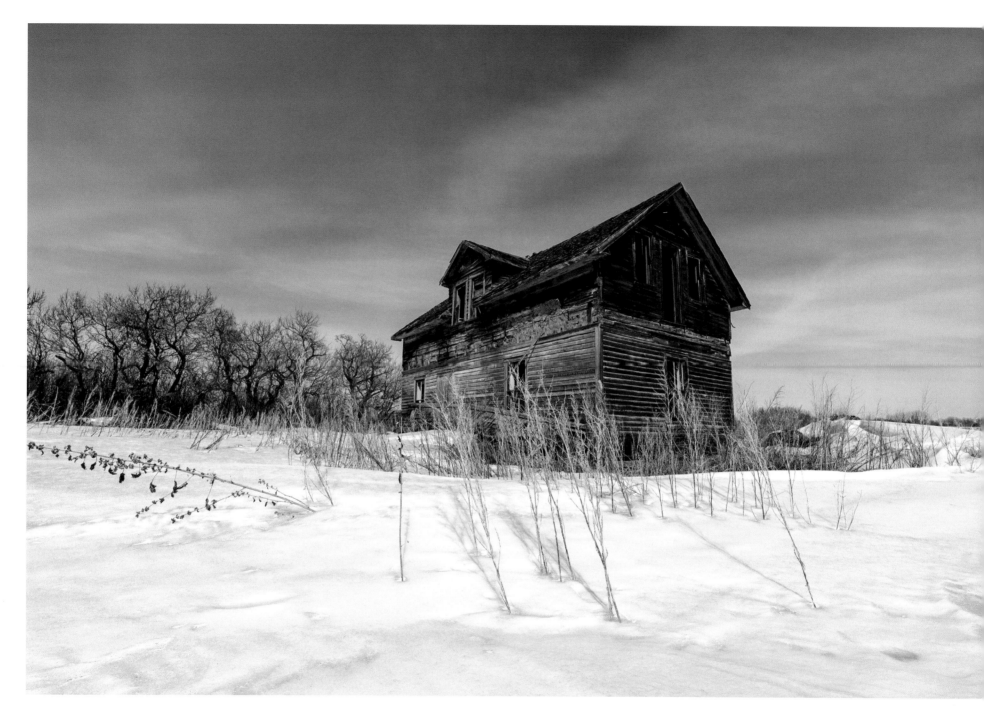

A beauty of an abandoned two-storey house in north central Alberta.

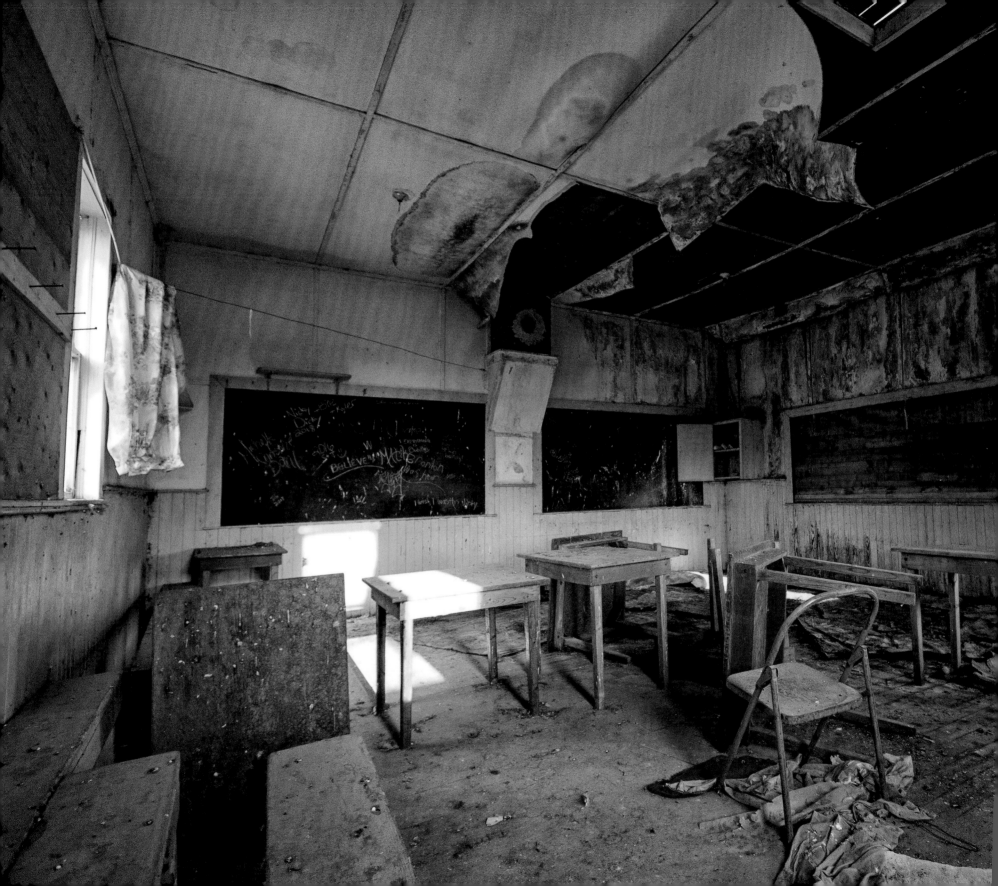

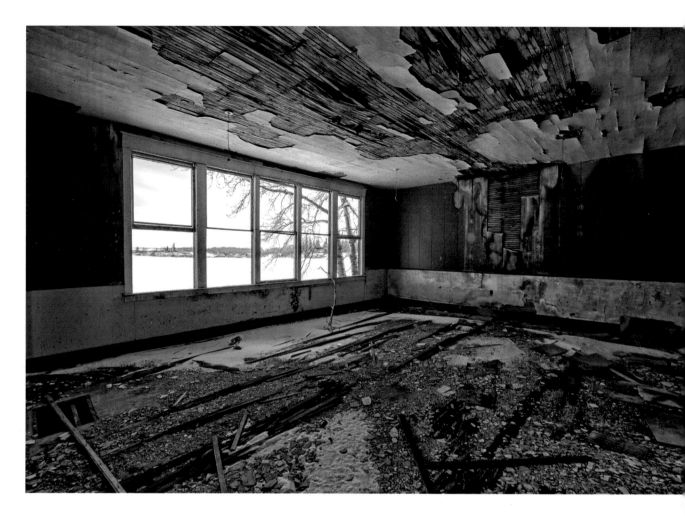

(**Opposite**) Inside the Wilmot School in September 2018.

(**Above**) Inside the Fairwood School in the Warwick area in Minburn County.

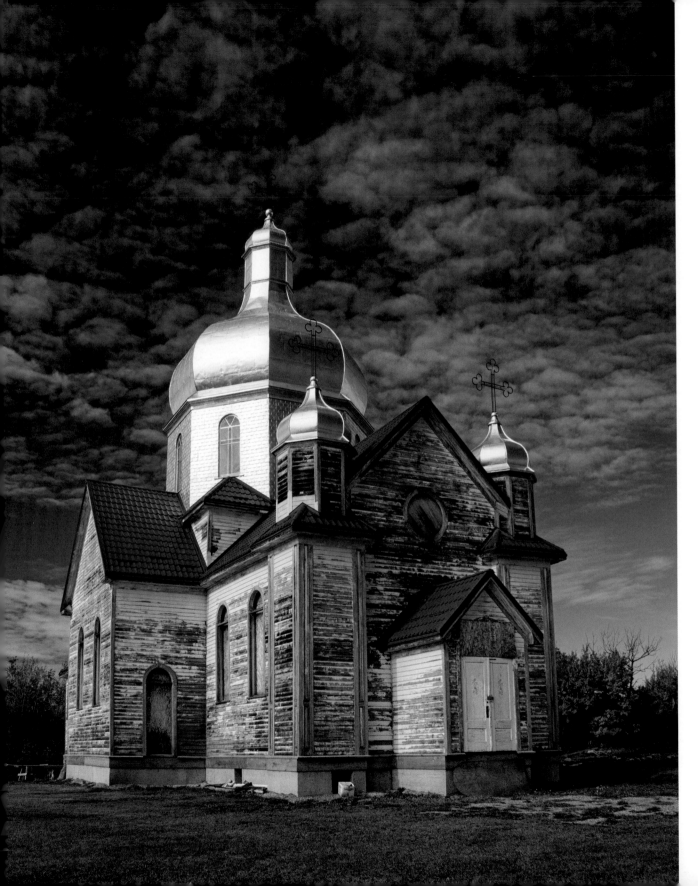

(Left) Probably one of the most impressive churches in Alberta — the Spaca Moskalyk Ukrainian Catholic Church near Mundare. Built in 1925 on land donated by Ukrainian settler Harry Moskalyk, the church held its last service in 1990. By 2011, with costly repair bills, the parish council voted to burn it down. In 2013, the decision was overturned and fundraising began to restore this icon. When I first found her, she had just been moved a few feet onto a new foundation. I revisited later when the roof was restored to its original beauty and then again to get a glimpse of the interior refurbishment. With the church's onion-styled Byzantine domes restored to their original glory and glistening in the sun, you can literally see her shining in the distance as you approach.

(Opposite) This home on a farm near Mundare was owned by John and Dorothy Serediak. The couple was married in 1936, and acquired a quarter section from Dorothy's father, Miron Mackowey, who had immigrated to Canada from the Ukraine in 1900. The house was built in 1948, the same year their youngest of their three sons was born. Indoor plumbing was added in 1962. After a house fire in 1995, they unfortunately did not have proper fire insurance to rebuild. John and Dorothy moved all of their belongings into the hog barns and moved to Vegreville. The contents of the house inside the hog barn sit essentially untouched by time. **Thank you to Kim Radench for the tour and family history.**

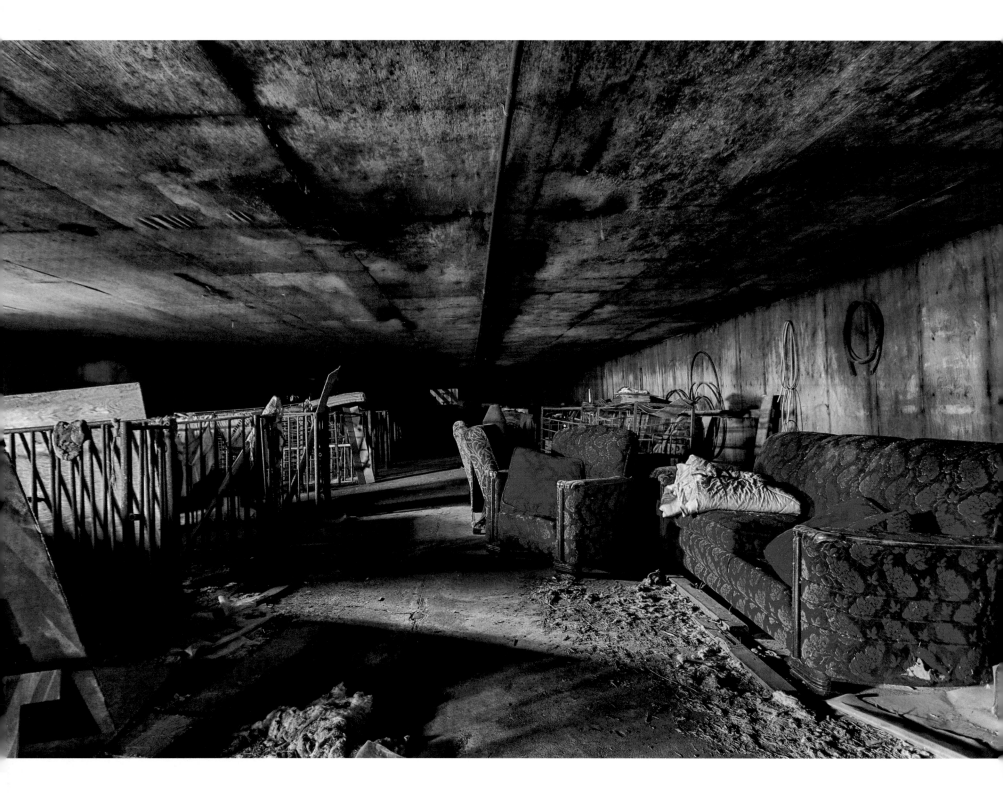

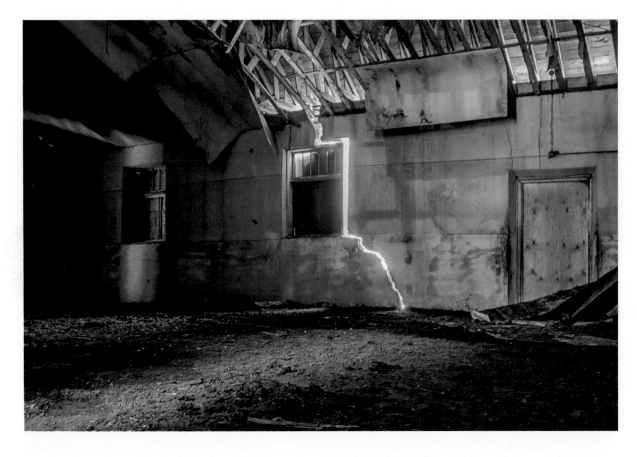

(Above) The Shandro Community Hall north of Willingdon and not far from the village of Shandro, located 70 km northeast of Edmonton. I was driving around the area looking for places to photograph and came across this beautiful, large stone building. I sneaked inside to take a peek. There are only a few remaining stone buildings in Alberta and this is by far the largest I have ever seen. Finished in 1935, the date of closure is unknown. The building is deteriorating; the wall has a large crack that has expanded over time, and the foundation and roof are failing.

(Opposite) The stage in the Shandro Community Hall as of January 2017.

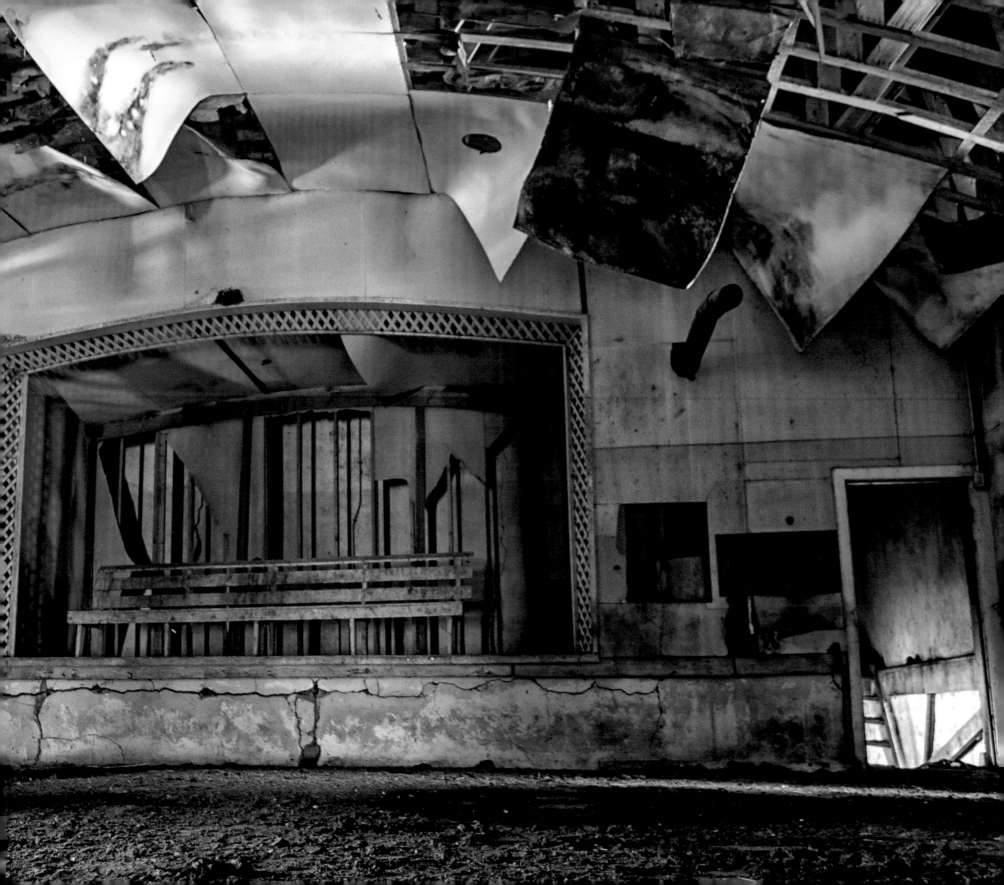

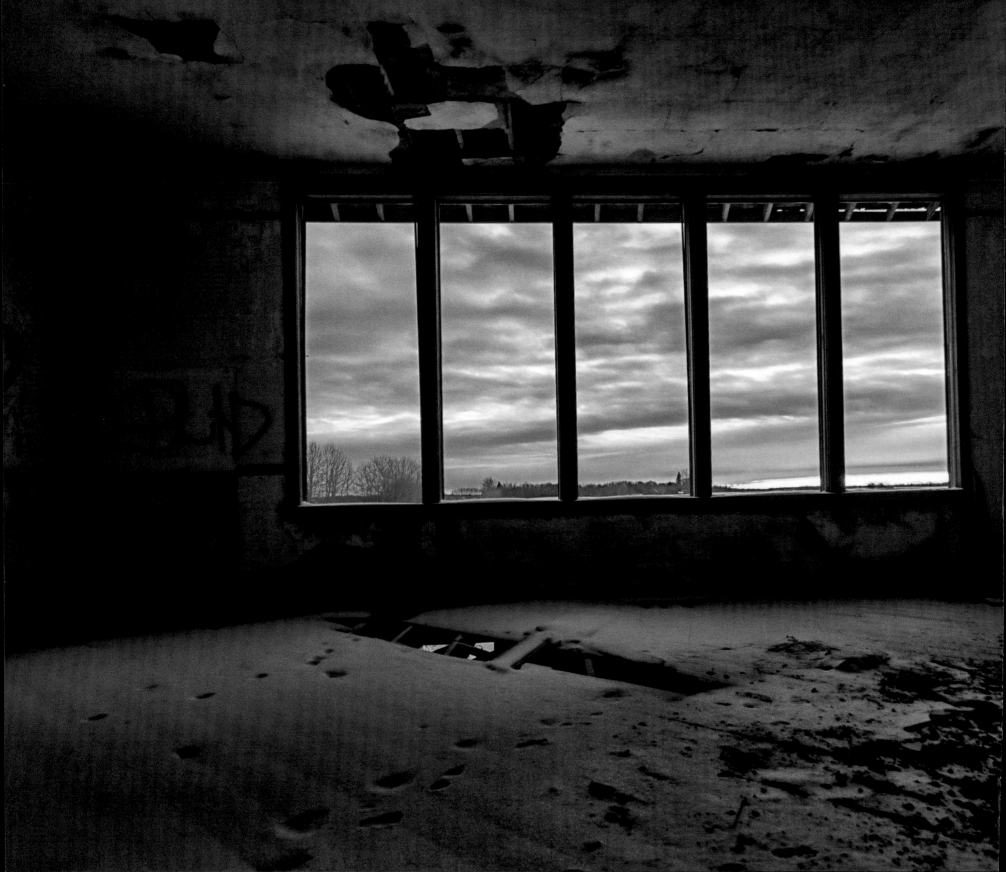

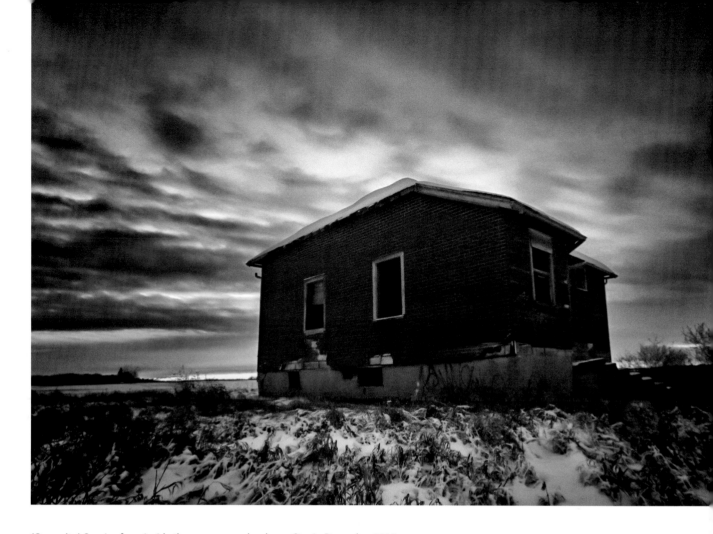

(Opposite) Sunrise from inside the one-room school near Star in December 2019.

(Above) An abandoned one-room school near Star, Alberta. The original building on the site was built in 1906 and closed in 1953. From a distance, this looks like an early brick building, but it is actually a thick red paper wrap glued to the outside the school. The students had a great view of the surrounding prairie from this location.

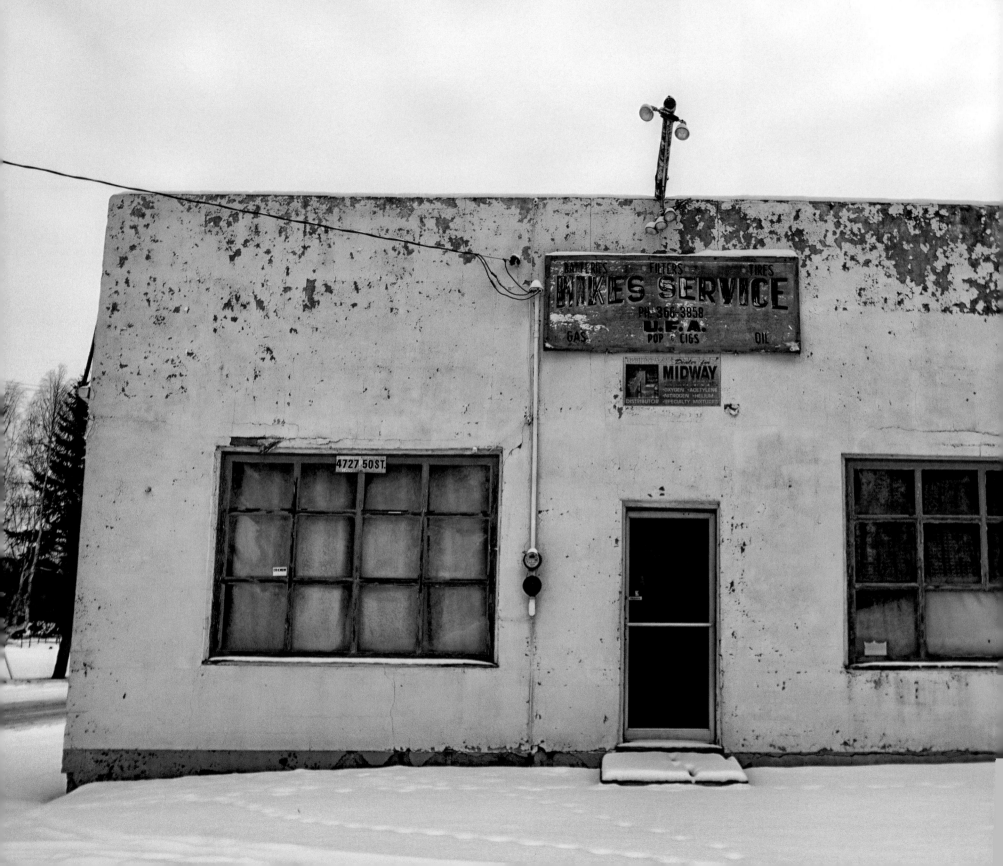

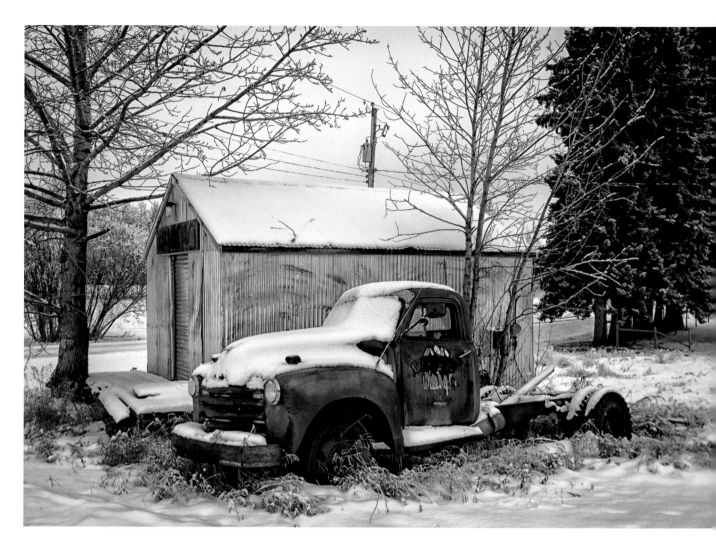

(**Opposite**) Mikes Service in Myrnam in December 2019.

(**Above**) Wonder if this abandoned truck in Beauvallon would start on this cold December morning?

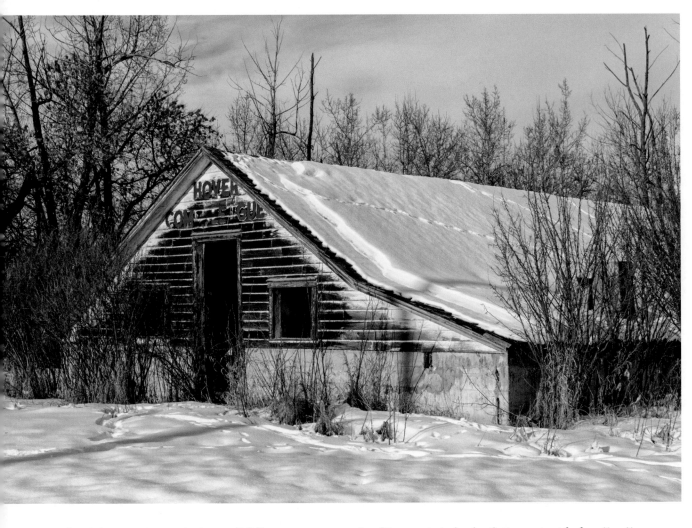

(Above)The Hover Community League Hall. There was no community of Hover — just a local gathering spot not far from New Norway. What was interesting about this place is that the windows were at ground level and the majority of the building was built below ground.

(Opposite) Outhouse behind the Myrnam railway station on a cold day in December 2019. I suspect patrons experienced a few drafty moments using the facilities, especially in the winter months.

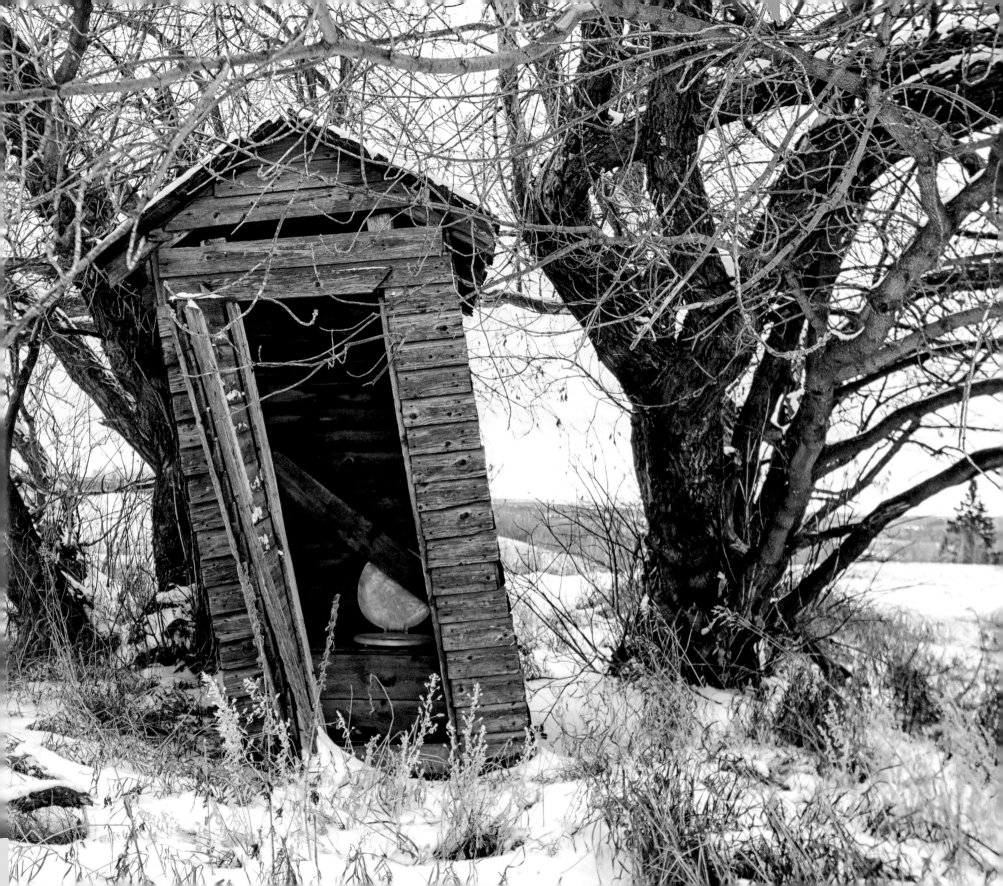

Acknowledgements

I would like the thank Vernon Oickle and the entire team at MacIntyre Purcell Publishing Inc. for making this project come to life. I would also like to acknowledge Allison Blackburn Billings, Glen Bowe, Rob Brennen and Chris Doering for submitting photographs and stories for this book.

Also, I humbly acknowledge all of the mentors who have provided me with photographic advice, suggestions and tips along the way to help me improve my skills. The work of Paul Nicklen, Brian Skerry and Mac Stone provides me with inspiration to be both photographer and storyteller, offering a fresh perspective of our world. Thank you!

To my thousands of Facebook followers, this little journey started out as a whim to create a page to share some photos and tell stories. I am constantly amazed at the stories you share and your appreciation for my work.

A great, big thank you to my full-time job for allowing me the flexibility to work on this project.

Finally, I am grateful to my wife, Rami, who has endured long road trips and unexpected stops as I photographed a deserted building, and my many, many hours travelling around Alberta and exploring the province's abandoned history.

Joe Chowaniec